A CAPSULE AESTHETIC

A Capsule Aesthetic

FEMINIST MATERIALISMS IN NEW MEDIA ART

Kate Mondloch

University of Minnesota Press

Minneapolis

London

A portion of chapter 5 was published in different form as "Wave of the Future? Reconsidering the Neuroscientific Turn in Art History," *Leonardo* 49, no. 1 (January 2016): 25–31.

The book's digital companion publication is accessible from the author's website, www.katemondloch.com.

Published by the University of Minnesota Press
111 Third Avenue South, Suite 290
Minneapolis, MN 55401-2520
http://www.upress.umn.edu

Printed in the United States of America on acid-free paper

The University of Minnesota is an equal-opportunity educator and employer.

22 21 20 19 18 10 9 8 7 6 5 4 3 2 1

Library of Congress Cataloging-in-Publication Data

Names: Mondloch, Kate, author.
Title: A capsule aesthetic : feminist materialisms in new media art /
 Kate Mondloch.
Description: Minneapolis : University of Minnesota Press, 2018. |
 Includes bibliographical references and index.
Identifiers: LCCN 2017022055 (print) | ISBN 978-1-5179-0048-9 (hc) |
 ISBN 978-1-5179-0049-6 (pb)
Subjects: LCSH: Feminism and art. | New media art—Themes, motives.
Classification: LCC N72.F45 M66 2018 (print) | DDC 305.42—dc23
LC record available at https://lccn.loc.gov/2017022055

For A. and O.

The proper subject of the humanities is not man—its proper subject is the vital matter that constitutes the core of both subjectivity and its planetary and cosmic relations.

—ROSI BRAIDOTTI, *THE POSTHUMAN*

CONTENTS

CHAPTER ONE

Inhabiting Matter

New Media Art and New Materialisms
Informed by Feminism

Epistemology, ontology, and ethics are inseparable. Matters of fact, matters of concern, and matters of care are shot through with one another. Or to put it in yet another way: matter and meaning cannot be severed.

— KAREN BARAD, "INTERVIEW WITH KAREN BARAD," IN RICK
DOLPHIJN AND IRIS VAN DER TUIN, *NEW MATERIALISM*

Artists such as Pipilotti Rist, Patricia Piccinini, and Mariko Mori typify a fascinating yet underappreciated variant of post-1990 new media art that draws attention to our encounters with new sciences, technologies, and other forms of matter, often in forceful and unexpected ways.[1] What is more, these artists create new media installations that offer novel experiential environments for exploring, inhabiting, and even critiquing our relations with science and technology in the twenty-first century. Consider the following propositions and provocations.

Pipilotti Rist's cathedral-scaled installation, *Pour Your Body Out (7354 Cubic Meters)* (2008), entreats us to "pour our bodies out"—and in the cavernous atrium of New York's Museum of Modern Art (MoMA), no less. The all-encompassing multimedia work consists of enormous biomorphic moving images projected onto all four walls of a colorful carpeted and cushioned interior. Immense cascades of magenta drapery partially enclose the otherwise sprawling exhibition space. Breast-shaped projectors emit dreamy jewel-toned imagery of female, animal, and natural forms merging in verdant and moist interactions. Upon entering the unabashedly feminized space, the installation's viewer-participants are free to choose how to explore it: some roam throughout the eroticized multimedia

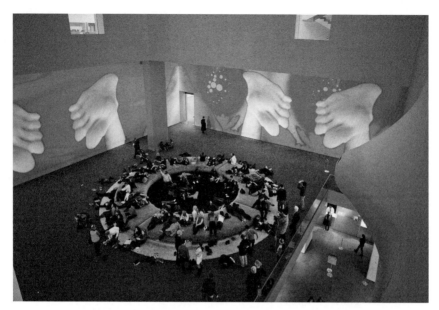

FIGURE I. Pipilotti Rist, *Pour Your Body Out (7354 Cubic Meters),* installation view, 2008. Multichannel video projection (color, sound), projector enclosures, circular seating element, carpet. The all-encompassing multimedia work includes enormous moving images projected onto all four walls of the Museum of Modern Art's atrium as well as custom-designed viewing and lounging areas. Copyright 2009 Pipilotti Rist and The Museum of Modern Art, New York. Images courtesy of the artist, Luhring Augustine, New York, and Hauser & Wirth. Photography by Thomas Griesel. Digital Image copyright The Museum of Modern Art / Licensed by SCALA / Art Resource, New York.

environment, circulating amid the other visitors; others sprawl, cheek by jowl, on a massive mattress-like seating element custom-designed by the artist. Regardless of which path they choose to follow or the perspective from which they view the piece, Rist's viewers find themselves surrounded by other viewing bodies, encircled by wall-sized projections, and enveloped by hallucinatory electronic music.

Many art historians think we already know how to judge this type of populist, large-scale multimedia installation: as commercialized and institutionalized media spectacle. Such projects are deemed to be emblematic of the contemporary art museum's commercially inclined experiential programming and bombastic architecture. On the one hand, that might not be entirely unjustified. After all, Rist's sumptuous installation is the first in the museum's history to inspire site-specific yoga lessons, both impromptu

and museum-sponsored. As many of the foremost cultural critics of the twentieth century have convincingly argued, we must be ever vigilant against the uncritical embrace of the popular and the new, particularly insofar as they are bound up with the culture industry (Max Horkheimer and Theodor Adorno), commodified spectacle (Guy Debord), and the seeming insatiable quest for the "experience of experience" itself (Rosalind Krauss).[2]

If we look closer, however, we might see that something else is going on in Rist's well-known MoMA installation. There is no getting out of the entangled stickiness of it all—you *feel* your surroundings in this immersive multimedia environment. If you "pour your body out" in your multisensory encounter with this work (and good luck avoiding it), new possibilities arise. You are provoked, no matter how briefly, to experience yourself as embodied, sensuous, and contingent—as an active body coconstituted with other lively bodies and processes. We pour our bodies out, and yet we simultaneously perceive ourselves doing so from a contextualized, embodied, and located point of view.

If Rist invites us to pour our bodies out, Patricia Piccinini instead requests that we wear our hearts on our sleeves. Piccinini's *We Are Family* exhibition (Venice Biennale, 2003) asks viewers to come face-to-face with otherworldly biotech-generated creatures. The most remarkable are hyperrealistic sculptures of charmingly grotesque bioengineered creatures engaged in various everyday activities: prematurely aged cloned boys playing a handheld video game, a nursing family of mutant porcine–bovine–hominoid crossbreeds, a small child amicably fondling presumably sentient flesh lumps (complete with mouths, hair follicles, and freckles), and so on. Tellingly, these immobile and nonsentient beings appear just "human enough" to inspire absorptive attention and even an anxious affection in their viewers. Encountering a room populated with Piccinini's transgenic humanoid objects is an extravisual experience that you feel in your gut. Who are these hybrid aberrations and what do they want? Should you love them? Pity them? Use them to decorate your home? However melodramatic these sculptures may be (a charge lobbed against the work by unsympathetic reviewers for reasons that parallel Rist's bad press), Piccinini's installation allows you to experience yourself shamelessly anthropomorphizing these nonhuman entities. And this, in turn, just might challenge your notion of what it means to be human in the first place.

Mariko Mori, for her part, requests that viewers leave planet Earth altogether. Mori's multimedia installation *Wave UFO* (1999–2003) invites gallerygoers to step inside a shiny sculptural UFO equipped with brainwave interface technology. Attendants strap three visitors at a time into

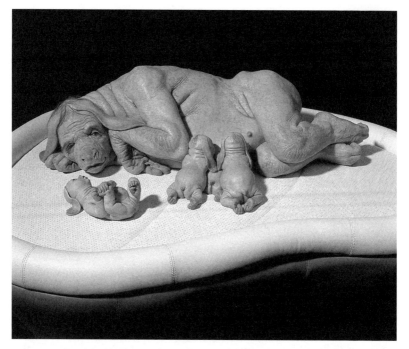

FIGURE 2. Patricia Piccinini, *The Young Family*, 2002–3. Silicone, acrylic, human hair, leather, timber. 80 cm × 150 cm × 110 cm (31.5 × 59 × 43 inches) (irreg.). This hyperrealistic, life-size sculpture depicts a nursing family of mutant porcine–bovine–hominoid crossbreeds. Photographer: Graham Baring. Photograph courtesy of the artist.

EEG brain-monitoring equipment that allows the threesome to watch simulations of their shared body–brain experiences accompanied by crystalline electronic music. Each individual participant's brainwave patterns are artistically rendered as slowly morphing and interlocking pastel patterns on a series of overhead screens. The redolent moving images on the screens in turn affect the ongoing brain activity of the other two participants, creating a neurofeedback loop. Mori's customized software interprets these data in a visual rendering that allows all three participants to see an evocative, and, importantly, highly mediated, translation of their interconnected brainwaves in action. Art critics have detailed the apparent ridiculousness of the work's New Agey ethos, lab-coated gallery assistants, and long queues. But when is the last time you *felt* neuroimaging technology and its sociocultural implications? When is the last time you *inhabited* distributed consciousness or the fluidity of subjectivity?

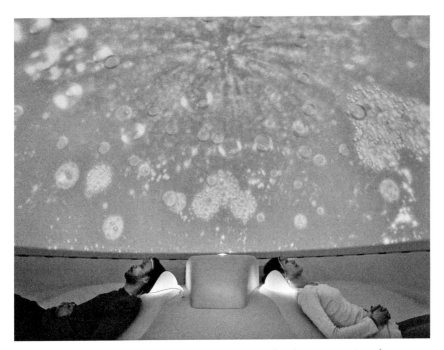

FIGURE 3. Mariko Mori, *Wave UFO*, 1999–2003, detail. Brainwave interface, Vision Dome projector, computer system, fiberglass, Technogel, acrylic, carbon fiber, aluminum, magnesium. 493 cm × 1,134 cm × 528 cm (194 × 446.5 × 208 inches). The artwork's participants are monitored by a brainwave-tracking apparatus while they watch projected images on hemispherical overhead screens. The images shown here are from the artist's prerecorded "Connected World" sequence. Courtesy of Shiraishi Contemporary Art, Inc., Tokyo, Deitch Project, New York. Copyright Mariko Mori 2009. All rights reserved. Photo courtesy of Mariko Mori / Art Resource, New York. Copyright 2016 Mariko Mori, member Artists Rights Society (ARS), New York.

New media installations like those of Rist, Piccinini, and Mori have been underappreciated by contemporary art scholars despite—or perhaps because of—their relative approachability and widespread popular success. The critical disregard of these projects by many (although by no means all) scholars may also be motivated in part by the gendered nature of the ostensibly passive and immersive corporeal reception these multisensory works promote.[3] These artists represent particularly extreme examples of new media installation art in that they are not afraid of affect, populist museum spectacle, or passive immersion—the very qualities said to make post-1990s media artwork an unwelcome debasement of the ostensibly

more critical media art practices of the 1960s and 1970s.[4] Indeed, Rist, Piccinini, and Mori get very close, possibly even too close, to the scientific and technological interfaces they set out to explore and critique. This book puts incriminatory analyses of post-1990 media installation practices into productive conversation with what I consider to be the prodigious contribution of these artists: their provocative enactment of the interfaces with new sciences and technologies that define our everyday lives.

At a time when reimagining the exchanges among human beings, technologies, and the other nonhuman creatures, forms, and processes that make up our world arguably has never been more urgent, installations such as those by Rist, Piccinini, and Mori far exceed their reductive characterization as institutionalized media spectacle. Participatory new media installations such as these deliberately mobilize the contemporary art museum's critical framing function in order to stage spectators' physical and emotional interactions with science, technology, and other objects (including human bodies), transforming these encounters into part of the work of art itself. The remarkable installations detailed above *perform* our affective and corporeal relations with the objects of media art, biotechnology, and the brain sciences such that we actively experience how our contemporary sciences and technologies create us even as we create them. Through creatively enacting a variety of human–nonhuman relations, these artworks reveal how human experience is always contextual and interactive, and they instantiate how subjects and objects emerge through their encounters with each other.

I propose that the experiential and environmental works of artists such as Rist, Piccinini, and Mori promote a critical and potentially revelatory spectatorship: one deeply informed by feminism's long-held epistemological commitment to exploring the mechanisms by which bodies and matter become meaningful. They not only carry on a feminist epistemological project, however—they do so in ways that directly employ and analyze twenty-first-century science and technology. These artists may justly be called theorists: practitioners in the growing interdisciplinary field of feminist theoretical materialisms.[5] Installations such as those by Rist, Piccinini, and Mori advance the ethical-political aims associated with feminist materialisms' models of material agency and embedded, contextualized embodiment—especially, as we shall see in what follows, feminist technoscience studies.

This book explores materialisms and modes of spectatorship in post-1990 new media art. It brings the research areas of new media art and interface studies into conversation in original ways while simultaneously maintaining a historical perspective that acknowledges the way in which

many of the qualities habitually attributed to our experiences with new media are not in fact "new."[6] Rist, Piccinini, and Mori are my central case studies because each has demonstrated a career-long investment in exploring the interactions between humans and new technologies (with a special focus on developing these speculations in material and experiential art environments) and each has been discussed in relationship to feminism, albeit inconclusively.[7]

This book focuses on the connections between new media art and feminist materialisms for two principal reasons: first, drawing out affinities between new media installation art and the persuasive ethical-political motivations of feminist materialisms helps us to recognize the often-obscured critical-aesthetic potential of these artistic practices and their spectatorship. It also helps us to think through a seeming paradox: how the artistic enactment of technological intimacy and mediated entanglement, as a feminist material practice, might offer a new model of critical aesthetics. Second, this approach allows us to appreciate how new media artworks such as those by Rist, Piccinini, and Mori constitute feminist theoretical materialisms in their own right. Artists may even go one better, at least by some reckonings, because they theorize not just with words, but *in* space, *with* technologies, and *through* bodies. As practicable material feminisms, these experiential artworks offer meaningful and heretofore unappreciated opportunities for examining the material, social, technological, and biological conditions that define our contemporary technoculture.

With this in mind, *A Capsule Aesthetic*'s objective is efficiently defined: to think new media art through feminist materialisms, and feminist materialisms through new media art.[8] To be clear: my intention here is not simply to propose philosophy as a way to explain art, or art as a means to illustrate theory. Rather, I aim to explore how these instruments can work together, provoke each other, and even begin to unite in the interest of larger critical and intellectual projects. In short, this study takes new media art seriously as a form of feminist theory and praxis, and it looks at art as a way to augment current feminist theorizing. Through extended case studies of specific installations, *A Capsule Aesthetic* expounds upon many of the motivating social, technological, and ecological concerns of feminist theoretical materialisms. These include, for example, the imperative to develop a post-anthropocentric theory of subjectivity, the momentousness of building interpretive bridges between the humanities and the sciences, and the urgency of feminism to contemporary ethics.

Feminism at the Interface

In terms of methodology, I approach these dynamic new media art practices as a study of spectatorship, the premise being that *how* one sees and experiences a given work of art is just as important as *what* one sees. Throughout the book, I consider the issue of spectatorship by examining the human–nonhuman interface conditions in a given media artwork: the array of physical, symbolic, and sociological sites of exchange among bodies, technologies, and other forms of matter.

The museum-based media installations examined in this book are distinguished by their purposeful staging of body–environment syntheses. There is no conception of an artwork or environment "over there" and the viewer "over here": the work is an *ongoing event* that happens at the ever-changing interface. This interweaving of lived phenomenal bodies with active nonhuman matter—the deliberate framing of embodied technointerfaces—challenges conventional models of spectatorship. Spectatorship studies tend to rely on traditional notions of the human subject's relationship to the world as a spectatorial view on an "outside" reality, on conceptions of aesthetic experience as exclusively sited in the observing subject, and/or on notions of the apparatus as all-determining.[9] Instead, as I will argue throughout this book, the interface is always a process-based enactment and the viewing subjects of media installations are simultaneously actors *and* observers, subjects *and* objects.[10]

Taking a cue from the works of art themselves, *A Capsule Aesthetic* introduces a spectatorship model in which "interface matters."[11] In the case of media installation artworks, the interface is of particular importance because the interface—where and how the viewing body encounters the material artwork—is in large part the meaning of the work of art itself. Installation artworks are participatory sculptural environments in which the viewer's spatial and temporal experience with the exhibition space and the various objects within it forms part of the artwork. These pieces are meant to be experienced as activated environments, rather than as discrete objects: they are designed to "unfold" during the spectator's experience in space and time, rather than to be known visually all at once.[12]

Installations are always contingent upon the viewer's embodied and contextualized experience, and they exhibit the entwined relationships between viewing subjects and material objects—this totally by design. Installation artists, crucially, use the institutional context of the visual arts as a frame to set off and activate the spectator's experience as a site of aesthetic-critical contemplation. In the case of the new media installations explored in this book, the spectator's experience of embodied

technointerfaces—which I have deemed to be a feminist materialist project—is of primary importance.

The corporeal and investigative spectatorship associated with installations made by artists like Rist, Piccinini, and Mori arguably intersects with a wide range of feminist critical approaches. Of course numerous difficulties are associated with periodizing and identifying feminism in art with regard to the multiplicity of feminisms since the 1970s—including generational and regional divergences, feminist critiques centered on race and class, and so-called postfeminisms. My goal in this book is not to demarcate definitively what constitutes an authentic feminist art; rather, my aim is to explore how expansive the intellectual inheritance of feminism(s) can be for theorizing contemporary artistic production and its methods. In *Self/Image: Technology, Representation, and the Contemporary Subject,* Amelia Jones proposes the useful term "parafeminism" to draw out affinities among multiple feminisms. "If postfeminism implies an end to feminism, through the term parafeminism, with the prefix 'para-' meaning both 'side by side' and 'beyond'—I want to indicate a conceptual model of critique and exploration that is simultaneously parallel to and building on (in the sense of rethinking and pushing the boundaries of, but not superseding) earlier feminisms."[13] *A Capsule Aesthetic* shares Jones's objective of tracing affinities across various feminisms. However, I make a strategic decision to eschew the restrictive label "feminist art" altogether, in favor of Mary Kelly's more capacious designation "art informed by feminism." As Kelly explains, "Perhaps we shouldn't maintain this formulation 'feminist art,' because an ideology doesn't constitute a style. Rather I would say 'art informed by feminism.'"[14] This approach allows me to recognize meaningful similarities across various feminist methods while also acknowledging that there is no single feminism and, moreover, that artists informed by feminism(s), Rist, Piccinini, and Mori included, do not necessarily self-identify as feminist.

I identify the feminism in these new media art practices not by virtue of the artists' professed investment in feminist philosophy, but rather by analyzing the particular model of artistic experience (the interface) proposed in a given work and appreciating its conceptual and methodological similarities to feminist frameworks past and present. Although written in a different context, Stacy Alaimo's qualification regarding the feminism in present-day theoretical materialisms is helpful here. Even if these theories do not explicitly address feminist questions of sex or gender, explains Alaimo, "they still have their roots in feminism as a social movement, via their insistence that the human body is, simultaneously, a political, ontological, and epistemological site."[15]

From a historiographical perspective, feminist philosophers for decades have been at the forefront of rejecting dualistic separations of minds from bodies or nature from culture and insisting (à la Foucault) on the material-izing force of broadly circulating ideas.[16] Postcolonial, environmental, and black studies have long shared overlapping concerns as well. The feminist precedents that most concern us in this study, however, are those that specifi-cally theorize how human bodies and nonhuman technologies are entan-gled. Feminist scholars of poststructuralism and psychoanalytic film theory developed the first spectatorship theories concerned with the complex rela-tionships among media technologies, bodies, and subjectivity as early as the 1970s. (Chapter 2 is devoted to revisiting these profoundly influential yet often misunderstood theoretical frameworks developed in the 1970s and 1980s—a period during which feminist theory and media art were very much entwined, and one that represents an important but overlooked prehistory to the so-called new materialisms.) I will argue throughout the book for the continued relevance of all these earlier feminisms, but the correspondences between post-1990 media art practices and contemporaneous feminist new materialisms are even more forceful and will be our focal point here.

Understanding Feminist New Materialisms

To appreciate the contributions of the feminist variants of new material-isms (feminist critiques of technoscience in particular), and to understand how they map onto the artistic practices at issue in this book, we first need to establish a working definition of new materialism and determine how it relates to the larger "material turn" across the humanities and social sciences over the past three decades. The material turn has been motivated both by the perceived inadequacies of the linguistic turn and by new sci-entific definitions of matter, including living matter.[17] While in many ways prefigured by earlier feminist theories (a point increasingly well articulated by writers such as Alaimo, Sara Ahmed, Rebekah Sheldon, Iris van der Tuin, and others, and one we will return to in chapter 2), the self-conscious scholarly turn toward matter has inspired a proliferation of theoretical approaches known as "new materialisms."[18] Scholarship in this interdisci-plinary area is more or less unified by the conviction that a viable twenty-first-century philosophy needs to account for the activity of materials and the nonhuman world. In their anthology *New Materialisms,* Diana Coole and Samantha Frost concisely describe the transformative influence of the shift in emphasis toward agential matter: "Conceiving matter as possessing its own modes of self-transformation, self-organization, and directedness, and thus no-longer as simply passive or inert, disturbs the conventional

sense that agents are exclusively humans who possess the cognitive abilities, intentionality, and freedom to make autonomous decisions and the corollary presumption that humans have the right or ability to master nature."[19] Whereas scholars' specific critical investments diverge and even contradict each other, writings on new materialism, such as those collected by Coole and Frost, tend to share certain basic characteristics, namely, a critique of anthropocentrism, an emphasis on the self-organizing powers of matter, a commitment to thinking from a planetary perspective, a reevaluation of subjectivity by accentuating the agency of nonhuman forces, and, ultimately, a reconsideration of the bases of contemporary ethics.[20]

Feminist variants of the new materialisms, such as those developed by scholars like Karen Barad, Rosi Braidotti, Donna Haraway, Claire Colebrook, and Elizabeth Grosz, are of special interest, in part because they maintain that bodies (human or otherwise) exist in interaction with an array of discursive forces.[21] Their specific writings reveal a rich and internally variegated body of literature, but all these thinkers bring the material (including the materiality of the human body) into the forefront of feminist theory and practice. Moreover—and this is key—they do so without losing sight of its sociocultural production. The logical imperative behind such an approach has been identified by Bruno Latour as part of his advocacy of science studies. Latour argues that the challenge for contemporary thinkers is to move beyond what he calls the failure of the "modernist settlement": the erroneous belief in the separation of the material and linguistic and of the social and natural worlds.[22] Instead, Latour proposes, we need to develop a material theory that encompasses language, materiality, science, and technology; that is, to understand the material in discursive terms.[23] In *The Material of Knowledge,* Susan Hekman convincingly argues that feminist theory is unmistakably the most developed and explicit of the contemporary "settlements" that meet Latour's call for material-discursive analysis. Her endorsement of feminist new materialisms is unequivocal: "My thesis is that this feminist attempt will be the driving force behind the formulation of a new settlement not only for feminism but for critical thought as a whole."[24] Hekman reasons that this is due to the sociopolitical commitment that lies at the root of feminism itself. As Hekman describes, this commitment has two aspects: "First, feminists want to be able to talk about the reality of women's bodies and their lived experiences in a patriarchal world. . . . Second, feminists want to assert the truth of their statements regarding women's status in that world."[25] In other words, the reason material feminisms convincingly unite an interest in materiality (including material bodies) with the insights of discursive analysis is twofold: feminists cannot afford either to lose women's bodily realities entirely or,

significantly, to ignore questions of political subjectivity and the socially constructed experience of bodies—which, as these theorists persuasively describe, are also material.[26]

Grosz described this feminist political ontology of the body as early as 1994. The objective is for "subjectivity to be understood as fully material and for materiality to be extended and to include and explain the operations of language, desire, and significance."[27] Braidotti, in conversation with Rick Dolphjin and van der Tuin, helpfully clarifies the starting point for feminist new materialist redefinitions of subjectivity. As explained by Braidotti, these feminist materialist thinkers understand the body or the embodiment of the subject as "neither a biological nor a sociological category, but rather as a point of overlap between the physical, the symbolic, and the sociological."[28] Like Latour, then, feminist theorists of the new materialisms begin from the premise that the material and the cultural are overlapping and coextensive. For feminist new materialists, however, knowledge production even more specifically is a material–semiotic relation that is emphatically *relational, embodied, and embedded.* This is significant because, as Braidotti points out in *The Posthuman,* even scholarship emerging from science and technology studies such as Latour's ultimately exhibits a "high degree of political neutrality" vis-à-vis the human (or, in Braidotti's terms, "posthuman") predicament. "Science and technology studies tend to dismiss the implications of their positions for a revised vision of the subject. Subjectivity is out of the picture and, with it, a sustained political analysis of the posthuman condition."[29] We will return to the intersections of contemporary feminism and posthumanism in chapter 4. At present, I want to underline how Braidotti's counterthesis encapsulates the significantly different project shared by many scholars associated with feminist materialist critiques of technoscience. Braidotti advocates for a conceptual framework that includes, as she puts it, "both scientific and technological complexity *and* its implications for political subjectivity, political economy and forms of governance."[30] In short, (technological and scientific) matter and (social) meaning cannot be separated.

What is essential to grasp is that feminist new materialists like Braidotti (and her like-minded artist peers) work both *through* and *against* the larger new materialisms (material turn). These feminist thinkers are exceptional in that they reject traditional subject-centered humanism, but *not* the fundamental importance of context and embodied experience. In so doing, they bring renewed attention to the questions of subjectivity that are sometimes occluded in materialist theories that challenge the interpretive exception of human experience, and even discount the embodied subject altogether. (For example, the critique of "correlationism" associated with

various speculative realisms, and the antipathy to relations in favor a "flat" world of autonomous objects among object-oriented ontologies.)[31] A recent article by Cecilia Åsberg, Kathrin Thiele, and van der Tuin in *Cultural Studies Review* pinpoints feminism's strategic contribution to the larger new materialism. They grant that while there are many productive points of overlap, feminist methods differ from materialist projects such as speculative realism in crucial and revelatory ways. "Trained with a political pathos that taps into sexual difference, feminist science studies, anti-colonial, environmental, animal and social justice movements, [feminist scholars] certainly can agree with the need to acknowledge the nonhuman (poor term, of course) agentiality." That said, Åsberg, Thiele, and van der Tuin go on to identify a decisive difference that marks feminist approaches: "Where speculative realists strive for an unmediated, wholly a-subjective real, feminist immanence ontology (in the singular plural) insists on the co-constitutive role of the embedded observer, the perspective and the rich agentiality (multi-subjectivity) of context itself."[32] As these feminist theorists insist, and as the embodied technointerfaces enacted by Rist, Piccinini, and Mori affirm, we are always interimplicated with each other and with the rest of the material world—and from a particular embodied and contextualized perspective.

Whether in scholarly or artistic configurations, feminist new materialisms' special perspective on the body and the contextualized embodiment of the subject successfully circumvents the abstraction and universalizing that sometimes (ironically) vexes other theoretical materialisms. While the critical practices, epistemologies, and ontologies of feminist theoretical materialism, pointedly, are always bound up with their politics, it is vital not to equate this sociopolitical commitment with identity politics and the potential anthropocentrism of that approach. Instead, for feminist new materialists, things and ideas *jointly* produce the world. Epistemology and ontology are inseparable. As Sheldon deftly explicates, "[Feminist] epistemology . . . is not a sieve filtering out the material world and leaving only our relation to ourselves; rather, epistemology directly acts on material liveliness."[33] For feminist new materialists, bodies are not merely cultural or biological, but rather are constituted in performative affective encounters—the very encounters and embodied interfaces enacted in the participatory art installations by Rist, Piccinini, and Mori.

Intra-action in Art and Theory

The artistic feminist materialisms examined in this book purposefully instantiate our myriad potential relations with nonhuman technological

entities and beings. Rist's feminized bastion of sensuous moving images and erogenous exhibition design submerges museum visitors like undersea divers. Piccinini's biotech babies cry out to be picked up and held to our chests. Mori's futuristic machine literally interweaves viewers' bodies with the scientific imaging apparatus and with their peers. In each, bodies and technologies open outward and constantly remake each other. These installations enable us to appreciate how coherent "bodies" and "technologies" do not preexist the interface (as one might conventionally assume), but instead are constantly in process.

In their critical engagement with new sciences and technologies, the installations explored in this book intersect most explicitly with feminist critiques of technoscience by writers such as Barad, Grosz, Braidotti, Haraway, Lucy Suchman, and N. Katherine Hayles.[34] In tracing the achievements of various new materialisms in *The Material of Knowledge*, Hekman assigns special priority to feminist materialist studies of technoscience because this specialized field "addresses epistemological, ontological, political, scientific, and technical issues simultaneously. It is concerned, not just with science, knowledge, or power, but with all of these at once, and most importantly, with the interactions among them."[35] Much like Rist, Piccinini, and Mori, these scholars have developed material perspectives to reconceptualize nature, biology, and other forms of matter, but also to critically address new developments in physics, neuroscience, and other technoscientific disciplines. The editors of the recently launched journal *Catalyst: Feminism, Theory, and Technoscience* succinctly indicate the timeliness of this increasingly prominent field in their introduction to the inaugural issue. "In a world infused with technoscience, the work of theorizing and inventing better relations and practices with technoscience remains urgent: from the ways in which scientific practices are built out of social hierarchies, to the ways in which new and old forms of militarisms propagate; from the ways that race relations build structural violence into the everyday, to the ways that new forms of life are being assembled in labs."[36]

As in the case of artists like Rist, Piccinini, and Mori, the analysis of human–nonhuman interfaces is a foremost concern for these scholars. In *Human–Machine Reconfigurations*, Suchman astutely observes that the term "interface," like the related concept of "interaction," in many ways falls short of capturing the always already entangled quality of human–computer interfaces. Suchman notes that whereas the construct of *interaction* suggests two entities given in advance that come together and engage in some sort of exchange, Barad's term "intra-action," in contrast, productively underscores the sense in which subjects and objects emerge through their encounters with each other.[37] Barad, a theoretical physicist

and feminist theorist, first introduced the concept of intra-action in a discussion of quantum physics: a field that studies the intra-actions of the observer, the observed, and observing instruments/apparatus, all of which are "agential," and none of which can be articulated in the absence of the other. Barad expands on these ideas in her theory of agential realism (Barad's name for her particular brand of feminist theoretical materialism): "On my agential realist elaboration, phenomena do not merely mark the epistemological inseparability of 'observer' and 'observed'; rather, *phenomena are the ontological inseparability of agentially intra-acting 'components.'*"[38] For feminist materialist critics of technoscience like Barad, observers, technological apparatuses, and what they observe do not predate their dealings with each other; because of this, they can only be known in their comings together (their intra-actions).[39] Moreover, observers, technological apparatuses, and what they observe *all* are active and possess some form of agency—not in the liberal humanist sense, but in the sense of a process-based enactment. (Note that while, like Suchman, I am profoundly sympathetic to Barad's project, I retain the use of the term "interface" throughout the book even as I detail the interface's *intra-active* fluidity.)

Alaimo and Hekman succinctly identify the mandate for appreciating "intra-activity" that inspires many of today's feminisms in the introduction to their anthology, *Material Feminisms*. They state: "We need ways of understanding the agency, signification, and ongoing transformative power of the world—ways that account for myriad 'intra-actions' . . . between phenomena that are material, discursive, human, more-than-human, corporeal and technological."[40] Alaimo's own notion of "trans-corporeality" exemplifies this trend and is especially relevant for our current argument regarding the potential contribution of artistic environments that enact human–nonhuman interfaces. She argues that focusing on what she calls transcorporeality—the movement across human bodies and nonhuman nature—stands poised to profoundly alter our sense of human subjectivity, ethics, and the individual's relation to scientific knowledge.[41] Reconceptualizing human subjectivity and agency as context-bound enactments is not transformative for ethics and the individual's relation to knowledge because it nullifies conventional accounts of agency and responsibility. On the contrary, *it is transformative because the embodied, embedded, and agential human subject still maintains some degree of political and ethical accountability for the new possibilities that are brought forth.*

My point is this: in projects conceptually analogous to feminist materialist critiques of technoscience, and similarly addressed to exigent sociocultural concerns, artists such as Rist, Piccinini, and Mori are centrally concerned with how science, technology, and society, all of which possess

agency (in the entangled ways described above), complexly interact to give us an understanding of the world. Moreover, both groups are explicitly concerned with how technological and scientific interfaces come to matter *through* and *with* human, phenomenal experience, and both are engrossed in reformulating definitions of embodied subjectivity. While much scholarship devoted to the feminist materialisms stays exclusively within the realm of theory, however, the new media installation artists examined in this book are exceptional in that they literally stage and enact scientific and technological interfaces in relation to the embodied phenomenal experience of human actors. If feminist theoretical materialism's reconceptualization of the material world allows us to acknowledge its influence on experienced reality, and thus enables us to imagine new ways of doing politics and ethics, material art practices informed by feminism are even more distinctive: they allow us to experience and inhabit these new ways of being firsthand. The participatory new media art environments of Rist, Piccinini, and Mori appropriate the art institution's critical framing function in ways that allow us access to feminist new materialisms that were previously unknown. By inviting us to pour our bodies out in conjunction with moving images (Rist), negotiate affective relationships with nonhuman creatures (Piccinini), and inhabit body–brain codependencies (Mori), these artists' new media installations allow us to actively experience *and* critically assess the multifaceted ways in which we are enacted with the material world. The profound aesthetic, ethical, and political implications of performative human–technology interfaces such as these will be our primary focus in the remainder of the book.

Chapter Outlines

Having already established the significant methodological and conceptual correspondences between post-1990 new media installation art and feminist theory, the remainder of the book comprises four thematic chapters organized around case studies of exemplary artworks, exhibitions, and critical texts. Chapters 2 and 3 establish a theoretical and historical model for understanding new media art as it has been informed by feminism and identify the art form's critical aesthetics. Chapters 4 and 5 approach the thematic of feminism in a less direct fashion. They do not explicitly re-argue for the "feminism" visible or not in each case, but rather build from the book's foundational premise regarding the affinities to feminist new materialisms in order to demonstrate the ways in which new media art may offer useful entry points for studying the place of human experience (and indeed the humanities) in our contemporary technoculture. Like

the artworks in question, the book's chapters traverse many different terrains—from art to cinema, from biotechnology to the brain sciences. Chapter 2, "Thinking Through Feminism: The Critical Legacy of 1970s and 1980s Feminist Media Art and Theory," explores the immediate prehistory of post-1990s new media art and materialisms in the feminist theories of media art and spectatorship of the 1970s and 1980s. The central case study is the pivotal exhibition *Difference: On Representation and Sexuality* (Kate Linker and Jane Weinstock, New Museum of Contemporary Art, 1984–85), which, together with Laura Mulvey's essay, "Visual Pleasure and Narrative Cinema" (1975), has become emblematic of feminist media art and theory inspired by psychoanalytic and poststructuralist models of spectatorship. The chapter's historiographical analysis of the exhibition and its critical context reveals the complexities and internal diversity of so-called social constructionist feminist theories in the 1970s–1980s, including feminist theories of media art spectatorship. This is especially significant in relationship to the material turn because these divergent social constructionist feminist models tend to be collectively dismissed as outdated for their alleged exclusive focus on language and representation. Instead, we will see how feminist art and spectatorship theories in many ways prefigured the concerns with the subject–object relations and technological interfaces that occupy many of the current new materialisms. This defensive rethinking of earlier feminist approaches allows us to more responsibly theorize and historicize post-1990 new media art in a manner that is mindful of past models, even while scrutinizing key points of departure.

Chapter 3, "Critical Proximity: Pipilotti Rist's Exhibited Interfaces and the Contemporary Art Museum," takes up the challenge identified in chapter 2 of theorizing feminist new media art in the wake of prior cinemacentric and language-based models of social constructionism and ideology critique. It proposes that analyzing the conditions of the body–technology interface enacted in a given work of art best assesses the critical contributions of post-1990 new media installation art practices. It also details why this approach yields special gains in ascertaining the transformative role of the contemporary art museum for new media art spectatorship. Rist's pioneering new media practice is the chapter's principal case study. One of the most celebrated artists of her generation, Rist's iconoclastic videos, sculptures, and installations have tested the prevailing critical frameworks for assessing media art and feminism. Several art historians have deftly detailed the ways in which Rist's playful approach to female subjectivity and embodiment generates a spectatorship that complicates the once-orthodox critiques of voyeurism, pleasure, and the gaze. This chapter

builds on that foundational work but with a focus heretofore unexplored by Rist's supporters: I evaluate and defend the critical-aesthetic potential of Rist's immersive and multisensory museum-based installations in light of the widespread commercialization, spectacularization, and institutionalization of moving-image art practices since the 1990s. Through extended analysis of *Pour Your Body Out,* particularly as it compares to her closely related feature film *Pepperminta* (2009), I demonstrate how the art gallery exhibition situation, including material and psychological conditions of spectatorship, facilitates a range of productive opportunities to experience and evaluate the myriad interactions among viewing bodies, digital media, and other forms of materiality that tend to go unnoticed outside of an art exhibition context.

Chapters 4 and 5 elaborate on these critical opportunities and investigate the interdisciplinary relevance of new media art works as they intersect with contemporary technoscientific discourses. Chapter 4, "Unbecoming Human: Patricia Piccinini's Bioart and Postanthropocentric Posthumanism," explores Piccinini's multimedia bioart as it relates to fluctuating and often paradoxical definitions of what counts or is valued as human in the age of biotechnologies. Piccinini creates fictitious hybrid life forms, working across various media to stage a variety of transspecies encounters. Through detailed analysis of the artist's *We Are Family* exhibition and its critical reception, the chapter explores what is at issue with the prevailing, positive judgments about Piccinini's work. Reviewers tend to theorize the spectator's experience in generous and ostensibly progressive terms, interpreting Piccinini's work as encouraging viewers to lovingly parent the pitiful creatures seemingly generated through biotech's experimental mishaps. I show how these dominant feel-good interpretations reveal an ongoing anthropocentrism of our relation to technology that may even be read as politically reactionary. Put simply, the nonhuman figures of biotechnology are made familiar and humanized at every turn in the literature documenting the artist's work. Through reference to specific works of art, I show how Piccinini's art objects promote a spectatorship that transcends these well-intentioned yet reductive frameworks and gestures instead toward a form of artistic experience that invites viewers to experience and care for nonhuman others in a positive relation based not on the grounds of their similarities with us (as dominant accounts suggest), but rather in an affirmative relation based on inexhaustible difference.

Chapter 5, "Mind over Matter: Mariko Mori, Art History, and the Neuroscientific Turn," extends chapter 4's emphasis on art and technoscience and focuses on the emerging nexus of art, art history, and neuroscience. It identifies the best of the neuroscientific trend in art history and criticism

while rejecting its false starts, particularly the contentious notion that human consciousness can be reduced to gray matter (i.e., the brain's neural activity). Mori's new media art practice structures this discussion. Since approximately 1995, Mori's artistic production has been closely engaged with emerging issues in scientific theories of consciousness. Her brainwave interface and multimedia installation *Wave UFO* thus offers an ideal entry point for interrogating the much-contested "neuroscientific turn" in the humanities. I propose that the most promising transdisciplinary encounters between the brain sciences and the humanities begin from the premise that human experience is embodied, but the "body" itself is interwoven across biological, ecological, phenomenological, social, and cultural planes. I suggest that artworks such as *Wave UFO*, by enacting body–brain events and challenging dominant assumptions about neuroimaging through experiential art environments, productively complicate and augment brain science research as well as its dissemination into other social and cultural arenas.

The book's conclusion reviews the text's primary contributions in identifying the critical potentialities contained in these museum-based new media installations and how they express themselves. This chapter elaborates on Mori's larger post-1990 oeuvre in terms of what I call "a capsule aesthetic": an artistic engagement with the notion of human experience as a nested intermingling of the human and nonhuman, the material and immaterial, the social and physical. I advance the construct of a capsule aesthetic as a way to revisit the book's premise that understanding new media installation art as it relates to feminist materialisms enriches pressing sociocultural debates about human–nonhuman interfaces in our contemporary technoculture. In an age of slippery categories—when dualisms such as active versus passive, animate versus inanimate, and self versus other appear increasingly unsustainable—artistic practices such as those of Rist, Piccinini, and Mori may very well antedate mainstream ethics. I suggest that the capsule aesthetic indeed may intimate a compelling nonhierarchical way to conceptualize the entangled relations—and co-implicated futures—of human bodies and the rest of the material world.

Thinking Through Feminism

The Critical Legacy of 1970s and 1980s Feminist Media Art and Theory

When we describe what it is that we do, when we consider how it is that we arrive at the grounds we inhabit, we need to appreciate the feminist work that comes before us, in all its complexity. We don't always have to make a return to earlier feminist work, but if we represent that work as being this or that, then we need to make that return. Such a return would be ethical: we should avoid establishing a new terrain by clearing the ground of what has come before us. And we might not be quite so willing to deposit our hope in the category of "the new."

—SARA AHMED, "OPEN FORUM, IMAGINARY PROHIBITIONS"

To appropriately theorize post-1990 new media art practices as they have been informed by feminist frameworks, it is imperative to revisit the foundational yet often misconstrued feminist art and media theories initiated in the 1970s and 1980s in the context of the linguistic or discursive turn—the definitive era during which media art practice and theory were closely intertwined. The majority of this book is devoted to analyzing the transformations in media art, materialisms, and spectatorship since 1990. This chapter, instead, takes to heart Sara Ahmed's caution that we must resist the predilection to "deposit our hope in the category of 'the new' ": it revisits this earlier period in order to draw out the significant and underappreciated points of continuity between feminist theory and media art practice in the 1970s and 1980s and the present day.

I contend that the feminist spectatorship theories and works of art inspired by the psychoanalytic and poststructuralist critical frameworks popularized in the 1970s and 1980s were the first to explicitly address the

material relations and embodied interfaces between viewers and media technologies as well as their sociocultural implications. These earlier feminist models thus serve as important precedents not only for contemporary media installation art practices such as those of Rist, Piccinini, and Mori, but also for the broader new materialisms presented in chapter 1. Providing an accurate overview of these earlier models and their ongoing critical relevance is complicated by several factors, however. As we will see in what follows, the feminist art and theory associated with psychoanalytic and poststructuralist models of spectatorship have been misrepresented in contemporary Anglo-American art historical discourse. These models have been deemed constitutive of a monolithic and homogeneous social constructionist feminism solely invested in language and representation: what has come to be known as "1980s theoretical feminism." In this regard, they are often overlooked or dismissed as irrelevant to contemporary concerns, especially the scholarly interest in materiality over the past three decades. This is of course not unique to art history. Much recent scholarship betrays a generalized fatigue with (if not outright rejection of) "heavy-handed theory" and the dismissal of the linguistic and social-constructionist theories associated with 1980s theoretical feminism in particular.[1] As contemporary critics across the academy strive to create theoretical models capable of accounting for the natural world and processes of materialization, theories and practices linked to linguistic and social-constructionist approaches, including the psychoanalytically informed media art and theory at issue here, have repeatedly come under fire for their alleged antibiologism and disregard of material, corporeal, and affective relations. This imprudent characterization of earlier feminism has proved so pervasive that it even extends, revealingly, to certain feminist texts associated with the new materialisms.[2]

The widespread production of a monolithic and homogeneous "social constructionism" is only possible through ignoring or misreading earlier feminist activity, however. Scholars such as Rebekah Sheldon have convincingly discredited reductive characterizations of a monolithic social constructionism by mining the early feminist critiques of science. Sheldon argues against one-dimensional accounts of the pre-1990 period and reminds us that "it is in fact difficult to find a moment in feminist science studies when questions of embodiment, nature, science, realism, and referentiality were not explicitly at stake."[3] I heartily agree with this assessment; my aim is to show how feminist psychoanalytic film theories of spectatorship and media art of the 1970s–1980s are a (heretofore unacknowledged) part of this vital feminist history.

This chapter deconstructs the discursive production of an increasingly narrow idea of 1980s theoretical social-constructionist feminism (within which psychoanalytic and poststructuralist theories of spectatorship have been subsumed), describes how we might better account for the internal diversity and institutional specificity of pre-1990s feminist art and media theory, and assesses why the enduring misreading of these practices matters both within art history and beyond. Our primary case study will be the influential exhibition *Difference: On Representation and Sexuality* (organized by Kate Linker and Jane Weinstock, New Museum of Contemporary Art, 1984–85) due to its widely recognized prominence vis-à-vis feminist psychoanalytic spectatorship theory and its commitment to artists who engaged and expanded on these ideas in media art practices such as film, video, and photography. The exhibition also provides an ideal case study for our purposes because, together with Laura Mulvey's field-changing feminist critique of cinema spectatorship, "Visual Pleasure and Narrative Cinema" (1975), it has come in art-historical discourse to exemplify a social constructionist feminism supposedly singularly focused on language and representation.[4] I will demonstrate how misinterpretations of the original exhibition, and the influence of this on its critical reception and related scholarship, continue to haunt the historiography and criticism of media art, feminism, and materialisms.

Recognizing the pervasive misapprehensions regarding feminist media art and theory in the 1970s and 1980s through a critical historiography of *Difference* is productive for several reasons. First, it enriches art criticism of contemporary new media practices, such as those of Rist, Piccinini, and Mori. Whereas feminist media art and theory of the 1970s–1980s and the new materialisms associated with post-1990 new media art clearly have significant dissimilarities (a point we will return to in detail), this chapter's case study affirms that the post-1990 emphasis on institutional context, embodiment, and material viewing conditions in new media installations is not entirely unprecedented (is not "new"). Rather, it was in many ways prefigured both by *Difference* and by the feminist media art and theory it showcased. Second, while a single, unified feminist project never existed in the first place (a point this book reaffirms), identifying historiographic inaccuracies that have led to the repudiation of particular feminist approaches is clearly beneficial, especially at a time when the art and theory associated with feminism's second wave are currently being historicized. (The proliferation of feminism-themed art exhibitions, conferences, journal issues, and anthologies since 1990 supports the notion that we have entered a period in which feminism itself—and, more specifically,

feminism's second wave as it intersects with the first two decades of self-identified feminist art practice in the 1970s and 1980s—can be consigned to the history books.)

Ultimately, however, the chapter's critical historiography of *Difference* is generative beyond the question of mere (art) historiographical inaccuracy. It reveals that key feminist artists and theorists engaged with psychoanalytic and poststructuralist frameworks in the 1970s–1980s prefigured some (though by no means all) aspects of broader "new" theoretical materialisms since 1990; among them are the intricate ways in which (material) bodies are entangled with their (social) representations, and the complex interactions between human bodies and nonhuman technologies. In this way, chapter 2 continues the first chapter's important work of identifying an underappreciated feminist throughline to the material turn: it offers an intellectual history of the formation of the new materialisms in the feminist and technological era that directly precedes our own.

Art History's *Difference* Problem

Before diving into our exhibition case study, it is helpful to set the scene and identify the main protagonists. To begin: what does "1980s theoretical feminism" mean and how did this construction come about? Accounts of feminism since 1990 (histories of media art and feminism primary among them) have been impaired by entrenched, polarizing accounts of feminism's second wave, including binary constructions pitting "essentialist 1970s feminism" against "theoretical/constructionist 1980s feminism."[5] Many scholars have addressed the by-now apparent flaws of this dualistic and reductivist model.[6] Yet the rhetorical trope of "1980s theoretical feminism" survives with stubborn persistence. This unfortunate shorthand continues to handicap critical histories of art informed by feminism: to refer to "theoretical feminism"—even if the idea is superficially problematized by being put in scare quotes—is to suggest a singular clarity of approach and theoretical orthodoxy that never in fact existed. Indeed, the so-called theory moment in visual production turns out to be disciplinarily specific; film studies tends to associate "theory" with 1970s cinepsychoanalysis or screen theory (particularly as associated with the journal *Screen*), whereas art historians associate many of the same concepts—theories concerned with language and the psychic, most especially gaze theory—with the 1980s.

Within the specific discipline of art history, "1980s theoretical feminism" refers to a hard-line social-constructionist approach exclusively focused on language, representation, and the psychic, often reduced even more

specifically to a caricatured rendition of gaze theory and the refusal of visual pleasure. This formation is inaccurate on at least two counts. First, and especially if we look outside the North American context, linguistic and psychoanalytic models were already foundational for both the production and criticism of art informed by feminism as early as the 1970s; the generational binary thus does not hold. Second, and more important, subtle but crucial variations exist within social constructionist approaches—particularly when we appreciate their interdisciplinary reach into film and video.

The New Museum's *Difference* exhibition (and, to a lesser extent, Mulvey's early arguments regarding the male gaze) has emerged as loosely interchangeable with the misleading notion of 1980s theoretical feminism through a series of influential articles and forums over the past thirty years, particularly within the (dominant) context of North American art history.[7] In terms of art historiography, the problem this critical elision presents is that the exhibition's critical project, and by extension the theoretical models that buoyed it, has been misremembered.

With this argument in mind, it makes sense to begin with a brief description of the show. Guest curators Linker and Weinstock organized *Difference* for the New Museum of Contemporary Art in New York (December 8, 1984–February 10, 1985), and it then traveled to the Renaissance Society at the University of Chicago (March 3–April 7, 1985), the List Visual Art Center at the Massachusetts Institute of Technology (a pared-down version, summer 1985), and, finally, the Institute of Contemporary Arts, London (July 19–September 1, 1985). The work featured in *Difference* spanned approximately a decade (from the mid-1970s to 1984) and featured a range of mixed-media works by Ray Barrie, Victor Burgin, Hans Haacke, Mary Kelly, Silvia Kolbowski, Barbara Kruger, Sherrie Levine, Yve Lomax, Jeff Wall, and Marie Yates, as well as videotapes by Max Almy, Judith Barry, Raymond Bellour, Dara Birnbaum, Theresa Cha, Cecelia Condit, Jean-Luc Godard, Stuart Marshall, Martha Rosler, and Philippe Venault. Weinstock curated both the video program, which was screened in the regular exhibition space at the New Museum, and an extensive program of short and feature-length films, which was presented simultaneously at the Public Theater during the exhibition's New York run.[8] While the video selections included a few lesser-known figures, Weinstock's film program featured celebrated works by established experimental filmmakers, among them Chantal Akerman; Lezli-an Barrett; Marguerite Duras; Valie Export; Anthony McCall, Claire Pajaczkowska, Andrew Tyndall, and Jane Weinstock; Sheila McLaughlin and Lynne Tillman; Mulvey and Peter Wollen; Michael Oblowitz; Sally Potter; Yvonne Rainer; Jackie

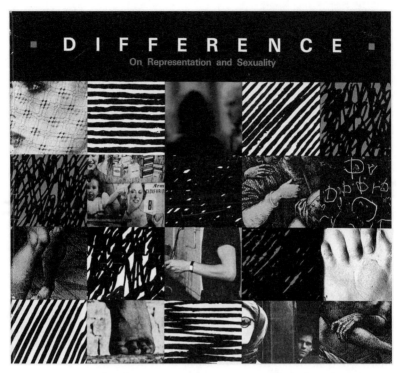

FIGURE 4. Cover of *Difference: On Representation and Sexuality,* ed. Kate Linker and Jane Weinstock, 1984. The exhibition catalog cover illustration incorporates details of many of the exhibited media artworks in a grid-like formation. Courtesy of the New Museum, New York. Photo: New Museum.

Raynal; Candace Reckinger; Liz Rhodes; Robina Rose; and Bettina Woernle. Taken as a whole, most of the pieces, whether still or moving-image works, featured a conceptual aesthetic in their frequent pairing of text and images and emphasized seriality in their modes of production and exhibition. Retrospective accounts of the exhibition tend to describe it as visually homogeneous and unvaryingly dominated by a monotonous black-and-white conceptual aesthetic, but the works were relatively diverse in form, medium, and content: from the ambitious variety of interests represented in video works such as Birnbaum's deconstructive media critique (*Technology/Transformation: Wonder Woman,* 1979), to Export's experimental narrative film (*Invisible Adversaries,* 1978), Levine's colorful photographic appropriations of the work of famous male artists, Kruger's large-scale black-and-white photocollages, and Wall's Cibachrome transparencies with fluorescent light, to name just a few.

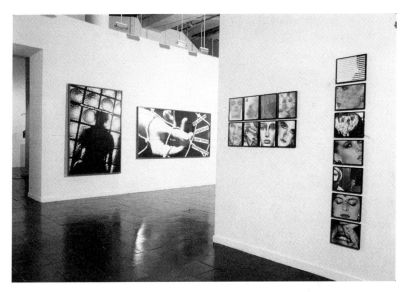

FIGURE 5. *Difference: On Representation and Sexuality,* installation view, 1984–85, New Museum, New York. The works in the exhibition frequently paired text and image appropriations, including the works by Barbara Kruger and Silvia Kolbowski pictured here. Courtesy of the New Museum, New York. Photo: New Museum.

In the words of Marcia Tucker, director of the New Museum, Linker and Weinstock's argument-based exhibition was "an intellectual as well as visual exploration of how gender distorts 'reality' "; it thus aspired to foreground "the ways in which representation, purporting to be neutral, is informed [instead] by differences in gender."[9] Given the curatorial focus on how sexuality is constructed through media forms such as photography, perhaps it is not surprising that the artists shared an overall focus on spectatorship and that photo-based practices—in the form of both still and moving images—dominated the exhibition. The artists used photo-based media to expose and undermine photography's ideological function in reaffirming sexual difference; in the process, they demonstrated that *how* one sees is just as important as *what* one sees. Kelly's contemporaneous description of the exhibition's focus on spectatorship is apposite: *Difference*'s viewers found themselves asking, "What do [these works] want of me?" and, in constructing an answer, they confronted the "almost comical" realization that "you are not yourself."[10] Inspired by psychoanalytic film theory and other feminist critiques of representation, the artworks in *Difference* intentionally exhibited how (material) bodies are constituted through (social) representations. Spectators of the artworks found

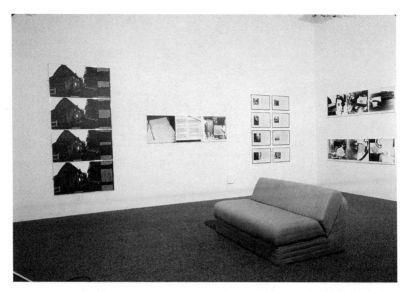

FIGURE 6. *Difference: On Representation and Sexuality,* installation view, 1984–85, New Museum, New York. Many of the photo-based artworks (like those by Marie Yates, pictured here) emphasized seriality in their modes of production and exhibition. Courtesy of the New Museum, New York. Photo: New Museum.

themselves to be simultaneously the "subject" and the "object" of inquiry. In short, these media artworks put viewers in a place of discovery contingent upon recognizing the mediating technological processes of embodied visual experience: an apparent precursor to the embodied technointerfaces performed in later media installations by Rist, Piccinini, and Mori.

Tellingly, the exhibition cohered around the curatorial priority assigned to film and video, both in the show's conceptual framework and scholarly catalog and within the exhibition itself. The catalog placed special emphasis on the media arts of film and video: almost all the essays affirmed the relevance of contemporary film theory through frequent references to debates in the British journal *Screen,* including Stephen Heath's work on editing and suture, and, especially, Mulvey's writing on spectatorship and the male gaze.[11] About the exhibition itself, Linker went so far as to declare that "it is impossible to view *Difference* in its separate parts . . . since much work in this area depends on investigations initially pursued in film."[12] Although the films were screened off-site at the Public Theater, the curators considered them to be an integral part of the New Museum's exhibition.

Given the centrality of cinematic discourses in the exhibition and catalog (two of the five essays were explicitly devoted to film and video), it is

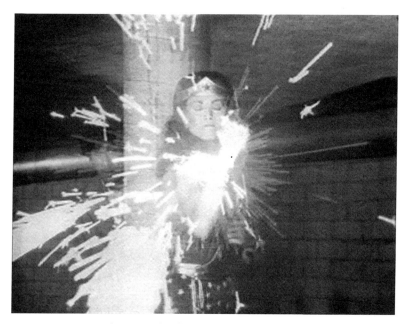

FIGURE 7. Dara Birnbaum, *Technology/Transformation: Wonder Woman,*
1978–79. Color video with sound, 5 minutes, 50 seconds. Birnbaum's video
deconstructs the ideological implications of Wonder Woman's cultural and
media-based transformation into a superhero. Courtesy of Electronic Arts
Intermix (EAI), New York.

striking to note how subsequent art-historical references to *Difference*
tend to overlook both the media-specific nature of these theories and the
moving-image works altogether.[13] In fact, within a few years of the exhibi-
tion's debut, its art-historical commentators tend to emphasize the aes-
thetic strategies and critical references pertinent to still-photo-based works
over and beyond those more specific to film and video. As we shall see, this
lack of attention to the exhibition's full range of media, its integral relation-
ship to cutting-edge film theory, and the distinctive art exhibition context
is in part to blame for the increasingly restrictive concept of 1980s theoreti-
cal feminism and, by extension, inadequate histories of present-day media
art, feminism, and materialisms more broadly.

Difference and/as 1980s Theoretical Feminism

Despite the reasonably varied content of the multimedia show and its cata-
log, the exhibition quickly became associated with a discrete and seemingly
cohesive critical project of social constructionist feminism. This section

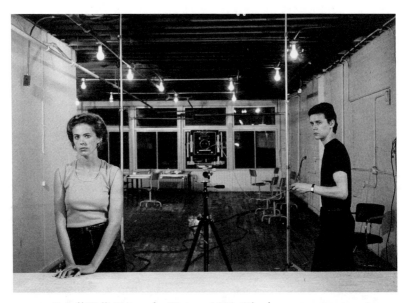

FIGURE 8. Jeff Wall, *Picture for Women*, 1979. Cibachrome transparency in lightbox, 142.5 cm × 204.5 cm (56 × 95 inches). Wall positions the media technology (camera) at the center of the work so that it not only captures the act of making the image (the scene reflected in the mirror) but also looks straight out at the viewer. Artwork copyright Jeff Wall. Courtesy of the artist.

explores how this discursive maneuver is intrinsically bound up with the far-reaching establishment of a generational model for feminism. *Difference* first appears as a rough synonym for 1980s theoretical feminism in Thalia Gouma-Peterson and Patricia Mathews's 1987 essay "The Feminist Critique of Art History," where it plays a seminal part in the authors' classification of two "generations" of feminist art.[14] The art historians identify a first generation, in which "woman was a fixed category" (exemplified for the authors by Nancy Spero), and a second generation, associated with a postmodern shift more broadly, in which "woman is an unfixed category constantly in process" (the authors cite *Difference,* and Kelly's contribution to it in the form of her renowned *Post-Partum Document* (1973–79), as exemplars). Gouma-Peterson and Mathews are careful to point out the potential deficiencies of this formulation, especially given that many first-generation feminists clearly understood sexuality as socially constructed even as they maintained that women have common shared experiences. Despite their scrupulous and measured approach, however, the article launched the generational model for feminist art, one that affirms a sharp

divide between first-generation essentialist and second-generation constructionist approaches—*Difference*, of course, being representative of the latter.
Feminist scholars have identified several unfortunate aspects of the generational model.[15] The many drawbacks include: a fixation on questions of
(oedipal) transmission and reception, the implication of biological reproduction as the sole model for influence (which privileges heterosexual coupling), the corresponding suggestion of linear development (specifically, the
notion that Kelly's second-generation approach both postdated and was a
calculated reaction to Spero's first generation), and, finally, the structural
omission of the fact that feminist writers of color issued calls to account
for multiple and even competing registers of difference already in the
1980s—well in advance of the so-called third wave.[16] By continually drawing on what are thought to be clear distinctions between first-generation
(essentialist) and second-generation (constructionist) commitments, both
the continuity among feminist approaches and the importance of intergenerational work are forgotten. This is a problem of long-term significance
both within art history and beyond because the diversity of feminist ideology and activism within these categories—including, significantly, the psychoanalytic spectatorship theories of interest here—is lost.[17] As Griselda
Pollock has identified, the narrow focus on feminism's generational and
geographical differences unconsciously depoliticizes feminism. Counters
Pollock: "the engagement between feminism and semiotics, post-structuralism
and psychoanalysis arose not as methodological icing on a disciplinary
cake but as necessary ways of thinking about issues and problems which
actually confront us in both social practice and the contemporary study of
culture."[18]

Since shortly after its debut in 1985, *Difference* has served as shorthand for theoretical or postmodern feminism in essays published in a variety of forums and from sometimes competing theoretical and political
perspectives. For example, writing in the mid-1990s on the topic of the
decreased prominence of 1980s theory in feminist art of the 1990s, Lydia
Yee and Kolbowski both assign emblematic status to *Difference* but to
disparate ends: what Yee diagnoses as a welcome refutation of 1980s feminist art and theory, Kolbowski characterizes as an unwelcome repression.
Irrespective of their differing positions however, both critics unintentionally
reaffirm unhelpful binary distinctions for feminist art based on generalized decades or generations, in which *Difference* is a symbolic stand-in for
an entire generation of artistic production.

In a 1995 survey of twenty-five feminist thinkers published in *October*
magazine, Kolbowski asks: "How can we understand recent feminist practices that seem to have bypassed, not to say actively rejected, eighties

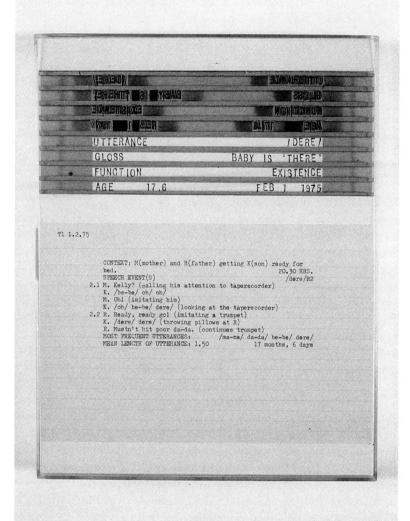

FIGURE 9. Mary Kelly, detail of *Post-Partum Document: Documentation II, Analysed Utterances and Related Speech Events*, 1975. Perspex unit, white card, wood, paper, ink, rubber, one of twenty-six units, each 25.5 cm × 20.5 cm (10 × 8 inches). Often cited as exemplary of "theoretical feminism," the objects and texts assembled in *Post-Partum Document* represent a six-year exploration of the mother–child relationship as informed by feminism and psychoanalytic theory. Courtesy of the artist and Susanne Vielmetter Los Angeles Projects. Copyright Generali Foundation. Photo credit: Werner Kaligofsky. Copyright 2016 Artists Rights Society (ARS), New York / IVARO, Dublin.

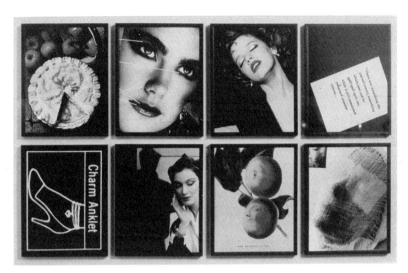

FIGURE 10. Silvia Kolbowski, *Model Pleasure V*, 1983. One color and seven black-and-white photographs, each 20.3 cm × 25.4 cm (8 × 10 inches). The work foregrounds details of found media images of fashion models in order to suggest how (material) bodies are entwined with their (social) representations. Collection of the Whitney Museum of Art. Courtesy of the artist.

theoretical work, for a return to a so-called 'real' of the feminine?" Familiar dualistic categories of 1970s essentialism versus 1980s constructionism structure her query: "What are the implications of the renewal of these oppositions of accessibility and elitism, of low and high art, of the real and the semiotic, for feminist art and critical practices in the 1990s?"[19] Although Kolbowski helpfully identifies an apparent trend in 1990s art, her ambition to analyze the place of feminist art practice in the 1990s suggests an anxiety about the loss of an imaginary and idealized feminist past exemplified by the artistic and theoretical work associated with *Difference*.

Like Kolbowski, Yee similarly positions *Difference* as emblematic of feminist art and criticism's purported "theory phase."[20] Their opinions regarding the efficacy of both the exhibition and its theoretical models differ greatly, however. In contrast to Kolbowski, who mourns the alleged repression of feminist art and theory informed by psychoanalytic and poststructuralist frameworks, Yee's essay takes issue with the programmatic nature of both "Linker's" show (Weinstock's role, like the film and video works themselves, essentially being forgotten) and the theoretical models informing its catalog. She appropriately observes that *Difference* "by

privileging gender . . . neglected to address adequately the impact and intersection of other forms of difference."[21] This assessment undoubtedly is justifiable; her larger criticism, however, takes a different angle. Yee explicitly criticizes *Difference* for confirming hierarchical binaries between essentialist feminism and postmodern theoretical feminism: "While the exhibition succeeded in identifying a common theoretical basis among a group of artists whose works were informed by gender difference, it also served to reify the distinction between, on the one hand, 'sexuality as a cultural construction' and, on the other, a 'perspective based on natural or biological truth.' "[22] But my point is this: the problem for which Yee faults the exhibition is less a failing of *Difference* itself than of the stereotype of 1980s feminism it had become—an indication of the show's increasingly polemical critical reception and its reliance on a troubled taxonomy.[23]

Over a decade later, in a roundtable discussion organized by Rosalyn Deutsche and published in 2008 in *Grey Room*, *Difference* again figures as emblematic of 1980s feminism and a delimited range of psychoanalytic and poststructuralist critiques. The panelists diagnose a current "anti-theory" turn in what they describe as the literal and metaphorical erasure of 1980s feminism and single out *Difference* as a paradigmatic example of the latter.[24] They observe that while art exhibitions concerned with feminism have flourished in recent years—*WACK! Art and the Feminist Revolution* (MOCA, 2007) and *Global Feminisms* (Brooklyn Museum, 2007) are among the most prominent—there has been a conspicuous neglect of 1980s theoretical feminism, both literally (by the scope and date of shows) and symbolically (by the curators' selective pruning of certain theoretical discourses). Deutsche speculates that the conspicuous neglect of *Difference* substantiates a broad-based suppression of "the 1980s" in current art-historical and museological accounts of feminism. Attentive to the problems attendant in feminism's periodizations, Deutsche makes the intriguing proposition that one might think of the 1980s "not as a literal decade but as a formation of ideas and practices that transgresses chronological boundaries"; even so, *Difference,* feminist theory, and an increasingly narrow definition of 1980s art (now recalled by shorthand as "Sherrie Levine, Silvia Kolbowski, Jenny Holzer, Barbara Kruger, etc.") are symptomatically fused in the respondents' comments.[25]

As the above outline of *Difference*'s discursive reception demonstrates, the status of the artistic and theoretical models associated with the exhibition has varied over the past three decades, even as the impulse to overperiodize and oversimplify feminist theories of the 1970s and 1980s has proved consistent. This is a problem for historians of practices informed by

feminism because these troublesome classifications have become ever more stable in the process, making it nearly impossible to appreciate the ways in which certain artistic and theoretical frameworks, such as those associated with *Difference,* exceed the reductive category of social constructionism, and, more to the point, the ways in which they anticipate the artistic and scholarly variants of the feminist new materialisms examined in this book.

When Was 1980s Feminism?

As we have seen, Linker and Weinstock's exhibition, and the paradigmatic status accorded to the show in subsequent scholarly publications, has played a defining role in the production of an increasingly fixed and coherent idea of 1980s feminism; this idea, in turn, has obscured the fact that two forms of feminism already existed in the 1970s and, moreover, that various strands of feminism were always and continue to be intertwined. While clearly the historical category of 1980s feminist art and theory is valid on some level, and a degree of generalization is inevitable in any historical or theoretical account, the idea of 1980s feminism is largely a discursive production of artists and critics working in North America in the 1980s. More precisely, it is the product of a disconnect between the time of the North American reception of psychoanalytically informed critiques of representation (in the 1980s, especially within the context of the New Museum's *Difference* exhibition and the appearance of key publications), and the time of their production (self-identified constructionist feminism had flourished in Great Britain since the 1970s).[26] In other words, the idea of 1980s constructionist feminism as somehow in calculated opposition to 1970s essentialist feminism is a misleading formulation: one that developed in critical conversations that were closely bound up with the reception of *Difference.*

Juli Carson explains how the New Museum itself was both product and producer of feminist discourses as they evolved throughout the mid-1970s and 1980s.[27] The museum, led by founder and director Tucker, intentionally staged polemical debates between "British/socialist" and "American/cultural" models of feminism, which, respectively, also came to be known as 1980s constructionist and 1970s essentialist through their provocative pairing.[28] Carson's careful historiography of institutional spaces and feminist problematics is useful for emphasizing instead the coexistence of diverse and sometimes overlapping Anglophone feminist projects throughout the 1970s: on the one hand, a largely British feminism

(especially artists and filmmakers associated with *Screen,* where Marxist and feminist theory were discussed in relationship to film and later to art) interested in analyzing women's representation in the visual field, and, on the other hand, a largely American feminism focused on cultural feminism and gender parity at work and at home (mainly New York–based artists associated with magazines such as the New York collective *Heresies*). The former, elucidates Carson, was predominately informed by the psycho-analytic writing of Juliet Mitchell *(Psychoanalysis and Feminism),* Julia Kristeva ("The System and the Speaking Subject"), and Laura Mulvey ("Visual Pleasure"), the latter by theorists such as Simone de Beauvoir *(The Second Sex),* Kate Millet *(Sexual Politics),* and Shulamith Firestone *(Dialectic of Sex)*.[29]

The propensity among North American art historians to associate art informed by poststructuralist and psychoanalytic feminism with the 1980s thus demonstrates an obvious (and ongoing) regional bias. Further, it re-veals how North American art historians engaged psychoanalytic theo-ries of gender significantly later than their peers working in literary and film theory. Jacqueline Rose's catalog essay in *Difference* in fact directly comments on the discipline's "time-lag" in relationship to film theory, specifically in terms of art history's delayed recognition of the fact that the entwined relationship between representation and sexuality (both of which are best described as part of a natural–cultural continuum) is not confined to the visual image and thus exceeds the narrow confines of the visual arts.[30] This considerable time lag and an overall disconnect between film theory and art theory has had long-term consequences for the disci-pline of art history. Mulvey's essay "Visual Pleasure and Narrative Cinema," published in *Screen* in 1975, is a case in point. This essay came to define an American feminist practice concerned with the male gaze only in the 1980s, at which point film artists and theorists had already made significant objec-tions, corrections, and qualifications to this initial formulation. In some sense, reducing art history's "theory phase" to Mulvey's 1975 essay, either directly or indirectly (through oblique references to "gaze theory" or de-bates about the relative merits of visual pleasure), is even more misleading than the formation of constricted categories and myopic periodizations for feminist art in the first place. The case of *Difference* is revelatory here. While Mulvey's article played an enormous role in *Difference* and was mentioned in nearly every catalog essay (and, together with Linker's arti-cle "Representation and Sexuality," was immortalized in the New Muse-um's influential anthology, *Art after Modernism,* published in the same year as *Difference*), it obviously is not interchangeable with 1980s feminist

poststructuralist and psychoanalytic art or theory more broadly.[31] This is the case not only because Mulvey's purposely manifesto-like article exclusively addressed itself to moving-image media and, even more narrowly, to classic narrative cinema, but also, and more important, because the brief 1970s denunciation of visual pleasure and attendant rejection of a viable female spectatorship implicit in polemical essays such as Mulvey's was problematized and debated almost immediately within film discourse, including revisions made by the original authors themselves.[32] In other words, even when the central importance of feminist spectatorship theory is in fact acknowledged in art-historiographic accounts of the 1970s–1980s, as in the case with *Difference*, it tends to be misconstrued based on troublesome categorizations inherent in the ongoing discursive construction of a myopic and singular social constructionist feminism.

For the purposes of the present argument, it is interesting to note that several critics commented on the exhibition's seemingly delayed engagement with relevant discourses in film theory. Aimee Rankin's review in *Screen* chastises the exhibition and the "art world" more broadly for their *retardaire* conservatism and contends that the exhibition's claims to progressive radicality are (at best) disingenuous. On the topic of the plastic artworks in *Difference*, she observes dismissively that "the more sophisticated representational strategies [had been] already elucidated in this context by a whole generation of experimental film-makers." Her critique passes over the films included in the show to interrogate the larger curatorial project on display in the central exhibition space. "It is the gallery exhibition which is the most unusual aspect of this show, and which thus demands the most critical attention, since these theoretical ideas, originally formulated in terms of the cinema by film journals such as *Screen* in the mid-1970s, and also quite familiar by now to students of comparative literature or continental philosophy, have only recently begun to trickle down into the cultural backwaters of gallery art."[33]

Rankin's review is useful for thinking about art-historical accounts of feminism's second wave, although perhaps not in the way the author herself would have intended—after all, despite her admonishments, the exhibition and its catalog were thoroughly engaged with cinematic discourses, and the curators themselves did not claim avant-garde status in the exhibition catalog. Rankin's essay nonetheless helps uncover another aspect of art history's "difference problem," that is: a recurrent neglect of film and video discourses relevant to feminist art, such as we have seen in the ongoing discursive reception of *Difference*, even when these discourses were clearly foundational for the artistic production in question.[34]

FIGURE 11. Chantal Akerman, still from *Je, Tu, Il, Elle,* 1974. Black-and-white 35 mm film, sound, 85 minutes. Experimental filmmakers like Akerman were at the forefront of critical work on developing a female spectatorship and attending to internal differences among feminist approaches to media art and theory throughout the 1970s. Artwork copyright Chantal Akerman. Photograph provided by Marian Goodman Gallery, New York / Paris.

This is not to argue that cinematic and linguistic theories applied to the plastic visual arts are *always* capable of accounting for static images and the material specificity of objects (not to mention the specific concerns relevant to media installation, body art, and performance); rather, it is to emphasize the importance of registering these salient influences in the histories of contemporary art informed by feminism.

As we will explore in more detail in chapter 3, art history's generalized inattentiveness to theories and practices associated with film and video, although by no means constant or universal, presents a particular handicap when writing the histories of media art. Indeed, from our present perspective, it is interesting to note how the tendency among *Difference*'s recent commentators to bypass time-based moving-image works and related theories of the cinematic in favor of still-photo-based practices might inform faulty periodizations and dualistic generational models for feminism more broadly: among others, the enduring misconception of 1970s essentialist versus 1980s constructionist feminism (the latter epitomized for art historians by *Difference*). After all, as previously mentioned, the "theory" moment that art historians attribute to feminist art in the 1980s has always been recognized by film scholars as inaugurated in the 1970s. For example, the film artists whose works were central to the New York staging of the exhibition—such as Akerman (*Je, Tu, Il, Elle*, 1974) and Rainer (*Film about a Woman Who . . .* , 1974)—were at the very forefront of critical work on developing a female spectatorship and attending to internal differences between feminist approaches throughout the 1970s. The overdrawn generational model and stereotype of 1980s social-constructionist feminism has commanded so much attention and ire that scholars risk missing the contribution that the exhibition *could* make to histories of media art and feminist theory, including artistic and scholarly variants of the feminist new materialisms. As we have seen, its key lessons include careful attention to interdisciplinary feminist theory and to a range of media art practices (still photography, but also installation, single-channel video, and experimental film) that frame these mediums and their embodied and material interface conditions within the specific institutional context of the visual arts. Considered this way, *Difference,* like the media art and theory it presented, sows the seeds of some of the later theoretical and artistic maneuvers that we will explore in the chapters that follow.

The Matter of 1970s–1980s Feminist Art and Media Theory

This chapter's critical historiography of the New Museum's *Difference* exhibition has shown that the specificity and sophistication of feminist theories of art and media spectatorship initiated in the 1970s and 1980s has frequently been discounted. This in large part is due to the reductive characterization of all psychoanalytical and poststructuralist feminist theories (and the media art associated with them) as hard-line social constructionisms. Instead, as we have seen, psychoanalytically informed models of media art and spectatorship theory such as those associated with *Difference*

explicitly focused on how representations become meaningful in material relations between bodies and (media) technologies. Far from insisting that images "make" bodies or that only cultural forces have agency, these innovative works of media art called attention to the subject's discontinuity with itself and put on display the ways in which natural bodies are interwoven with their cultural representations and with other objects.

While feminist artists and theorists influenced by psychoanalytic and poststructuralist models in the 1970s–1980s studiously rejected the modernist conception of reality as an objective given (most apparent in critiques of biological determinism), it is erroneous to conclude that they, as consummate social constructionists, ignored *all* material and natural processes. Instead, by investigating issues of embodiment and subjectivity as related to media technologies and spectatorship, artists and writers such as those associated with *Difference* posited a necessary relationship between matter (the things in the world, including human bodies) and meaning (how we interpret those things). In the case of the exhibition's catalog essays, the writers explicitly embraced poststructuralist theory to emphasize how representation and sexual identity are always in process; they identified psychoanalytic theory, and Jacques Lacan's writing in particular, as critical tools to understand sexual difference as a social and historical construct, one that is in part changeable and thus ripe for artistic intervention. Lacan's concept of desire as always beyond or before the individual is also central to this equation: for Lacan, meaning and matter are always already enfolded and entangled.[35] In Deutsche's words: "Idealist aesthetics were radically questioned by feminist critiques [in the 1970s–1980s] that used psychoanalysis to explore the ways in which vision—looking at images—is always mediated by sexuality, fantasy, and desire"—concepts that were not narrowly conceived as individual, but rather indicated the embodied, located, and embedded nature of human experience.[36] As Richard Rushton has written, the turn toward psychoanalytic theory in visual studies and practice in the 1970s–1980s, while admittedly shortsighted in some respects, did not preclude engagement with materiality as is often implied; instead, psychoanalytic theory in fact allowed scholars and media practitioners to invent ways of providing a cinematic body and thereby engaging the topic of the material body and the senses.[37]

Having established a fuller and more nuanced historical understanding of feminist media art and theory in the 1970s and 1980s, we can now appreciate how the questions of nonhuman or bodily affect, as well as the reflexive link between ontology and epistemology, are not unique to the new materialisms. While post-1990 new materialisms deal more explicitly

with the nonintentionality of affect and the "liveliness" of matter, many of the motivating concerns of the scholarly materialist turn—phenomenological theories of embodiment, conceptions of both living and nonliving forms of matter as exhibiting some form of agency, and notions of human experience as a nature–culture continuum that is simultaneously materially real and socially constructed—were prefigured in feminist art and theory of the 1970s and 1980s. These earlier models serve as important but underacknowledged precedents for the analyses of material-discursive embodiment in scholarly and artistic new materialisms since 1990, including the feminist materialist critiques of technoscience explored throughout this book.

While I thoroughly endorse Ahmed's position regarding the importance of feminist historiography and have argued for the historical significance of these earlier feminisms, I do not in any way want to suggest that changes have not occurred and that there is nothing new about the institutional and ideological contexts associated with new media art and contemporary feminist new materialisms. Relevant distinctions in the post-1990 period include: a postcinematic paradigm, the ubiquity of digital and technoscientific practices, definitions of feminism that exceed the focus on women and gender, and different ideological and institutional contexts (including the institutionally sanctioned move toward immersive, experiential installations). Most significantly, whereas feminist theorists in the 1970s and 1980s analyzed embodied experience and ostensibly durable realities, feminist new materialists use the concept of "enaction" to describe practices in the here and now that produce essentially *ephemeral* effects (effects coextensive with the practices that create them). Iris van der Tuin concisely describes this transformation: "[Feminist] New materialism does not merely affirm the biological or the cultural body, but rather confirms that bodies are constituted in affective encounters."[38]

The challenge for the next chapter is to account for important transformations in the artistic experience associated with post-1990s new media art without forgetting the conceptual and methodological precedents associated with feminist media art and spectatorship theories since their initial coupling in the 1970s and 1980s. I propose that present-day feminist media art criticism needs a balance between the ongoing centrality of the predominantly cinematic feminist psychoanalytic theories of spectatorship—a centrality that we shall see is maintained principally by way of its present-day repudiation—and entirely different reference points since 1990. Chapter 3 expands upon the investigations of the interrelations among the physical, the symbolic, the sociological, and the technological in feminist

materialisms since 1970 by investigating the interface conditions particular to pioneering media artist Pipilotti Rist's vast oeuvre. With special attention to the institutional context and material viewing conditions of her media artworks, the chapter explains why it is essential to account for the body–technology interface in assessing experiential museum-based new media art and spectatorship and outlines the distinctive contributions of this approach.

Critical Proximity

Pipilotti Rist's Exhibited Interfaces
and the Contemporary Art Museum

The museum . . . is a space where you can try to find your presence.
Not being in the past or in the future, just being there. That is what
I also want with my installations.

— PIPILOTTI RIST, "FANTASY AND DISTRACTION"

One of the most celebrated media artists of her generation, Pipilotti Rist
(b. 1962) creates iconoclastic videos, sculptures, and installations that
have tested prevailing critical frameworks for assessing media art. *Pipilotti
Rist: Eyeball Massage,* a retrospective exhibition at London's Hayward
Gallery in 2011, offers a suitable introduction to the Swiss artist's vast
oeuvre. Hypersaturated color images of nature, bodies, and liquids—some
enchantingly beautiful (lush landscapes, ideal human physiques), others
conventionally abject (menstrual blood, decomposing fruit)—beckon
from every room, including, notably, the women's loo. The majority of the
moving images are tweaked at every turn through Rist's characteristic
mobile and automatic camerawork, as well as her lavish use of image su-
perimposition and juxtaposition, strong contrast and negative images, and
uncanny contortions of scale (thumb-sized Pipilottis, basketball-sized ap-
ples). Videos play in continuous loops, an impression underscored by the
artist's career-long proclivity for self-appropriation and remixing of par-
ticular images and sounds (female bodies, flowers, worms, underwater im-
ages, and menstrual blood are favorites). Hallucinatory audio soundtracks
croon, cajole, or lull in ambiguous relationship to their source. Cooking
utensils, conch shells, and viewers' laps serve as projection surfaces. Vari-
ous media architectures manipulate viewers' bodies by enticing viewers to
stick their heads into a wooden edifice, peer into a hole in the floor, and

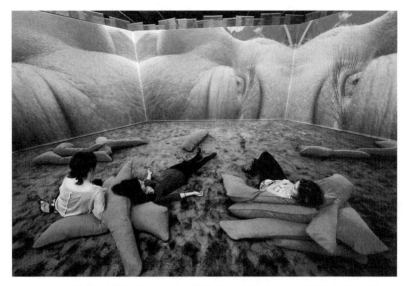

FIGURE 12. Pipilotti Rist, *Lungenflügel (Lobe of The Lung),* 2009. Audio-video installation. This installation view shows Rist's ongoing use of cushioned floors as viewing platforms for recumbent spectators to watch the artist's large-scale projected images. Installation view, Hayward Gallery, *Eyeball Massage,* London, England, 2011. Photo: Linda Nylind. Courtesy of the artist, Hauser & Wirth, and Luhring Augustine.

lie prone on the cushioned floor. Encountering Rist's works of art, spectators experience themselves intermingling with the intoxicating imagery as well as other bodies and media forms; and they feel themselves embedded within these vibrant webs of relations.

What are we to make of Rist's unruly body of work? How do we understand the many incongruities of its come-hither eroticism tinged with disruptive abjection, sensual immersion tempered with collective introspection, and unusual camerawork that studiously avoids objectifying perspective? The first two chapters began the important project of identifying the exceptional qualities of post-1990 media art practices such as Rist's as they have been informed by feminism; we learned, for example, that these new media practices productively frame the experience of embodied technointerfaces. Chapter 3 is devoted to developing a critical model capable of appreciating precisely how body–technology interfaces are enacted in paradigmatic practices such as Rist's and to ascertaining the role of the contemporary art museum. In what follows, I assess Rist's work as it has intersected with major theoretical debates in media art and feminist

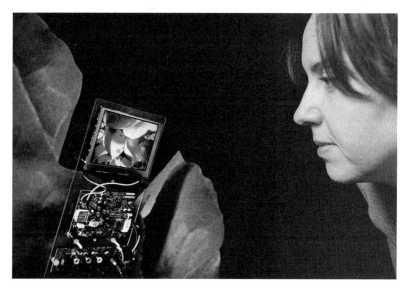

FIGURE 13. Pipilotti Rist, *Mutter, Sohn & der heilige Garten (Mother, Son & the Holy Garden)*, 2003. Video installation. View of spectator getting a close-up view of Rist's tiny screen-reliant installation. Installation view, Hayward Gallery, *Eyeball Massage*, London, England, 2011. Photo: Linda Nylind. Courtesy of the artist, Hauser & Wirth, and Luhring Augustine.

art criticism. I begin by describing the invaluable contributions feminist art historians have made in identifying new modes of critical spectatorship in Rist's artistic production. I build on these accounts by repositioning them in a larger frame: I train my attention on the institutional exhibition context and viewing conditions associated with the artist's moving and projected image works and situate her practice within the critical discourses surrounding gallery- and museum-based media art from the 1960s to the present.

With an eye toward ascertaining the special relevance of their respective exhibition contexts, I examine Rist's exemplary digital video installation at the Museum of Modern Art, *Pour Your Body Out (7354 Cubic Meters)* (2008), as it compares to her closely related feature film *Pepperminta* (2009). I demonstrate how the contemporary art museum exhibition situation, including material and psychological conditions of spectatorship, facilitates a range of distinctive and critically productive opportunities. Most important, I propose that in many ways it is the critical framing function of the institutional context of the visual arts that enables Rist to set off and activate experience (in this case, experiential interfaces among bodies,

technologies, and other forms of materiality) as a site of aesthetic-critical contemplation.

With this in mind, I locate Rist's installation *Pour Your Body Out* within the critical genealogies of museum-based media installation art. Many art historians dismiss present-day moving-image installations such as Rist's out of hand for their similarities to immersive spectacle and their alleged complicity with the demands of the experience-hungry contemporary museum. We will see that while these critiques are spot on in some ways, they prove to be inadequate in others. In the chapter's final section, I propose a new way of thinking about Rist's museum-based media art practice that supports the insights of feminist art historians regarding critical feminist spectatorship while also addressing the legitimate concerns of media art historians regarding contemporary moving-image installations as institutionalized spectacle. Through extended analysis of the interface conditions associated with *Pour Your Body Out,* I conclude that Rist's museum-based practice establishes a novel model of critical aesthetics premised upon what I call critical proximity.

After Visual Pleasure

The scholarly literature surrounding Rist's practice exemplifies the contested terrain associated with feminist media art criticism over the past three decades, especially as such debates have concentrated on issues of visuality and spectatorship. Rist's work is still routinely evaluated in relationship to the so-called visual pleasure era of feminist theory most famously associated with Laura Mulvey's pioneering feminist critique of scopophilia in cinema, "Visual Pleasure and Narrative Cinema," even if only by way of its repudiation.[1] As described in chapter 2, the profoundly influential psychoanalytic and linguistic criticism of writers such as Mulvey, Mary Ann Doane, Jacqueline Rose, Mary Kelly, and others inspired many artists and critics working in the late 1970s and 1980s to eschew representations of sexuality, eroticism, and desire altogether because of the problematic status of the male gaze.

In recent years, the widely influential critiques of visual pleasure that dominated feminist theories of representation in the 1970s and 1980s have themselves been criticized for discounting emotional and corporeal experience, along with any positive benefits to passive and pleasurable looking. Indeed, some thirty-five years after Mulvey's field-launching article, judgments regarding the relative merits of "pleasure" come up in nearly every critical review of Rist's media art practice. Several prominent feminist art historians, including Amelia Jones, Peggy Phelan, and Christine Ross, have

approached Rist's work from precisely this point: as a prototypical complication of once-dominant psychoanalytical and poststructuralist feminist theoretical frameworks.[2] These writers have deftly detailed how Rist's playful approach to female subjectivity and embodiment appears to stymie critical frameworks for assessing feminist media art in terms of voyeurism, pleasure, and the gaze and have proposed provocative new definitions of feminist media art spectatorship in the process.

In her book *Self/Image,* Jones focuses on Rist's media art works for what she takes to be their emblematic demonstration of the reciprocal relationship between bodies and desire: a relationship that Jones argues has been repressed by influential psychoanalytic and poststructuralist argumentation. Purposely building from models implicit in Rist's own production, Jones recodes empathetic, intersubjective, and immersive spectatorial experience as progressive feminist practice.[3] For Jones, Rist's video installations in which viewers are "immersed rather than positioned as disembodied gaze," provide foundational examples of a mode of art practice that she calls "parafeminist." The term is intended to signal how Rist's aesthetic strategies constitute not a *post*-feminism, but, rather, "a radical extension and reworking of strategies, ideas, and political values that are still feminist in the sense that they offer a critical perspective on subjectivity as (still) embodied, gendered, and sexed."[4]

Phelan offers a slightly different account of Rist's aesthetic strategies vis-à-vis anti-ocular feminist theory, arguing that Rist's work deftly issues a "double call." The artist's videos and video installations reject the implicit puritanism associated with previous critiques while also incisively demonstrating the unresolved challenge of being "fully-embodied [female] subjects under patriarchy."[5] Rist accomplishes this through techniques such as mismatching images and sound and imbuing the work with a subtle but pervasive sense of foreboding, both of which serve to deconstruct conventional concepts of desire and fulfillment. Whether or not the female bodies on display in Rist's videos reward the "male gaze" is less important for Phelan than how a given art work signals the overall impasse of feminist representation in patriarchal culture: the dissonance with conventional critiques of representation is part of the point.

Ross pursues a similar tack in her interview with the artist in 2000, theorizing that Rist's "musical fantasies" predictably inflame the viewing subject's desire, but not, crucially, without a degree of criticality.[6] For Ross as for Phelan, Rist's clever aesthetic strategies "seduce the viewer into an awareness of nonplenitude *despite* pleasure."[7] In this sense, the critical operation in Rist's work is less related to self-reflexive Brechtian models, in which the artist uses a distancing effect to make spectators self-aware,

than it is to Warhol's canny deployment of popular representations, images that captivate their viewers even while "manifesting the subject's desire to be different."[8] Rist's video artworks invite a viewing experience that is inextricably bound up with the many spectatorial pleasures of popular music and television; the critical impact comes from the way in which they encourage viewers to engage with pleasurable fantasies that simultaneously adhere to and protest desire.

Elisabeth Bronfen synthesizes many of these positions vis-à-vis psychoanalytic notions of pleasure and desire in her catalog essay for Rist's retrospective exhibition, *Eyeball Massage*. For Bronfen, Rist's work productively overturns voyeurism and gaze theory because the artist effectively visualizes female sexuality—the very lack that is theorized to uphold fetishism. In explicitly detailing the viscerality of female embodiment, including processes of bodily mutability and decomposition, Rist opens up a space in which the female body becomes the subject of "investigation rather than fetishism, curiosity and empathy rather than [the object of] desire."[9]

While their critical investments differ, these writers have done crucial work in identifying moments of continuity and rupture with previous theoretical models and in proposing new frameworks to illuminate the progressive aspects of Rist's practice and their relationship to theoretical constructs such as desire. These scholarly accounts are exemplary in the way they underline how Rist's work transcends tired reductionist emphases on active versus passive, embodied versus disembodied, voyeurism and its refutation. It is also informative to see how Rist's practice is habitually positioned at the epicenter of debates regarding the contested critical legacy of 1980s theoretical feminism identified in chapter 2. However, these otherwise convincing texts do not always sufficiently engage with the broader paradigms through which moving images and media installation art have been discussed.[10] Failing to account for Rist's practice as it relates to the histories and critical legacies surrounding the expanded field of media art production from the 1960s to the present (museum-based practices in particular), presents a twofold problem: first, it contributes to a propensity to overlook the distinctive and significant "exhibited interface" capacity characteristic of museum-based media installations—their critical materialist engagement with the new media interfaces that make up our contemporary technoculture. Second, it sidesteps important questions regarding the institutionalization of film and video practices by museums and galleries since 1990 and the modes of reception they (re)define.

Pour Your Body Out

We can identify the catalytic function of the art museum exhibition context through detailed analysis of Rist's moving-image installation *Pour Your Body Out* (2008). One of the artist's most ambitious works of art to date, the enormous digital video installation filled the notoriously cavernous second-floor lobby atrium of New York's Museum of Modern Art, where it was on view from November 19, 2008, to February 2, 2009. (The work's subtitle, "7354 cubic meters," refers to the calculated volume of the exhibition space in the second-floor lobby atrium designed by Yoshio Taniguchi as part of the museum's 2004 remodel.) *Pour Your Body Out* is an especially useful case study because its visual vocabulary and thematic content is characteristic of much of Rist's decades-long art practice, including, significantly, her feature film *Pepperminta,* which debuted at the Venice Film Festival in 2009.

Pour Your Body Out consists of a candy-toned eruption of moving images projected onto all three walls of a carpeted and cushioned interior. Huge breast-shaped video projectors emit nonnarrative sequences depicting various exchanges among female, animal, and natural forms. Like much of Rist's work, the imagery toys with the extremes of attraction and repulsion—an unclothed "Eve" frolics, at one with the primal viscosity of the natural world: grunting pigs, lush produce, fertile fields, rotting flowers, energetic worms, teeming water, trickling blood. Cascading magenta curtains frame the installation's primary viewing space while also facilitating tantalizing glimpses of the room-sized (25 ft. × 200 ft.; 7.6 × 61 m) video projections from other floors of the museum. Meandering bodies navigate every corner of the feminized atrium and its surrounding areas: lingering on the balconies, reclining on the carpeted floor, lounging on the colossal eye-shaped sofa and handmade pink cushions in the atrium's center. Hallucinatory electronic music underscores the all-encompassing environmental quality of the work, which immerses the assembled museum visitors like undersea divers.

Released in the same year as the MoMA installation, the artist's feature film *Pepperminta* (2009; 84 minutes, color) shares a similar aesthetic. Indeed, both moving-image works are composed from the same raw footage shot on location in Switzerland, Austria (Vienna), and the Netherlands (Noordoostpolder). Self-appropriation through image and sound recycling is not uncommon for Rist; in this instance, however, she arranged a buyout from the film's producers to use parts of the accumulated footage in three art installations, including *Pour Your Body Out.*[11] Due to this shared pedigree, the film boasts much of *Pour Your Body Out*'s lush, jewel-toned

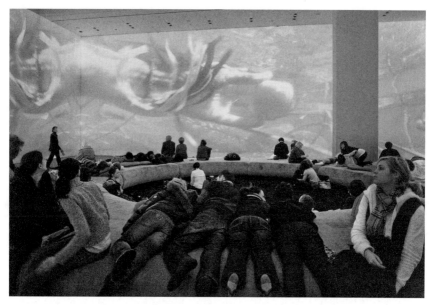

FIGURE 14. Pipilotti Rist, *Pour Your Body Out (7354 Cubic Meters)*, installation view, 2008. Multichannel video projection (color, sound), projector enclosures, circular seating element, carpet. One of *Pour Your Body Out*'s nonnarrative image sequences depicting various exchanges among female, animal, and natural forms; this detail also confirms Rist's persistent interest in underwater imagery. Copyright 2009 Pipilotti Rist and The Museum of Modern Art, New York. Images courtesy of the artist, Luhring Augustine, New York, and Hauser & Wirth. Photography by Thomas Griesel. See also figure 1. Digital Image copyright The Museum of Modern Art / Licensed by SCALA / Art Resource, New York.

imagery: a lovely heroine Ewelina Guzik (Pepperminta) traipsing through unmistakably labial tulip fields, merging with water and blood, and frolicking with a pig and foodstuffs in exuberant displays of growth and decay.

Both *Pour Your Body Out* and *Pepperminta* feature Rist's distinctive intimate mobile camerawork—hand camera traveling; rhythmic, poetic editing; and the use of a fisheye lens to achieve extreme close-ups. While acknowledging their many formal similarities, the artist nevertheless efficiently distinguishes between the two moving-image works. In a recorded conversation with the museum guards at MoMA, she classifies *Pour Your Body Out* as a "poem" and *Pepperminta* as a "full story with a narrative."[12] Like a poem, *Pour Your Body Out* is primarily concerned with the

FIGURE 15. Pipilotti Rist, *Pepperminta* (video still), 2009. Rist's feature film *Pepperminta* (which debuted at the Venice Film Festival) shares much of the same footage with its installation art cousin, *Pour Your Body Out* (a site-specific artwork created for the atrium of the Museum of Modern Art, New York). Copyright Pipilotti Rist. Courtesy of the artist, Hauser & Wirth, and Luhring Augustine.

aesthetic qualities of sounds and images above and beyond their contribution to an overarching narrative and welcomes multiple paths and interpretations.[13] *Pepperminta*, for its part, tells a more cohesive tale of the preadolescent and adult Pepperminta's nonconformist adventures with a series of human and nonhuman playmates. Above and beyond any particular disparities in visual and narrative content, however, these visually similar media works offer dramatically different viewing experiences, based in large part on their institutional exhibition contexts.

Pepperminta, a feature-length film, was designed for viewing in a theatrical screening context: multiple, stationary viewers observing the work in a darkened auditorium for a fixed duration. (While of course no two screenings of a film are ever identical, and no two viewers will experience a film in the exact same way, Rist's assessment of institutional norms is helpful here. She observes: "Unlike in a museum, there is a common agreement in a movie theatre that everyone looks in the same direction and no one leaves the room for 80 minutes."[14]) *Pepperminta*'s installation art cousin operates according to a very different logic. In contrast to the film's fixed eighty-four-minute duration and seated audience, *Pour Your Body Out*'s museum visitors are invited to roam throughout the illuminated space or recline on comfortable cushions in whatever position, and for whatever exploratory spectator-determined duration, they see fit.

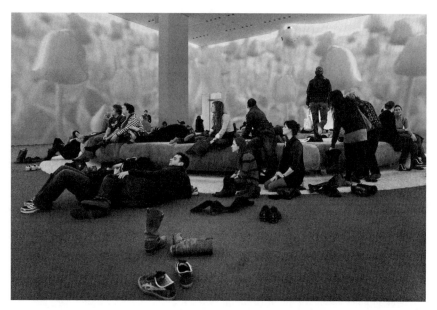

FIGURE 16. Pipilotti Rist, *Pour Your Body Out (7354 Cubic Meters)*, installation view, 2008. Multichannel video projection (color, sound), projector enclosures, circular seating element, carpet. Viewers are invited to lounge on the colossal eye-shaped sofa and handmade pink cushions at the center of the exhibition space. Copyright 2009 Pipilotti Rist and The Museum of Modern Art, New York. Images courtesy of the artist, Luhring Augustine, New York, and Hauser & Wirth. Photography by Thomas Griesel. Digital Image copyright The Museum of Modern Art / Licensed by SCALA / Art Resource, New York.

Unlike *Pepperminta*, *Pour Your Body Out*'s video and audio tracks are played on continuous and nonsynced loops (sixteen minutes and ten minutes, respectively). This disparity distinguishes it from theatrical cinema screenings in two additional ways: first, no two viewers will ever see precisely the same combination of audiovisual material; and second, no single viewer is likely (or even expected) to experience the sound and image combinations in their entirety. While *Pepperminta*'s audience is predicted to remain stationary and focused on the diegesis (after all, the artist's professed intention is to offer "a full story with a narrative"), *Pour Your Body Out* anticipates the inverse: one must physically move through the 360-degree exhibition space in order to fully experience the sculptural, environmental work (a self-directed meandering that, following the artist, we might call "poetic"). The wall label written by the artist at the entrance to *Pour Your Body Out* is instructive. It coaches: "Please feel as liberated

as possible, and move as freely as you can or want to! Watch the videos and listen to the sound in any position or movement. Practice stretching: Pour Your Body Out of your hips or watch through your legs. Rolling around and singing is also allowed!"

What is important to emphasize in comparing the two works is this: in contradistinction to Rist's cinema-sited piece, her museum-based installation engages the viewing conventions associated with art exhibition spaces (ambulatory viewers, exploratory duration, and a heightened awareness of material objects) and with installation art (in which the material interface conditions between viewers and objects are central to the very meaning of the work itself) to set off and activate the viewing experience as a site of aesthetic-critical contemplation.[15] *Pour Your Body Out*'s particular variant of moving-image art and critical spectatorship thus could be described appropriately as art-gallery- or museum-*reliant*. This is crucial insofar as the white cube art exhibition space has been widely criticized for its ideological associations. In an interview with Ross (excerpted in the chapter epigraph), the artist remarks: "[The museum] is a space where you can try to find your presence. . . . That is what I also want with my installations." Ross's subsequent synopsis of Rist's position is astute. She states: "In the '70s–'80s, the museum was often criticized for its closure vis-à-vis the outside world. The art gallery was seen as a 'white cube' supporting the modernist conception of art as autonomous and separated from life. What you are arguing here is that this separateness also has a positive side: the museum provides sites that permit us to think and meditate."[16] Although Ross unfortunately leaves the topic of the art exhibition context undeveloped, her comments point to how *Pour Your Body Out* exploits the museum's autonomy—a site to "think and meditate" about a given media installation (that is, its interface conditions)—to critical ends. In a seeming paradox, *Pour Your Body Out* uses the ideological coerciveness of the "white cube" gallery space (most famously theorized by Brian O'Doherty) to critical advantage: it uses the white cube's framing function to materialize and put on display the interfaces among viewing bodies, digital media, and other forms of materiality that tend to go unnoticed outside of an exhibition context.[17]

I will address the well-known institutional embrace of large-scale immersive moving-image works since 1990 and turn a critical eye on Rist's emancipatory claims in what follows. For now, what I want to call attention to is how Rist's comments confirm that it is the art exhibition context that allows her to bring media spectatorship itself into view and to facilitate alternate modes of engagement. "I thirst after materialized fantasies in which people can physically meet," proclaimed the artist as early as 2001.[18] In

elucidating the specific "materialized fantasies" proposed in *Pour Your Body Out*, Rist explains: "I try to work as immersively as possible because I think we always try to frame everything behind and within the square format and it affects us strongly." Her solution: "It is a kind of remedy to make the work as huge as possible—it becomes like our skin. In life you are often alone, but when you come together in imaginary rooms [of the museum] you become a common body."[19] The museum thus offers media artists something exceptional: a site to critically frame and engage the (typically overlooked) material and experiential interfaces between viewing bodies and digital technologies that characterize our twenty-first-century technoculture. In this way, our enactive and affective relations with contemporary technologies and other forms of matter is reflected in this art as a point of contemplation.

Let me be very clear: the institutional context of the art gallery or museum is neither determinist nor without exception. One could hypothetically have a similarly self-reflexive viewing experience with digital media outside of the institutional context of the visual arts, and not every viewer is apt to understand installation art works in the same environmental or critical terms. In general, however, the spectatorship conventions associated with the institutional context of the visual arts, and with installation art in particular, afford an especially primed ground for the attentive, embodied, and materialized reception of both physical objects and the exhibition space. In contrast to cinematic moving-image works such as *Pepperminta*, museum-based installations such as *Pour Your Body Out* explicitly foreground spatialized, material, and time-based interfaces between viewing bodies and media objects as part of the work itself. This context is especially generative for artists working with new media technologies because it allows them to bring attention to typically overlooked phenomenal and perceptual relationships among bodies, digital media, and other material forms and processes.

In the next section we will explore the critical reception of *Pour Your Body Out*, especially as it relates to critiques of the contemporary museum and immersive media installations. We will see how the work's critical reception exemplifies debates about large-scale moving-image environments since the 1990s and examine the strengths and weaknesses of these claims.

Pour Your Body Out's Critical Reception (Or, the Feeling of What Happens)

Pour Your Body Out proposes a very specific model of subject–object relations: it enthusiastically promotes and exhibits collective, enfolding, and

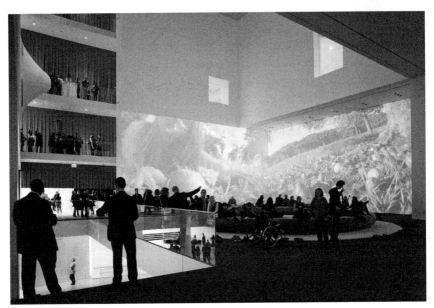

FIGURE 17. Pipilotti Rist, *Pour Your Body Out (7354 Cubic Meters)*, installation view, 2008. Multichannel video projection (color, sound), projector enclosures, circular seating element, carpet. This view shows the various perspectives from which spectators are invited to experience this multisensory environmental-scale work. This detail also shows the immense magenta curtains framing the atrium space as well as one of the installation's enormous white, "breast-shaped" projectors. Copyright 2009 Pipilotti Rist and The Museum of Modern Art, New York. Images courtesy of the artist, Luhring Augustine, New York, and Hauser & Wirth. Photography by Thomas Griesel. Digital Image copyright The Museum of Modern Art / Licensed by SCALA / Art Resource, New York.

multisensory encounters among viewing bodies, media technologies, and other forms of matter. Despite its enormous scale, the installation encourages face-to-face, body-to-body intimacy and coexperience. Viewers are invited to sit, recline, or perambulate throughout the illuminated media environment in the constant company of other viewing bodies. Indeed, Rist effectively uses viewers' bodies themselves as an art medium in her quest to bring attention to the act of viewing (spectatorship) as such. Viewed from the atrium floor, for example, swarming mobile viewers seem to flow in concert with the ambient electronic music. Seen from the galleries above the lobby, wriggling supine bodies animate the massive eye-shaped sofa in close proximity to the physical media apparatus (projectors, images,

wall screens, and so on). The requirement that audience members remove their shoes in the carpeted sections of the installation both generates impromptu sculptural mounds of footwear and facilitates an overall sense of intimacy and camaraderie among the symbolically disrobed and arguably feminized audience members.

Reviewers of the exhibition—sympathetic and unsympathetic alike— tend to reference these emotional, bodily, and sculptural arrangements in explaining the museum-based art installation's enormous popular success (a popularity significantly *not* shared by its theatrical cinema-based variant, *Pepperminta*).[20] In an upbeat review for *Artforum*, Cameron Shaw identifies a transformative effect in the work's peculiar blend of stimulating audiovisual material, snuggling lovers, napping tourists, and cavorting children. "To this viewer," proclaims Shaw, "it looked a lot like love."[21] Irrespective of how one feels about this optimistic reading (or, for that matter, the artist's admittedly utopian claims regarding the capacity of the museum's "imaginary rooms" to generate a "common body"), it is clear that Rist's installation nurtured and called attention to a very distinctive model of museum-based media spectatorship. "It's a different kind of museum experience," explains MoMA curator Klaus Biesenbach, who organized the installation. "One where you can come, take your shoes off and relax."[22] Art historian Catrien Schreuder enthuses that Rist "transforms the museum into a place where you feel free, where you can briefly shed conventional patterns of behaviour and where you become part of a greater whole," adding, "It is not often that I find myself lying in a museum with my socks next to the head of a stranger."[23] Perhaps most telling of *Pour Your Body Out*'s unusual agenda, MoMA issued an invitation for museum visitors to "Put the oM in MoMA" and participate in a free seventy-five-minute yoga lesson inside of Rist's sprawling video installation.

In taking stock of the installation's aforementioned characteristics, as well as its popular reception, it is tempting to disparage the entire project within well-established critical frameworks that forcefully denounce such works for their alleged passive immersion, technological mysticism, and complicity with "experience"-inducing blockbuster museums, particularly as such works are interpreted as perversions of the authenticity associated with certain phenomenologically informed film and video installations of the 1960s–1970s.[24] Tanya Leighton efficiently recounts the dominant scholarly position regarding the critical potential of media art in the 1960s–1970s and its supposed undoing in the post-1990 period in her introduction to *Art and the Moving Image*. Critical media practices in the 1960s and 1970s are praised for their phenomenological acuity and rigorous denunciation of mass media conventions within the institutional

context of the art museum: "Against the totalizing logic of mass commu-
nication, a number of artists took to film to explore the phenomenological
and physiological conditions of perceptual experience for the viewer, and
to exploit the realm between the autonomous space of the museum and the
spectacular realm of the mass media."[25] Contemporary immersive media
installations, in contrast, are believed to "'seduce and captivate the viewer'
through their 'rush of special effects' and their proximity to 'illusion-
promoting spectacles and dubious speculations.' . . . Instead of offering
alternatives to spectacle, they simulate the slickness of television or film,
aestheticizing or 'artifying' already well-known experiences of the mind-
blowing intensities produced by the media culture at large."[26] Because of
their allegedly passive mode of spectatorship, many media art historians
deem immersive multisensory installations such as *Pour Your Body Out*
to be, at best, apolitical, and, at worst, complicit with manipulations of the
cinematic apparatus, dominant society, and the consumerist ethos of
the contemporary art museum (a point we will return to momentarily).

In some key respects, however, Rist's project in fact mines the inheri-
tance of the much-admired gallery-based critical media installation art
practices initiated in the 1960s and 1970s.[27] Working within the institu-
tional context of the visual arts, artists such as Peter Campus, Valie Export,
Joan Jonas, Dan Graham, Bruce Nauman, and Michael Snow created
gallery-based film and video installations indebted to minimalism's phe-
nomenological legacy, postminimalism's explorations of site and process,
and various practices of institutional critique.[28] In so doing, these artists
embraced a self-consciously dual spectatorship—one simultaneously
caught up in the space of illusionist representation *and* made aware of the
grounded, material conditions of the experience. Moreover, like Rist, these
artists were fundamentally concerned with the spatial, temporal, and ma-
terial dynamics of the viewer–technological object relation in ways not
strictly confined to the "cinematic."[29] Similar to *Pour Your Body Out*, then,
certain critical museum-based moving-image practices in the 1960s and
1970s used the viewing conditions associated with the art gallery's "white
cube" in order to draw attention to the material media apparatus and
critically reflect on modes of spectatorship associated with a range of sites
(sometimes, although not always, including the art gallery itself) as well as
wider discursive concerns such as everyday media spectatorship (including
regimes not limited to the cinematic).[30]

Despite these similarities, the differences between Rist's *Pour Your
Body Out* and its media installation predecessors in the 1960s and 1970s
clearly are nontrivial. There is a growing body of critical literature concerned
with the widespread commodification and institutional endorsement of

moving image and media installation works such as Rist's since approxi-
mately 1990. Perhaps not surprisingly, the effects are described almost
exclusively as negative. The contemporary museum is critiqued as a neo-
liberal ideological apparatus invested in an "attention" or "experience"
economy premised on the production of networked, active, and participatory
citizens.[31] What I have described as Rist's critical engagement with mate-
riality and surfaces could be interpreted instead as an alignment with the
demands for large-scale participatory media environments favored by
twenty-first-century art museums. Indeed, although the majority of critical
reviews of the MoMA installation were in fact positive, several writers
take Rist's project to task along the lines established by scholars skeptical
of contemporary museum-based installations. Dorothy Spears's dismissive
review in *Art in America* is a case in point: "Rist's tantalizing installations
speak the universal language of pleasure to an audience weaned on Am-
bien, electronic billboards, and echoing, whitewashed spaces . . . sensation-
seeking crowds cluster at handrails, gaping down. . . . [The artist's] trump
card . . . is to reward anyone who enters her deftly orchestrated environ-
ments with art's equivalent of a temple rub."[32] *Pour Your Body Out* is criti-
cized here precisely for being a disingenuous reflection of the neoliberal
museum—a "deftly orchestrated" temple rub reward for obedient spectacle-
seeking consumers.

These judgments are valid on many levels. It is instructive and necessary
to understand installations like *Pour Your Body Out* in light of the wide-
spread popularization and institutionalization of moving-image works in
big-budget, big-brand cultural centers such as MoMA over the past two
decades.[33] At the same time, however, it is essential to recognize that the
"exhibited media interface" contribution of works such as *Pour Your
Body Out,* and the art gallery or museum's strategic role in this, risks being
overshadowed by assessments of the insidious "new institutionalism" and
media installation as uncritical spectacle.

Erika Balsom's extended evaluation of *Pour Your Body Out* in *Exhibit-
ing Cinema in Contemporary Art* is worth engaging in detail because she
links Rist's project not only to commercialized museum spectacle but also
to what she deems to be a politically suspect feminism. Balsom's critique is
unambiguous. She argues that Rist's use of "extravagant visuals, high pro-
duction values, and a maximalist aesthetic of visual hypersaturation and
bombast . . . unsettlingly mirrors the spurious production of affect and
sensation by the image commodities of advanced capitalism."[34] Further,
on the topic of the artist's engagement with feminism, Balsom diagnoses a
retrograde essentialist conception of femininity. She writes: "If *Pour Your*

Body Out is to be conceived as a feminist intervention at all, it is a feminism already defeated by its disturbing anchorage in an extra-discursive conception of the body that equates woman with nature. As the cushy colors and squishy, magnified breasts come together to coat the white cube in washes of pink, one has to question if *Pour Your Body Out* is doing anything more than reinforcing the very binaries that have served to largely exclude women artists from institutions such as the MoMA in the first place, while simultaneously neutralizing any ability that space might have to offer an alternative to the image-saturation of mass culture by simply rendering it gigantic and by hyperbolizing it—and delighting in that hyperbole."[35]

Balsom's evaluation of Rist's project is interesting on several accounts. First, according to conventions set by MoMA itself, this overtly feminized artwork should not have been featured at, much less commissioned by, the great citadel of (masculinist) modernism.[36] Given the museum's historic disdain for feminine/feminized cultural production, it thus seems unfair to dismiss the symbolic significance of a female artist being given free rein to engage the disciplining architecture of MoMA's pristine white walls, particularly insofar as said artist probes the gender politics of MoMA's history by displaying the oozing erotics of rotting life and menstrual blood in a sensuous womb room—"gigantic and hyperbolic" or otherwise. Indeed, the fact that disparaging references to the artwork's "suffocating" or "immersive" "womb" abound in the negative reviews of *Pour Your Body Out* would seem to suggest an ill-disguised apprehension about (feminized) bodies, passivity, and sensuous collective viewing, especially as it intersects with mass culture.[37]

Second, to denigrate this work as an essentialist reduction of the female body and nature is to reaffirm problematic hierarchical binaries of "essentialist" and "theoretical/constructionist" feminism that fail to appreciate how many artistic practices have always exceeded these dualistic categories (as detailed in chapter 2 and as writers such as Phelan, Jones, and Ross also convincingly demonstrate).[38] It is also vital to remember that feminist art itself enjoyed a notable popularity in contemporary museums in the early twenty-first century, as seen in a series of exhibitions such as Connie Butler's *WACK! Art and the Feminist Revolution* (Museum of Contemporary Art, Los Angeles, 2007), Maura Reilly and Linda Nochlin's *Global Feminisms* (Brooklyn Museum, 2007), and Camille Morineau's *Elles@centrepompidou* (Musee National d'Art Moderne, Centre Pompidou, Paris, 2009). This serves as an important reminder that feminism too can be marketed and deployed in ever-changing ways, such

that the identification of a presumably "noncommodifiable" variant of feminist art is a fiction that must be contested. On both accounts, then, Balsom's analysis cannot accommodate how Rist's project redeploys both digital spectacle and the experience-hungry museum to critical and arguably feminist ends.

While it is unquestionably valuable to consider the ways museums function as technologies of power, and to recognize that the MoMA-based *Pour Your Body Out* definitely could not happen to the same effect elsewhere (as amply evidenced in the case of *Pepperminta*), it is untenable to presume that the museum has ever been an uncompromised space of autonomy and clear-sighted criticality (as Balsom readily acknowledges). Similarly, just as the white cube gallery space is always ideologically determined, there is no artistic production that is inherently or purely oppositional. Tamara Trodd has observed that much writing on the topic of the projected image betrays a clandestine modernist longing for an authentic outsider status somehow outside of ideology. Trodd correctly advocates that art and media scholars need to rework prevailing frameworks in order to achieve a "rigorous critical theory of the projected image as a category in contemporary art, which is materially attentive and formally specific, but is not exclusionary of popular culture, considerations of identity or rapt and sensuous viewing responses in the way that the modernist critical framework for the projected image, it seems, continues to want to be."[39] In other words, we need an interpretive model for media installation art that recognizes its own complicity with ideology, rather than posing itself as superior to it.

As Balsom aptly observes, Rist unapologetically borrows the elaborate visual displays and sensational effects of contemporary mass culture. She does so, however, in order to frame aspects of it—namely, the ways in which bodies and other active material forms and processes constantly remake each other. Moreover, Rist achieves this critical effect by taking the much-maligned contemporary museum's power and its hunger for affective, sensational art as a given; she offers the sought-after "experience," but in order to highlight a different agenda—an intimate, embodied, and materialized interactivity with the lively forms and affects of today's technoculture. In a seeming paradox (or at least a paradox for our current models premised upon an idealized critical distance and the denunciation of museum spectacle), *Pour Your Body Out* enacts a calmative and immersive sensorial experience in the contemporary art museum to induce spectators to appreciate the dynamic relations among viewing bodies, technological objects, and other forms of matter—all of which are revealed to be active and to possess some form of agency.

Doing Nothing, Absolutely Together

The mode of spectatorship associated with Rist's museum-based installa-
tion serves as an ideal metaphor for the intrinsic closeness associated with
evaluating today's new media ecologies identified in the feminist new ma-
terialisms explored in chapter 1. We might encapsulate *Pour Your Body
Out*'s particular rendition of feminist materialism with the following
maxim: you have to pay attention in order to pour your body out, and you
have to pour your body out in order to pay attention. As substantiated in
journalistic reviews of the exhibition, the installation's visitors, far from
being passive and uncritical, could not help but be self-reflexive about the
collective and corporealized experience of lying barefoot on a sofa with
strangers while enmeshed in Rist's sexualized mediascapes. Similarly, while
MoMA's prearranged yoga lesson is undeniably part of a creative market-
ing campaign for the visitor-hungry mega museum (who can forget the
solicitation to "Put the oM in MoMA"?), the fact that similar nonspon-
sored yoga practices and gatherings occurred throughout the installation's
tenure at the museum suggests that *Pour Your Body Out*'s call for corporeal
awareness of the body–environment mutuality performed by the work of
art resonated with its audience.

It is in instantiating new, previously unidentified modes of experience
with new media that installations such as Rist's suggest a prospective politi-
cal aesthetics—a contention distinctly at odds with scholars who construe
the work as bereft of critical competencies. Political theorist Davide Panagia
argues for the possibility of political subjectivity and agency through experi-
ences that enable us to see and sense differently. According to Panagia in *The
Political Life of Sensation,* "Sensory experience interrupts our perceptual
givens, creating occasions to suspend authority and reconfigure the arrange-
ment of a political order. Democratic politics . . . involves a taking part in
those everyday practices that interrupt our common modes of sensing and
afford us an awareness of what had previously been insensible."[40] Mieke Bal
articulates a similar position but with specific reference to the politics and
poetics of media installation art. Bal argues that the capacity of the "aesthetic
situation" to encourage thinking beyond ordinary boundaries and going into
other, unfamiliar spaces is of vital importance to sustain the conditions of a
functioning political domain. In her words: "Art, with its imaginative and
often fictional images, its experiments in the not-yet-existing but thinkable
variations of what is considered normal, and its slower mode of functioning
in comparison to the frantic pace of everyday life, is a privileged area where
such spaces can be constructed. The aesthetic situation intensifies this po-
tential, and video installation embodies it in its very form."[41]

Following Panagia and Bal, *Pour Your Body Out* could be understood as engendering a critical spectatorship in the sense that it reflexively engages the politics of everyday life associated with the new visual and affective regimes of digital media culture. Aesthetic philosopher Juliane Rebentisch offers a slightly more nuanced claim for installation art's particular mode of political efficacy. For Rebentisch, such works are not political in any direct sense of the term, but rather indirectly or potentially. As described by Rebentisch, "Art works on a perception of the given, which it shares with the emphatically political. Instead of remaining at the level of the seeming evidence of the immediately given, this given itself becomes a problem, a problem of interpretation. The ethical-political function of art would then at least in part consist in the fact that it reminds us that what is, is not everything."[42] She further specifies: "Having an aesthetic experience means *experiencing experience,* that is, encountering the world of experience familiar from the real world anew in the mode of reflexive distance."[43]

While I concur with Panagia and Bal in their definitions of the political potential of media installation art, particularly as refiltered through Rebentisch's more measured definition of an implicit rather than explicit politics, it is important to clarify how the "reflexive distance" these three critics champion in fact unfolds in a distinctly different manner in works such as *Pour Your Body Out.* As we have seen, *Pour Your Body Out*'s spectatorship by no means supports a traditional model of critical distance: it is not an operation performed by an unimplicated observer or from some detached rational perspective. Instead, it is a model of reflexive distance premised upon what I call a *critical proximity.* It stages distance from and attention to aspects of contemporary technoculture that otherwise go unnoticed, but always from an insistently located position of intimate and embedded *nearness.* As suggested in the introduction, feminist materialist scholars such as Donna Haraway may come closest to identifying the significance of this "critically proximate" mode of engagement. Haraway's demarcation of "embedded objectivity," for example—a nonalienating yet reflexive distance that deliberately avoids transcendence and subject–object dualisms—helpfully points to the potential ethical-political implications of Rist's cultivating and framing of the experience of critical proximity.[44]

Jerry Saltz's evocative description of the curious goings-on in *Pour Your Body Out* nicely encapsulates the subtle provocation of new media installations such as Rist's. Remarking on the atmospheric quality of a structured pause during the group yoga activity, the critic surmises: "It took audience participation to a new level: doing nothing, absolutely together."[45] Doing

nothing, but not *absolutely* nothing. As we have seen, *Pour Your Body Out* is as much about the interface conditions among the viewing bodies and other material forms, as it is about the visual content. Borrowing Rist's words, we might more accurately describe the work as a museum-reliant invitation for viewers to "find their presence" and "think and meditate" amid the vibrant materiality of bodies, spaces, and (techno) objects with which we are always already entwined. Like the other feminist new materialisms examined throughout this book, Rist's museum-based installation stages a spectatorship of critical proximity that addresses materialization as a complex and open process, matter as lively and productive, and subjectivity as enmeshed within the very stuff of the world. I do not want to suggest by any means that we should blindly celebrate this art as conclusively "resistant," however; rather, I am proposing that it offers an entirely different mode of critical aesthetics for which we do not yet have an ample vocabulary.

In summary, new media spectatorship is both the medium and the message for *Pour Your Body Out*. Returning to the critical feminist spectatorship identified in Rist's work by writers such as Jones and Ross, we see that they are correct in arguing that Rist's mode of artistic experience extends and challenges the once-dominant ocularcentric critiques derived in large part from feminist psychoanalytic film theory. Rist's works of art openly solicit multisensory immersion and pleasure; her playful approach to picturing female embodiment and subjectivity complicates familiar psychoanalytic frameworks for understanding the gaze and theorizing desire. This chapter aspired to supplement current conversations regarding Rist's media art practice by placing the arguments of feminist art historians in a larger critical frame of museum-based media art history and criticism. It has emphasized the creative and disruptive potentialities for moving-image works in an art gallery exhibition context and shown how artists like Rist knowingly manipulate this highly charged institutional context to create sculptural installations that materialize the interfaces among bodies, technologies, and other forms of matter that structure our contemporary technoculture. Through an extended case study of *Pour Your Body Out*, we have seen how Rist deploys the contemporary museum context to frame a very particular model of contemplative, distributed, and multisensory new media experience. The artistic experience performed in *Pour Your Body Out* is simultaneously reflexively critical and inexorably immersive—what I have designated as a model of critical proximity.

Chapter 4 will explore further permutations in spectators' complex affective and corporeal responses to experiential museum-based new media

art through analyzing Patricia Piccinini's bioart. We will revisit the curious dialectic between "pouring one's body out" and critical perception in conjunction with Piccinini's much-discussed *We Are Family* exhibition held at the Venice Biennale in 2003. Through detailed analysis of specific works of art, we will evaluate the prominent social, cultural, and political issues at stake in encountering the artist's hyperrealistic nonhuman creatures in an age of pervasive digital and biotechnologies.

Unbecoming Human

Patricia Piccinini's Bioart and
Postanthropocentric Posthumanism

> Both kinship and ethical accountability need to be redefined in such
> a way as to rethink links of affectivity and responsibility not only
> for non-anthropomorphic organic others, but also for those
> technologically mediated, newly patented creatures we are sharing
> our planet with.
>
> —ROSI BRAIDOTTI, *THE POSTHUMAN*

The Australian multimedia artist Patricia Piccinini (b. 1965) creates imagi-
nary hybrid life forms, working across various media to stage a variety of
transspecies encounters. Until now, there has been remarkable continuity
in readings of her oeuvre. Aside from a few fleeting references to commod-
ity culture or the specificity of the Australian environment, the critical
reception of her work has been dominated by a focus on the nature of the
viewer's affective experience with the unusual creatures depicted in her
works of art.[1] To some extent this is familiar interpretive terrain for bio-
art criticism. Christoph Cox's account in the exhibition catalog for
Becoming Animal is representative; he observes how "uncanny, monstrous
creatures . . . summon in us sympathies and identifications that draw us into
affective relationships with the non-human."[2] In the case of Piccinini's
work, however, the appreciation of the viewer's emotional and affective
experience has a characteristic affirmative flavor. The majority of critics,
and indeed the artist herself, tend to theorize the spectatorial experience
in generous and ostensibly progressive terms of empathy, care, vulnerability,
and parenting in the face of biotech experiments gone awry.

 This chapter's aim is to evaluate and ultimately expand the critical
discourse surrounding bioart projects such as Piccinini's. First, however, it

is valuable to recognize that the category of bioart itself has various, sometimes competing, definitions. Bioart can refer to artwork engaged with representations of medical and biological research, as well as to "disruptive" uses of biological material. However, as Eugene Thacker and others have argued, reducing bioart to works that deal with biology simply as an artistic medium is problematic. According to Thacker, the term "bioart" "marginalizes (or niche markets) art, effectively separating it from the practices of technoscience . . . the notion of a 'bioart' also positions art practice as reactionary and, at best, reflective of the technosciences."[3] Claire Pentecost's capacious definition of bioart is helpful for understanding Piccinini's inclusion within the genre: "Bioart projects often engage in activities broadly understood as 'scientific' (e.g., using scientific equipment or procedures, making a hypothesis and testing it, furthering an inquiry usually considered the province of the life sciences, *or addressing a controversy or blind spot posed by the very character of the life sciences themselves*)," presumably through employing any number of artistic media.[4]

Piccinini's pivotal *We Are Family* exhibition (Australian Pavilion, Venice Biennale, 2003) is this chapter's central case study. The critical reception of the bioart objects in *We Are Family* is especially interesting because the exhibition has become a testing ground for boundary-marking definitions of what it means to be human in the age of biotechnologies. The vast majority of accounts of Piccinini's *We Are Family* describe "cutely grotesque" creatures who arouse empathy and "parental" affection in their viewers. I propose instead that Piccinini's bioart objects superficially invite and yet ultimately exceed these well-intentioned but reductive characterizations. My argument knowingly treads a thin line: I contend that while the prevailing interpretations of Piccinini's work are perceptive in many ways and generally are endorsed by the artist herself, they are nonetheless hampered by a symptomatic bias that obscures other compelling contributions of the artist's practice. This is not to insinuate that I think that the artist's intention does not matter; on the contrary, I contend that her art objects exhibit a lively agency of their own that invites us to reconsider their prevailing critical reception.

Upon closer inspection, the art objects in *We Are Family* suggest a model of artistic experience that circumvents familiar categories such as compassion and parental care. Instead, these works traffic in the *un*familiar (the un-"familial"): they gesture toward a viewing experience based on an encounter with radical and inassimilable difference—an encounter with beings with whom we have no necessary ties or affinities. The persistent feel-good judgments regarding Piccinini's artistic engagement with

biotechnologies—judgments that inadvertently repress the transitory moments of negative affect that viewers experience with Piccinini's non-human creatures—thus reveal a deep-seated anthropocentrism that may even be read as politically reactionary. Through attentive examination of the material art objects themselves, I propose an alternative interpretation of the spectatorial experience associated with Piccinini's work: a mode of viewing suggestive of a postanthropocentric posthumanism.[5] By focusing my analysis of the artwork in *We Are Family* on the topic of anthropo-morphism, I aim to clarify the ethical and theoretical stakes that are im-plicit in the artwork and, indeed, make it a vital form of social work. This intervention generates important gains beyond merely diversifying inter-pretations of the artist's practice. It allows us to recognize the ways in which bioart projects such as Piccinini's invite viewers to experience and care for nonhuman others in a positive relation based not upon familiar human-centric qualities, but upon inexhaustible and potentially destabi-lizing difference. In the chapter's conclusion, I suggest that this relation also may offer a convincing model for ethical accountability to humans, animals, and technological beings in everyday life.

We Are Family

Piccinini's exhibition for the Australian pavilion at the 2003 Venice Bien-nale offers a cogent entry into her practice insofar as its immediate popular success set the stage for her debut in the international art world and es-tablished the now ingrained terms of critique.[6] Curated by Linda Michael, the suggestively titled *We Are Family* exhibition featured a dozen or so hyperrealistic yet primarily fantastical life forms and their accoutrements installed in such a way as to suggest an expanded definition of a typical Western domicile. As detailed in Michael's essay for the show's catalog, the exhibition "converted the Australian Pavilion into a home," in which viewers were invited to visit "families of human, transgenic, and unidentifi-able beings."[7]

The exhibition included six pieces—a single-channel video, a group of sculptures, and four installations. *Plasmid Region* (2003), a video described by the artist as the "'heart' of the show," depicts pulsating raw fleshy biomorphic forms in an unending three-minute loop set to a reflective soundtrack of piano music in surround sound. *Team WAF (Precautions)* (2003) consists of five high-gloss helmets custom-designed for the irregu-larly shaped heads of a group of presumably fictitious yet adventurous and design-savvy creatures.[8] The four installations—*Game Boys Advanced*

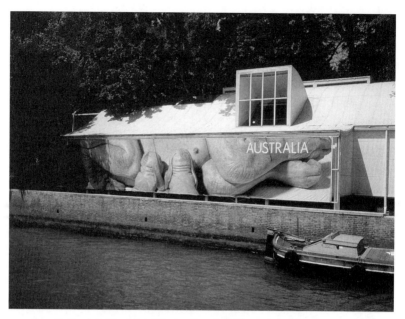

FIGURE 18. Patricia Piccinini, *We Are Family* Billboard, Venice Biennale, 2003. Exterior view of the Australian Pavilion advertising Piccinini's *We Are Family* exhibition at the 2003 Venice Biennale. Photograph courtesy of the artist.

(2002), *Still Life with Stem Cells* (2002), *Leather Landscape* (2003), and *The Young Family* (2002–3)—present a series of futuristic dioramas depicting lifelike sculptures of transgenic creatures. In keeping with the exhibition's titular conceit ("We Are Family"), each installation depicts some familial scenario revolving around children. *Game Boys Advanced* consists of two casually dressed Caucasian boys engrossed in a handheld video game, who, upon closer examination, turn out to be unnervingly prematurely aged clones. *Still Life with Stem Cells* features a young white girl amicably fondling animate puppy-sized lumps of flesh roughly the same color, pliability, and texture as her own.[9] *The Young Family* shows a nursing mother and four offspring of indeterminate species (porcine in posture and scale, human or simian in eyes and appendages) sprawling on a stylish Scandinavian bed frame. Finally, in *Leather Landscape*, shoebox-sized hybrid creatures—humanoid crossbreeds inspired by African meerkats and their young—take a variety of poses atop what looks to be a postmodern leather sectional-cum-playstructure, where one of the creatures appears to be engaged with an inquisitive human toddler dressed in pink overalls.

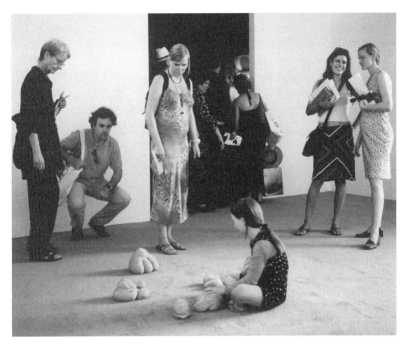

FIGURE 19. Patricia Piccinini, *Still Life with Stem Cells*, 2002. Silicone, acrylic, human hair, clothing, carpet. Installation view of spectators interacting with the artwork, including the lifelike sculpture of a seated Caucasian human girl in the center. Installation dimensions variable. Photographer: Graham Baring. Photograph courtesy of the artist.

The exhibition's hyperrealist sculptures have generated by far the most popular and scholarly interest. These objects are worth exploring in detail, especially since similar formal and thematic typologies—notably, what we might call the "adorable mutant infant" and "young humanoid children paired with displaced invented species" genres—continue to form a substantial part of Piccinini's practice.[10] The majority of the figures could be (and have been) described as endearingly monstrous. The sculptures' hyperrealism is enhanced through the use of mise-en-scène, life-size scale, genuine hair (from both animals and humans, although their application is not always species-specific), and realistic-looking flesh. (Piccinini creates the uncanny effect of lifelike skin by molding silicone over fiberglass frames.)[11] No detail is overlooked in the quest for verisimilitude: hair follicles, pores, wrinkles, and nails are so convincing that the spectator's experience might be compared to that of observing figures in a wax museum—where one knows one is in the company of faux beings yet may

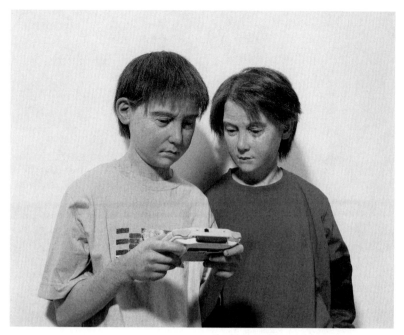

FIGURE 20. Patricia Piccinini, *Game Boys Advanced,* 2002, detail. Silicone, acrylic, human hair, clothing, handheld video game, life-size. 140 cm × 36 cm × 75 cm (55 × 14 × 29.5 inches) (irreg., life-size). This detail view highlights the premature aging of the boy clones depicted in Piccinini's hyperrealistic sculpture. Photographer: Graham Baring. Photograph courtesy of the artist. See also figure 2.

find oneself apologizing for backing into an inorganic starlet, Jedi, or ex-president just the same.

How do we classify the strange creatures that make their home in the Australian Pavilion? It is tempting to categorize them perfunctorily as either human or nonhuman. With the exception of the two homo sapiens girls, however, none appear to fit assuredly in those binary categories; indeed, one quickly gets the impression that this mixing of the human, animal, and technological is precisely the point. As Michael remarks of the interspecies activities staged in Piccinini's *Leather Landscape:* "The grouping conveys a sense of community, in which the child feels utterly at home. . . . Elsewhere a baby-sitter minds several children, enacting a role common for meerkats, whose community challenges our idea that the 'social contract' is intrinsically human. This new sculpture will assume a coincidence between the emotional and communal life of humans and animals."[12] The unusual creatures in *We Are Family* seem to trouble any secure distinction

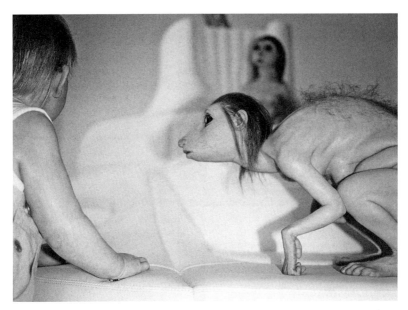

FIGURE 21. Patricia Piccinini, *Leather Landscape*, 2003, detail. Silicone, acrylic, leather, human hair, clothing, timber. 290 cm × 175 cm × 165 cm (114 × 69 × 65 inches) (irreg.). A synthetic human toddler engages with fanciful humanoid crossbreeds inspired by African meerkats and their young. Photograph courtesy of the artist. See also figure 2.

between natural and artificial creatures, and between sentient and non-sentient beings. My use of the word *beings* is deliberate; the lifelike yet discernibly nonliving sculptural entities in *We Are Family* tend to be experienced as responsive and feeling life forces owing to a range of biomorphic cues, from the obvious—eyes, limbs, flesh—to the implied—cell-like movement in *Plasmid Region*, puckered slits on the flesh lumps in *Still Life with Stem Cells*.[13] This curious implicit animism is significant because it solicits a haptic mode of viewing and contributes to the audience's self-conscious affective projections.

Piccinini's self-professed intention for *We Are Family* in many respects has produced the dominant critical response for the exhibition and much of her larger practice. It is therefore worth carefully examining Piccinini's numerous assertions about the works of art as family members. Her advocacy of the viewer's parental/familial affiliation with the eccentric techno-beings she creates is unambiguous. "There is a family inside the show," writes Piccinini, "[one] that includes us as well as these creatures that I present." On the way in which this pertains to how we should relate to

the various life forms generated through biotechnology and genetic engineering in everyday life, she ruminates: "If we are family, then how does that change our attitude, how does it determine our responsibility to the creatures we create?" Ultimately she concludes that "whether you like them or you don't like them, we actually have a duty to care. We created them, so we've got to look after them."[14] Piccinini indeed routinely describes her relationship to her work as an unyielding obligation between a creator and its offspring; for example, "I can honestly say that I love my family of works.... I find them beautiful rather than grotesque, miraculous rather than freakish; but I do fear for them in a world that I see as both extraordinary and deeply problematic."[15] Even Mary Shelley's infamous Dr. Frankenstein serves as a cautionary tale about caretaking and parental obligation. Piccinini writes: "Frankenstein's mistake is that . . . he does not take responsibility for his creation. Having brought his creature into the world he should also be liable for its life here." Dr. Frankenstein's flaw, concludes the artist, was his failure to be a "good parent."[16]

Expanding upon the family theme in a different context, Piccinini has written: "I would never create anything I didn't love," while conceding that loving the family thus produced is not necessarily without challenges. The artist's remarks about her *Siren Mole (SO2)* (2001), a fictitious animal intended to be a commentary on genetic engineering and specifically SO1 ("Synthetic Organism 1"—the world's first fully synthetic, bacteria-like organism), is a case in point.[17] She describes her platypus-esque sculpture as "an animal that needs to be looked after, an animal in fact that cries out to be protected."[18] Due to their maladapted bodies (heavy head, pale hairless skin, and short, frail limbs), these artificial animals are in danger from both predators and the elements; indeed, "their very existence is predicated on their symbiotic relationship with us" because these artificially engineered, "pre-domesticated" creatures simply cannot make it on their own.[19] Having brought them into the world, reasons Piccinini, "we" (presumably including the audience) are obliged to nurture, love, and parent them.

Critics, for their part, echo many of Piccinini's interpretive positions. Most writers describe the viewer's experience with the artist's experimental life forms in terms of kinship, care, and child-rearing. Juliana Engberg's description, for example, affirms the role of the viewer as a parental protector: "Empathy is enhanced by the fleetingness of these creatures, or their vulnerability to the elements. . . . [They] worry the maternal in us."[20] Helen McDonald expands this argument: "In Piccinini's art emotion inhabits the material, everyday world and is at its most beautiful and productive when urging care and responsibility for others." Like Piccinini, McDonald associates the viewer's experience with nothing less than an ethical obligation:

"[Piccinini's works] imply that the biggest challenge posed by life—for artists, scientists and other everyday citizens alike—is to care for children, nurture them, keep them safe, buffer them against unnecessary disappointment and love them in spite of their faults."[21] The persistent critical focus on human parenting and empathy is further reflected in the titles of exhibitions of Piccinini's work—*We Are Family* (2003), *(Tender) Creatures* (2007), *Hold Me Close to Your Heart* (2011), *Nearly Beloved* (2012), and the like.

It is important to recognize that even the journalistic or curatorial accounts that draw attention to the conflicted feelings viewers experience in the presence of Piccinini's unusual life forms tend to arrive at more or less the same conclusion regarding the viewer's alleged sense (or, better, *duty*) of familial care. For these critics, the viewer's initial feeling of disgust or nausea soon gives way to empathy and a sense of parental responsibility toward these life forms due to the creatures' purported cuteness and childlike vulnerability. A press release for the artist's *Relativity* exhibition (2010) puts it this way: "Often confronting yet endearingly vulnerable . . . [Piccinini's sculptures] assert the power of social relationships, love and communication."[22] Writing for Piccinini's *Hold Me Close to Your Heart* exhibition in 2011, curator Başak Doğa Temür confirms: "The strength of Piccinini's work evokes [a] tension through direct physical encounters as she brings the viewer face to face with hideous yet friendly creatures . . . the infant-like attributes of these creatures immediately evoke an inevitable sense of sympathy, care, affection, love and even an urge to cuddle and protect them."[23] Both authors contend that Piccinini's biomorphic creatures are indubitably grotesque and monstrous; at the same time, however, their infantile aspects are invoked to confirm their vulnerability and consequent lovability as our familiar and cuddly kin.

Theorizing the affective experience generated by Piccinini's practice in terms of instinctive sympathy for and guardianship of vulnerable progenies is undeniably compelling, particularly since the artist herself encourages it in her writing ("we have a duty to care") and through apparent formal cues (one need only think of the cherubic, bare-bottomed suckling mutants in *The Young Family*). In the next section, however, I will show how this seemingly agreeable interpretation willfully ignores certain qualities of the works in favor of others, thereby inhibiting appreciation of the radically estranging qualities of Piccinini's lively objects.

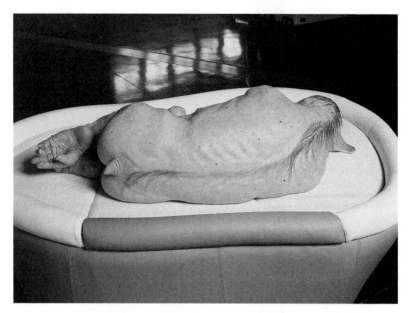

FIGURE 22. Patricia Piccinini, *The Young Family*, 2002–3, back detail. Silicone, acrylic, human hair, leather, timber. 80 cm × 150 cm × 110 cm (31.5 × 59 × 43.5 inches) (irreg.). Piccinini's mimetic bioart sculpture—shown frontally in figure 2—is perhaps less "cute" when seen from behind. Photographer: Graham Baring. Photograph courtesy of the artist.

Are We Family?

Careful visual analysis of the works of art in *We Are Family* reveals that many of the pieces are not quite as familiar, cute, or vulnerable as dominant critical frameworks have made them out to be. To this end, I would like to invite us to linger more productively on the awkward and uncomfortable spectatorial experiences some reviewers hurriedly classify as transitory disgust or nausea. Consider *The Young Family*. While the weary nursing mother is unabashedly likable when viewed from the front, the hybrid sow creature is much less sympathetic when viewed from the rear. From this hindmost vantage point—a point of view that reveals a horse-like mane on an abject naked body that culminates in a phallic stubbed tail and eerie monkey-paw appendages—the bioengineered figure is distinctly unsettling. Once displaced from the recognizable "patient mother" genre, it is no longer clear if one should feel threatened, pitying, or neutral toward this unknown life form.

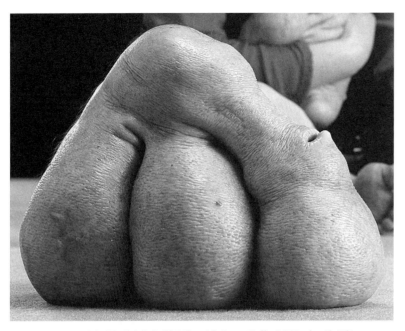

FIGURE 23. Patricia Piccinini, *Still Life with Stem Cells*, 2002, detail. Silicone, acrylic, human hair, clothing, carpet. Installation dimensions variable. Close-up view of the inert, yet seemingly animated flesh lumps shown in *Still Life with Stem Cells* (figure 19). Photographer: Graham Baring. Photograph courtesy of the artist.

Similarly, the ostensibly agreeable Play Doh–like lumps of animate flesh in *Still Life with Stem Cells* are distinctly odd when seen from up close. The title itself suggests a pun: Are these hunks of live flesh "still" (in the sense of being immobile), or are these abject lab creatures "still" (as in nevertheless) life forms meriting our attention and respect? The creatures' hairy moles, surface veins, and wrinkles are redolent of middle-aged Caucasian humanoid skin, which generates a jarring contrast with the smooth, untainted skin of the girl child cradling them. The flesh blobs' puckering body cavities—anus? mouth? gash?—further disarm the spectator in ways that complicate the dominant upbeat critical discourse. If the functional bodily cavities indicate that the flesh lumps are autonomous and ambulatory, however, do they in fact need us to care for them, as critics insist? Moreover, do "we" really make friends (family) with these strange mutant life forms as naturally and spontaneously as the artist's commentators suggest?

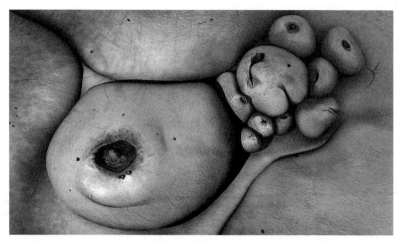

FIGURE 24. Patricia Piccinini, *Plasmid Region,* 2003. DVD PAL 16:9 with 5.2 surround sound, three-minute looped. Piccinini's video piece in *We Are Family* features disquieting moving images depicting what the artist describes as a "flesh factory." Photograph courtesy of the artist.

Linda Michael hints at the creatures' potential autonomy and lack of reciprocity in her catalog essay for *We Are Family* by identifying the possibility of a "disinterested sympathy" among viewers. Piccinini's creatures, she writes, "do not clamour for our attention—they are already in happy families. They are without the requisite 'aura of motherlessness, ostracism, and melancholy' that makes us want to 'adopt' (or more accurately, buy) consumer items." Tellingly, even despite the exhibition curator's perceptive observation, critics overwhelmingly humanize and infantilize Piccinini's creatures in their reviews of the exhibition.[24]

Plasmid Region, the exhibition's sole moving-image work, has a special place in this discussion. Despite the artist's commendation of the piece as "the heart of the show," the video is often skimmed over in reviews of the exhibition. (Revealingly, Piccinini's video works in general tend to receive cursory treatment.) *Plasmid Region,* in contrast to the at least superficially appealing and approachable nature of the other objects in the show, depicts recursive growth cycles of patently irregular, sporadically hairy, and veined tissues emitting from an unidentified pulsing organism.[25] Biomorphic fleshy orbs with uneven perforations churn at a lava-lamp form and tempo. The bulbous objects are roughly breastlike in form but their variations in scale and proliferation are doggedly perplexing. Their dark red interiors, sometimes exteriors, are suggestive of bloody wounds or growths

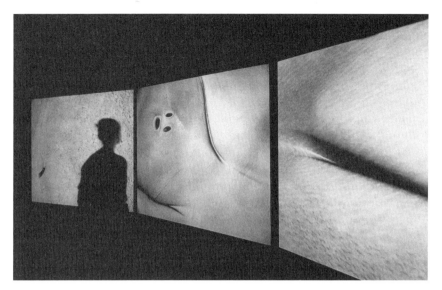

FIGURE 25. Patricia Piccinini, *The Breathing Room*, 2000. Three-channel video installation with sound. Dimensions variable. Like *Plasmid Region*, this room-sized video installation also features nonidentifiable yet evidently organic fleshy forms. Photograph courtesy of the artist.

of some kind. The title's reference to plasmids (small, circular, double-stranded DNA molecules that scientists use to clone, transfer, and manipulate genes) implies that one is looking at a kind of flesh factory, although its status as malignant or benign is pointedly unresolved.

Piccinini suggests that *Plasmid Region* represents biotechnological reproduction: "I was trying to join together biological reproduction with mechanical production, like a kind of production line that continuously pumps things out in a factory. In some ways, this symbolizes the fantasy of biotechnology, where the 'bio' and 'technology' become fused into an inseparable whole." She underlines that this mode of reproduction is characteristically uninhibited: "In some ways you might think that these floating blob things might go on to form the stem cell blobs in *Still Life with Stem Cells*, or even the helmets in *Team WAF (Precautions)*, as the forms are quite similar."[26]

Plasmid Region's interrogation of biotech fantasy is part of the artist's informal trilogy of video pieces featuring pulsing life forms—including *The Breathing Room* (2000), a video installation with a sound-active floor, and *When My Baby (When My Baby)* (2005), a single-channel projection. Stella

Brennan, one of few writers to evaluate Piccinini's videos in detail, nicely summarizes the key challenge of these works. On the topic of *When My Baby (When My Baby)*, she writes: "[The video] could be read as a portrait of another life form, of another way of being. Contrariwise, it could be seen as a play on our empathy towards objects with an approximately mammalian floorplan, on our need to make our technological products look back at us, on our wish to see Men in the Moon and faces on Mars."[27] Brennan insinuates two distinct interpretations: on the one hand, the work allows viewers to experience a novel life form. Conversely, the video reflexively draws the viewer's attention to an anthropocentric impulse: the desire to construe (and arguably domesticate) unfamiliar creatures in humancentric terms.

Borrowing from Brennan, we might bridge these two analyses. Works such as *Plasmid Region* are powerful precisely because they stage encounters with "other ways of being." Moreover, they do so in such a way as to highlight the audience's promiscuous teleologies: our desire to assign human attributes and meanings to nonhuman objects and things. Put differently, being in close proximity to the nameless, faceless beings in Piccinini's moving image works makes viewers hyperaware of precisely how different—how very *non*human—these other life forms actually are. If critics have skimmed over odd details of *We Are Family*'s hyperrealistic sculptures to arrive at relatively comfortable anthropomorphic readings of the three-dimensional works, the life forms in the stubbornly ambiguous *Plasmid Region* video prove less easy to construe as kin more or less in our own image.

Plasmid Region, by featuring organic nonhuman entities that are patently hard to look at, much less to turn into amiable relatives, helps us to identify what is really at stake in the viewer's experience with the various life forms assembled in *We Are Family.* Much like Piccinini's video, the hyperrealistic sculptures, too, offer encounters with untamable difference, inviting viewers to reflexively recognize that these entities cannot simply be reduced to human-centered interactions. The staying power of prevailing interpretations of parental obligation toward our cute (if grotesque) offspring thus requires further analysis.

In the next section we will consider what this feel-good emphasis might mean and what might it say about our ongoing boundary-mapping practices between human and nonhuman beings. Donna Haraway's description of the material-discursive production of knowledge is germane here. She writes: "Bodies as objects of knowledge are material-semiotic generative nodes. Their *boundaries* materialize in social interaction. . . . Siting (sighting) boundaries is a risky practice."[28] As we will see in what follows, Piccinini's

We Are Family and its critical reception not only exemplify how lively, productive, and unfixed matter can be but also underscore the promise in remapping established boundaries.

Unbecoming Humanism

On some level the unfortunate generalizations about Piccinini's practice can be attributed to hasty analysis, perhaps aided and abetted by the photo-centric dissemination and reception of art objects meant to be experienced firsthand. The challenges associated with the photo-mediated reception of material and experiential works of art are of course a challenge for all art criticism, particularly in the Internet era when JPEGs are routinely circulated to represent experiential works of art.[29] This issue bears special relevance, however, in cases where the critical discourse centers around issues of the spectator's immediate affective experience with purposefully mimetic and biomorphic objects (as is the case with Piccinini's practice). The limited and necessarily incomplete photographic representations of Piccinini's work undoubtedly have contributed to a critical discourse that largely ignores the very aspects of located, fleshly embodiment that generate the works' productive moments of discomfort and "bad" affect. What is unmistakable, however, is that even as these hybrid techno-beings fall outside of our familiar taxonomies, *We Are Family*'s interpreters work tirelessly to explain the artistic experience with the various "embryonic figures, babies, mothers and clones" in recognizable and nonmenacing terms. The insistence upon the vulnerability of the creatures and our need to take care of and/or parent them as family exposes a deep anthropocentric bias, a desire to remake everything in (hetero)normative human-centric terms, irrespective of competing evidence—transgenic markings, alien body parts, indecipherable countenances, and the like.

In contrast to dominant critiques, Haraway has cogently argued that Piccinini's works such as *Bodyguards / Nature's Little Helpers* (2004) exceed heteronormative concerns insofar as they provoke the question of care for intra- and interacting generations beyond mere reproduction. We will return to this proposition shortly.[30] For now, however, the apparent and unqualified promotion of the heterosexual nuclear family and humanist logic in the critical and popular reception of *We Are Family* merits careful scrutiny. However well intentioned, the prevailing interpretive framework not only conceptualizes these entanglements of human and nonhuman entities within the well-known confines of the heterosexual nuclear family, it also betrays a paternalistic and primitivizing impulse vis-à-vis the Other: Piccinini's anatomical pariahs are unintimidating if—and only if—they

are experienced as obvious subordinates. ("We" must take care of "child-like" others.)

Daniel Harris offers an explanation for the potential attraction of the "cutely grotesque" aesthetic in his *Cute, Quaint, Hungry, and Romantic: The Aesthetics of Consumerism*. He writes: "The grotesque is cute because the grotesque is pitiable . . . the aesthetic of cuteness creates a class of outcasts and mutants, a ready-made race of lovable inferiors."[31] Harris goes on to link this impulse to a seductive consumerism. The sanguine focus on cuteness and sentimentality in the discourse surrounding Piccinini's oeuvre has implications even beyond commercial viability in the art world, however. At a time when biotech stands to make a profit off of all that lives, and life itself is computable and malleable in dazzling and dizzying ways, the significance of the fact that Piccinini's radically different creatures are consistently described as nonthreatening, infantile, and controllable should not be discounted.

The prevailing critical reception of Piccinini's practice has effectively obscured other pressing ethical and political questions about biotech's promissory rhetoric of endless progress, enhancement, and empowerment of the human being via science by speculating almost entirely about the affirmative familial quality of our relationships to its ostensibly cutely grotesque mishaps.[32] Helen McDonald's optimistic description is exemplary: "Piccinini's art is infused with hope that these kinship ties and her affectionate characterizations will engender a sense of responsibility in today's technological world."[33] The critical propensity to understand the artworks as cute and sentimental (as "affectionate characterizations") promotes a reassuring illusion of the human subject's mastery and agency ("responsibility in today's technological world") that obscures the political and social challenges associated with developing commercial products made from biological systems. The sentimental critical focus on the alleged "cuteness" of biotech's incongruous yet inevitable accidents (asking us to say "aaawww" instead of "aaahhh!," as it were) furthers the illusion of human exceptionalism, agency, and control that the contemporary technosciences otherwise undermine.[34]

At the most fundamental level, then, the impulse among Piccinini's commentators to subordinate and sentimentalize the nonhuman creatures in *We Are Family* suggests an unintentional reappearance of a traditional humanism. This return is unfortunate because it neutralizes the potentially destabilizing difference of the otherwise enigmatic biotech bodies populating her practice by conceptualizing them in relation to a universal and all-powerful human subject. As Haraway has skillfully declared: "The discursive tie between the colonized, the enslaved, the noncitizen, and the

animal—all reduced to type, all Others to rational man, and all essential to his bright constitution—is the heart of racism and flourishes, lethally, in the entrails of humanism."[35] It is interesting to reconsider curator Michael's claims for *We Are Family* with this observation in mind. According to Michael, Piccinini's works urge us to consider the "coincidence between the emotional and communal life of humans and animals."[36] Following Haraway, the seemingly progressive idea of treating other species as our kin by extending *human* rights to them could also be interpreted as yet another infelicitous endorsement of human exceptionalism—a rather disingenuous attempt to detect a shared *humanity* uniting divergent species. After all, the often-cited quality of empathy is a *human* ethical value and not necessarily a universal, transspecies one.[37]

As we have seen, understanding Piccinini's work in the anthropocentric terms of sympathetic bonding and familial obligation portends a reactionary return to the surety of human power and distinctiveness. More to the concern of the present argument, however, is the way in which this unintentional critical prejudice also misrepresents the potentially disruptive nature of the critical proximity otherwise promoted and performed by Piccinini's work. While Piccinini's commentators are correct to emphasize the viewer's highly affective experience with these different species and life forms, and to discern an implicit model of care, the supposedly inescapable reactions of parental nurturing and bonding are in fact premised upon discursively fixing the creatures within stabilized and anthropocentric frames of reference. Examining the art objects up close and with renewed attention to disruptive moments of negative affect instead exposes the discrete and perhaps even unknowable identities of *We Are Family*'s bioart objects.

Uneasy Nature (or, Toward a Postanthropocentric Posthumanism)

The viewer's experience with Piccinini's nonhuman life forms can be understood constructively as a relationship based *not* on the objects' endearing humanoid infantile qualities but, rather, on their inexhaustible otherness. Appreciating the ways in which our experiences with Piccinini's creatures fall outside of familiar and recognizable categorizations is transformative because it destabilizes the traditional centrality of the human subject. In so doing, it allows us to appreciate how the bioart works in *We Are Family* do indeed solicit a relationship based on a sense of affinity, but a sense of affinity that operates along nonanthropomorphic lines. Instead of merely encouraging us to remake others as ourselves (as prevailing accounts imply), these works of art urge us to understand human and

nonhuman beings as qualitatively different and yet profoundly entwined and coconstituted.

Haraway's observation about the philosophical challenges these novel human–nonhuman interfaces propagate is apposite: "To care is wet, emotional, messy, and demanding of the best thinking one has ever done."[38] Rosi Braidotti offers one such response in defining what she calls postanthropocentric posthumanism. In *The Posthuman,* Braidotti designates this approach as "post-anthropocentric" in that it takes nonhuman "organic others" seriously, and "post-humanist" in that it eschews the erroneous sense of cognitive self-mastery associated with traditional humanism in favor of appreciating and celebrating our flexible and multiple contemporary identities. Posthumanism should not be confused with *anti*humanism, however. Braidotti is at pains to explain how this radical feminist project is by no means groundless or without an ethics: "To be posthuman does not mean to be indifferent to the humans, or to be de-humanized. On the contrary, it rather implies a new way of combining ethical values with the well-being of an enlarged sense of community, which includes one's territorial or environmental inter-connections."[39] Postanthropocentric posthumanism, then, celebrates the affirmative connections between human subjects and multiple, unfamiliar (unfamilial) others. It rejects the idea of a universal normative human subject and autonomous subjective agency, but rejoices in the humanities and the cultivation of human ethics committed to expansive definitions of community and concern.

It is here that Piccinini's art practice may serve as a potential bridge: a practical, material manifestation of the speculative projects outlined by feminist theorists such as Braidotti. When seen in their full potential, the lively objects assembled in *We Are Family* direct attention to a mode of subjectivity that eschews humanist self-centered mastery while affirming nonhuman organic others—transmuted pigs, elderly children, ambulatory tumors—in all their destabilizing difference. This openness toward alterity is profound because it occurs despite any actual shared social identity, morality, or species, and despite (indeed, perhaps even because of) transient moments of negative affect. Nicole Seymour's delineation of a queer ecological ethic of care gets to the heart of the matter. The care in question for Seymour brings us full circle to Haraway's astute identification of an intra- and interacting generational model of care in Piccinini's work. It is "a care not rooted in stable or essentialized identity categories, a care that is not just a means of solving human-specific problems, a care that does not operate out of expectation for recompense."[40] Although written in a different context, Petra Lange-Berndt suitably encapsulates the transformative potential of this postanthropocentric posthuman ethic. She writes:

"If the knowing self is partial, never finished and whole, it can join with another, to see together without claiming to be another. Phenomenology insists on a macroscopic, anthropomorphic view, while to be complicit with the material means, above all, to acknowledge the non-human."[41] As we have seen, the spectator's experience with the dynamic bioart objects in *We Are Family,* upon closer inspection, does not necessarily align with the dominant interpretations; far from soliciting an anthropocentric parenting of cute inferior beings, these works of art generate an artistic experience that provocatively enacts precisely the nonhierarchical material-relational complicity with nonhuman others outlined by Braidotti, Haraway, Seymour, and others.

In conclusion, while *We Are Family* has provided our central case study thus far, it is interesting to note that the model of artistic experience as a nonessentialized nonhuman-subject–centered ethic of care can profitably be discerned in aspects of Piccinini's production beyond her 2003 exhibition. Indeed, one of the artist's early works, *Protein Lattice—Subset Red, Portrait* (1997), is especially instructive in this regard and links Piccinini's aspiration to that of many of the other feminist new materialisms explored throughout this book. The photograph presents a truly exceptional vision of what Braidotti's proposal for a postanthropocentric posthumanism might look like on an applied basis. Two highly groomed, fleshy, and exotic others are on display—a fashion model and a synthetic rat inspired by the famous Vacanti mouse (a laboratory animal with what looks like a human ear grown on its back)—with no clear hierarchy between human and nonhuman.[42] Practiced models, they gaze laconically in opposite directions. Neither creature looks dismayed or even particularly surprised to be together. We do not know who the star is, or who serves as the pedestal for whom. Indeed, there is a suggestive visual interpenetration between their forms. The fleshy, almond-shaped ear perched on the rat's back echoes the woman's mouth, eyes, shoulder, and breast. The woman's eye shadow is fur-colored and her entire eye from brow to lower lids is rodent-shaped. The two primary orifices (her mouth, its ear) are so near to one another and so similar in shape that they seem almost ready to merge or embrace. The hairless animal conceivably could have grown out of the model's shoulder or been affixed there through some fleshy interface.[43]

In assessing this photograph, the quintessential anthropocentrism of rat experimentation for human beauty products or organ harvesting (in the form of the presumably human ear on the rodent's back) immediately springs to mind. Indeed, this image has frequently been mobilized in the service of articles on both topics. Upon further analysis, however, the relative agency of each subject is less clear. The woman's hand appears almost clawlike due

FIGURE 26. Patricia Piccinini, *Subset Red (Portrait)*, 1997. From the series *Protein Lattice*, Type C photograph. 80 cm × 80 cm (31.5 × 31.5 inches). This photographic pairing of human and nonhuman features a fashion model and a synthetic rat inspired by the famous Vacanti mouse (a laboratory animal with what looks like a human ear grown on its back). Photograph courtesy of the artist.

to the suggestive proximity of the animal. Human fingernails are rendered alien, and wrist wrinkles rodent-like. One of the model's fingers could easily be construed as part of the rat. (The prospect is not so outlandish if one considers that the rodent has already acquired a human ear.) It is equally conceivable that the human life form could be growing parts for the rat's benefit (some tiny rat feet between the fingers of her hand, perhaps?). Appropriating Braidotti's vocabulary, we might identify the animal–human interaction depicted in *Protein Lattice* as an ethical relation based on positive grounds of "joint projects and activities."[44] While viewers cannot

know for sure what "joint project" the duo might be undertaking, they can readily recognize their alliance and mutual care. Rather than offering spectators a reassuring illusion of mastery based on a heteronormative familial bond, the photograph affirms how human subjects are coconstituted with the inassimilable difference of nonhuman others (cute, rodent-like, or otherwise).

As we have seen through detailed analysis of artworks ranging from the *Protein Lattice* photograph to the multimedia objects assembled in *We Are Family*, Piccinini's practice offers a critical perspective that has long gone unrecognized. Piccinini's nonhuman life forms are *not* simply family: instead of merely promoting parental affection in viewers, her work models a form of ethical relation in which care or a sense of entangled responsibility need not be based on anthropocentric or even biological frameworks. In this way, it may offer a practical model for conceptualizing the ethics of contemporary human–nonhuman relations, both within the institutional context of the visual arts and beyond. "Ethics," clarifies Karen Barad, "[is] not about right responses to a radically exteriorized other, but about responsibility and accountability for the lively relationalities of becoming, of which we are a part. Ethics is about mattering, about taking account of the entangled materializations of which we are part, including new configurations, new subjectivities, new possibilities."[45] Piccinini's work promotes an ethic of care stripped of human exceptionalism and standardized identities, dissociated from traditionally humanist and anthropocentric demands for reciprocity or guarantees of success; instead, it acknowledges, preserves, and affirms boundless difference and collaborative exchanges within context. To encounter these works of art in their fullness is to come face-to-face with the inexhaustible, nonreciprocal otherness of nonhuman technological beings, and, crucially, to care for them all the same.

The transdisciplinary significance of Piccinini's bioart practice—its performance of new configurations, new subjectivities, new possibilities—is suggestive of similar critical potential in the other new media art practices explored in this book. Chapter 5 focuses on the Japanese artist Mariko Mori's interest in contemporary brain science and neuroimaging as it intersects with current discussions about the much-debated neuroscientific turn across the arts and humanities. Taking the artist's brainwave interface and multimedia installation *Wave UFO* (1999–2003) as our principal case study, we will see how experiential art environments such as Mori's propose further "new possibilities": these speculative artistic formations complicate and augment brain science research as well as its dissemination into other social and cultural arenas.

Mind over Matter

Mariko Mori, Art History, and the Neuroscientific Turn

> The material plane of forces, energies, and effects that art requires
> in order to create moments of sensation that are artworks are
> shared in common with science. Science, like art, plunges itself into
> the materiality of the universe.
>
> —ELIZABETH GROSZ, *CHAOS, TERRITORY, ART*

Since approximately 1995, the artistic production of the Japanese artist Mariko Mori (b. 1967) has been closely engaged with emerging issues in technoscience and theories of consciousness. This interest has been reinforced by selective experimentation with advanced technologies: her multimedia projects have incorporated high-tech tools ranging from 3D video to fiber optics, neutrino data-tracking equipment (neutrinos are a form of invisible dark matter generated by supernovas), and brainwave visualization tools.[1] This chapter explores Mori's interest in contemporary brain science and neuroimaging as it intersects with current debates about the much-contested "neuroscientific turn" across the humanities. I propose that one artwork in particular, Mori's brainwave interface and multimedia installation *Wave UFO* (1999–2003), offers an ideal entry point for interrogating the emerging nexus of art, art history, and neuroscience. This work is of primary importance because it is here that the artist's intervention into critical discourses surrounding the brain sciences shifts from being implicit—endorsing the idea of human experience as networked and irreducible—to explicit—creatively exploiting brain-imaging technologies themselves in an experiential work of art.

This chapter is framed around two interrelated questions: What might a productive interchange between neuroscience and a traditionally humanist

field, such as art history, look like? How might an art practice such as Mori's inform this discussion? First, I offer a detailed analysis of the neuroscientific turn in art history and the broader humanities and examine the surrounding controversy. I identify certain problematic tendencies associated with the neuroscientific turn, including mechanistic and deterministic materialist explanations of human consciousness that unintentionally reinscribe mind–body dualisms. I argue that humanists must be careful to avoid this type of scientific determinism. At the same time, however, I also emphasize that discoveries in the contemporary neurosciences have a potentially catalytic role for humanistic research and should not be excluded from art historical inquiry as some "neuroskeptics" suggest.

In the chapter's second section, I argue that works of art critically engaged with the brain sciences and their critical reception, such as *Wave UFO*, may model a viable interdisciplinary approach to considering questions of aesthetics, perception, and the brain. Through a detailed case study of Mori's experiential multimedia installation, I show how the artist strategically deploys brainwave-measuring technology in order to productively challenge mainstream perceptions about the technology and indeed about neuroscience itself. *Wave UFO* stages how subjectivity is a complex negotiation across the natural and the cultural that, contrary to pervasive misunderstandings, cannot be reduced to neural activity. Mori's installation affirms that human cognition is always embodied and, moreover, that the sites of embodiment are dispersed across biological, social, and cultural registers.

I conclude that Mori's *Wave UFO* offers two primary contributions to present-day research on human consciousness and subjectivity. First, like many of the other material feminisms introduced throughout this book, feminist critiques of technoscience in particular, the work helps illuminate the risks associated with reductivist approaches to matter—the brain's gray matter or otherwise. As we shall see in what follows, the viewer's experience with *Wave UFO* indicates that we are more than our brains; human experience is materially embodied, but the "body" itself is interwoven and distributed across biological, ecological, phenomenological, social, and cultural planes. Second, Mori's multimedia environment models the forward-thinking interdisciplinarity required to approach the urgent sociopolitical issues regarding the role of the natural world that animates much contemporary scholarship. For neuroscience, this means taking seriously the philosophical and material insights of the arts and humanities. For art and art history, this means being informed by, yet not overdetermined by, relevant discoveries in the brain sciences.

Assessing the Neuroscientific Turn

To appreciate the contributions of Mori's creative engagement with the brain sciences and scientific imaging technologies, it is important to begin with a detailed introduction to the neuroscientific turn as it has emerged in the humanities and social sciences since the 1990s.[2] Mori's stated ambition for *Wave UFO* hints at the chapter's eventual payoff: "I hoped that if someone entered *Wave UFO* expecting to see interwoven layers of consciousness, they would be able to perceive them in this visual sequence. We [normally] may not be able to see them visually, but life is evidence of the multidimensional connection of all things."[3] In this section, my aim is to take the cues of the best of the neuroscientific trend in art history and criticism while rejecting its false starts; the next section, instead, will be devoted to demonstrating Mori's productive engagement with both.

While the methodological turn toward the brain sciences has been exciting and generative for humanists in multiple ways, particularly as it has inspired greater self-reflexivity about research methods, it has also inspired some misguided critical approaches and contributed to the reinstatement of problematic hierarchies. Perhaps unsurprisingly, the increasing influence of neuroscience on philosophical explorations conventionally associated with the humanities is a contentious issue. This is especially true in the case of research bridging the humanities and the brain sciences on topics such as aesthetic experience, creativity, and human consciousness. While some champion such studies as providing unparalleled opportunities for understanding unresolved mysteries of the mind, others accuse them of being reductionist and essentialist, if not of outright mishandling insights garnered from other disciplines.[4]

Findings in neuroscience have motivated cultural theorists to rethink the complex interplay between the cultural and the natural with renewed emphasis on the formative role of the natural world, including human bodies and brains. In "Literature and the Cognitive Revolution," for example, literary critics Alan Richardson and Francis Steen affirm the pertinence of biological/neurological information to conventionally humanistic pursuits such as literary analysis: "To construct culture, human beings intimately rely on immensely complex bodies, nervous systems, and sensory systems; these structures have a history that is neither identical to nor separate from the culture they make possible."[5] The pair goes on to argue convincingly that the dominant critical methods of the past fifty years for assessing art and culture often overprivilege the cultural at the expense of the natural. The critics cite approvingly works of cognitive literature criticism that approach their subject at the level of the species, for example, those that evaluate the

brain's capacity for literary conventions such as figurative thought, creative leaps, and fictional representation.

Religious studies scholar Edward Slingerland's research in cognitive neuroscience has led him to critique dominant methods in his field and to propose a theoretical model capable of exceeding arguments in favor of the body–mind dualism. He describes the revisionist charge for humanists even more starkly than Richardson and Steen: "Human-level structures of meaning should not be seen as possessing special ontological status," insists Slingerland, "but rather must be understood as grounded in the lower levels of meaning studied by the natural sciences, instead of hovering magically above them."[6] Attempting to theorize a tenable methodology, he urges cultural scholars to "get beyond the unhelpful, and intellectually paralyzing, social constructivist dogma that continues to inform most of the work in [the] field" and to cultivate a kind of "dual consciousness"—the ability to understand human beings simultaneously as physical systems *and* as persons.[7] Despite the disciplinary-specific nature of these critiques, Slingerland's argument, like Richardson and Steen's, fittingly signals two prominent trends in the humanities: (1) an unequivocal shift away from postmodern and poststructuralist thought, which, as we have seen in previous chapters, has been criticized for foregrounding the social and linguistic construction of meaning at the expense of the biological; and (2) a widespread reorganization of the contemporary critical landscape in light of new ways of thinking about biological and material actors.

In the specific case of art history, the nascent but growing interest in the brain sciences has played out primarily around current research on aesthetics, perception, and the brain. In recent years, environmental biologists and cognitive scientists have discovered what appear to be "law-like" aspects to artistic experience and viewing habits—from the purportedly universal preference for particular landscapes (open, savannah-like environments are apparently the key), to the cross-cultural fascination with the exercise of artistic virtuosity.[8] Working under the banner of "neuroaesthetics," scientists such as Vittorio Gallese, Vilayanur Ramachandran, and Semir Zeki have investigated the neural underpinnings of such phenomena (for instance, exploring the neural mechanisms underlying empathy) and speculated as to their sociocultural relevance.

Art historians like Barbara Stafford, David Freedberg, and John Onians are part of a growing trend of humanist researchers engaging current scientific research on artistic perception and the brain. Stafford's *Echo Objects: The Cognitive Work of Images* (2007) was among the first monographs to urge scholars of visual culture to confront the brain's material realities in the analysis of cultural objects (significantly, Stafford's book

calls for a reciprocal exchange between humanists and scientists in such endeavors).[9] Freedberg investigates the neurobiological underpinnings of visual perception to slightly different ends; the art historian turns to the discovery of mirroring mechanisms (our ability to show similar patterns of neural activity when observing the actions of others as we would during a mirrored action) and embodied simulation (our ability to co-enact the bodily actions of others without acting in actuality) to explain empathetic responses to images in general, and to works of visual art in particular.[10] Onians, for his part, goes so far as to contend that understanding the neural basis of the mind is essential to understanding the nature of art; his "neuroarthistory" promises to rewrite the history of art along those lines: a 2007 essay, for instance, puts forth a neurobiological, quasi-evolutionary explanation for the origins of representation in Paleolithic art.[11]

Despite the promise of transdisciplinary research in the new neurodisciplines (neuroliterary criticism, neuroaesthetics, and neuroarthistory among them), critics have been quick to distinguish the striking methodological deficiencies of many texts. The neuroskeptics/neurodoubters focus primarily on two interrelated problems: on the one hand, a reification of science and a corresponding overreach in scholarly claims (in the case of neuroarthistory, artist and art historian Julian Bell, for example, charges that "the term 'neural' is being used as scientific window-dressing for resoundingly non-scientific speculation"[12]), and, on the other hand, accusations of reductionist tendencies in neuroscience itself (on the topic of neuroaesthetics, philosopher Alva Noë bemoans the lack of sustained engagement with actual art. He quips: "We find *not* that neuroaesthetics takes aim at our target and misses, but that it fails even to bring the target into focus"[13]). Jenell Johnson and Melissa Littlefield contend that writers in the neurodisciplines stemming from humanistic disciplines such as art history tend to defer to neuroscience as a definitive approach, and to marshal frequently decontextualized neuroscientific findings as indisputable objective evidence for otherwise subjective arguments as well as for arguments that often are not in fact new, yet are still presented as in some sense revelatory.[14]

These admonitions are apposite. I agree in principle with critiques of the reductionist deference to (neuro)science in recent scholarship. Humanities scholars are correct to be vigilant against unwittingly reinforcing a hierarchical divide between the humanities and the sciences and to guard against the naturalistic fallacy, "the mistake of identifying that which is natural with that which is right or good (or, more broadly, the mistake of identifying moral properties with natural properties)."[15] That said, critics of the humanities-based neurodisciplines such as neuroarthistory tend to overlook two important points. First, rethinking the material and natural

world in light of its recent articulations in the sciences, including the brain sciences, might productively extend and complicate research methodologies in the humanities at a time when once-dominant social constructionist models of criticism appear insufficient. As aptly articulated by Diana Coole and Samantha Frost in the introduction to their *New Materialisms,* social constructionist critical frameworks seem inadequate at a time when "foregrounding material factors and reconfiguring our very understanding of matter are prerequisites for any plausible account of coexistence and its conditions in the twenty-first century."[16] Humanists committed to accounting for the lived experience of human bodies as they interact with other material forces—with the environment, with socioeconomic structures, with technological conditions, and with other bodies—might find promising new avenues of research through critical engagement with conventionally nonhumanistic disciplines such as neuroscience. Indeed, as we will see in what follows, Mori's *Wave UFO* suggestively intimates this type of interdisciplinary approach.

The second issue that tends to go unrecognized by neuroskeptics is that critiques of reductionism or essentialism in neuroscientific studies do not necessarily expose a failure of scientific models as much as a miscommunication or misapplication of key insights. This problem is compounded by the fact that many writers in the neurodisciplines rely on popular writing about neuroscience, whether written by scientists targeting a generalist audience or by science reporters, as foundational literature. In dramatic contrast to peer-reviewed scholarly neuroscientific writing, popular neuroscientific accounts, by virtue of their intended audience, often stretch well beyond empirically validated claims and engage in considerable speculation. Meanwhile, scientists themselves have cautioned that biological and psychological factors are insufficient to effectively explain human experience or consciousness; many scientists (although by no means all) take for granted that cognitive processes "criss-cross the conventional boundaries of skin and skull."[17] In a 2005 article published in *Nature Reviews Neuroscience,* for example, a team of cognitive and behavioral neuroscientists argues for the relevance of the physical/biological *and* the cultural in designing appropriate research methods for the study of human cognition; in other words, even if certain aspects appear to be "hardwired," actual cognition depends strongly on situational and cultural context.[18]

While I do not want to discount fine-grained disagreements about the exact relationship between the biological and sociocultural or the explanatory limits of particular methodologies, it is worth emphasizing that blanket criticisms of neuroscientific reductionism are in themselves reductionist.[19] Louise Whiteley succinctly identifies this problem in relationship

to the critical discourse surrounding neuroimaging. "A risk with rhetorically powerful polemics against reductionism is that they fail to examine what it might look like for neuroscience to inform or engage rather than simply dictate moral and legal responsibility. This risks alienating those invested in neuroscientific research, many of whom have an acute awareness of the limits of their techniques, and also risks missing potentially productive refigurings of the relationship between neuroimaging and the topics it purports to inform."[20] In sum, allegations of unchecked reductionism among brain scientists may consequently reveal less about the methodological biases of brain science researchers *tout court* then about the mismanaged ways scientific data sometimes are disseminated.

Widespread misconceptions about the capacities of neuroimaging in general, and fMRI (functional magnetic resonance imaging) in particular, offer a case in point. The peculiarities of brain-imaging technologies such as fMRI merit detailed explanation because they are central to Mori's *Wave UFO*. Although Mori's multimedia installation employs EEG (electroencephalogram) technology rather than fMRI (EEG measures the brain's electrical activity directly; fMRI records changes in blood flow, which is an indirect marker of brain electrical activity), she does so in the interest of disputing popular misconceptions about *all* brain-measuring techniques—fMRI the most prominent among them. The two technologies in fact are often considered jointly, particularly as they are used side by side in some clinical and research applications. More to the point, in terms of popular reception, the two techniques tend to be subsumed into the widespread cultural fascination with neuroscientific explanations of experience, especially as related to behavior.[21]

As Mori will indeed demonstrate, it is crucial to recognize that brain scanners are not literal windows onto brain activity. As important as the fMRI technique has been in advancing our understanding of the functional architecture of the brain, when presented out of context to nonspecialists, the potent brain scan images used to visualize the data collected by an MRI machine can contribute to the mistaken belief that fMRI enables scientists to capture visual proof of brain activity. We are all familiar with the brightly colored graphics representing fMRI results from subjects performing particular tasks or experiencing particular emotions. The technical and methodological shortcomings of fMRI and the challenges associated with how these images enter the public domain are often less apparent. Rather than offering glimpses of thoughts in action, fMRI technology monitors changes in blood oxygenation levels in response to a given stimulus as a rough correlate for changes in neural activity. (Active brain cells consume more energy and oxygen, which triggers the rush of blood.) In

other words, the colors indicate statistical tests rather than absolute levels of brain activity. Further, much more of the brain is already active or lit up at any given time—all that can be observed is the additional activity associated with the stimulus or thought. Cultural critic and scientist Raymond Tallis adeptly explains the fallacy associated with images purporting to document which areas of the brain light up in any particular scenario, especially those associated with traditionally humanistic research topics of affect and emotion. "The experiments look at the response to very simple stimuli—for example, a picture of the face of a loved one compared with that of the face of one who is not loved. But, as I have pointed out elsewhere (for the benefit of Martians), romantic love is not like a response to a stimulus. It is not even a single enduring state, like being cold. It encompasses many things, including not feeling in love at that moment; hunger, indifference, delight; wanting to be kind, wanting to impress; worrying over the logistics of meetings; lust, awe, surprise; imagining conversations, events; speculating what the loved one is doing when one is not there; and so on."[22]

In "fMRI in the Public Eye," scientist Eric Racine and his colleagues identify the conceptual and methodological limits of using neuroimaging data in accounting for concepts such as human subjectivity or consciousness as a problem of "neuroessentialism": the presentation or interpretation of brain-imaging research in such a way as to inaccurately equate subjectivity and personal identity to the brain.[23] (For example, the mistaken belief that one can see compassion "light up" with fMRI leads to the erroneous conclusion that compassion must be entirely contained within the brain.) The hasty reduction of subjective identity to the brain often constitutes a methodological stumbling block for researchers at the intersection of the humanities and brain sciences because it facilitates the unfounded notion that neuroimaging technologies are independently equipped to answer complex questions about behavior, emotion, taste, and perception. While this reductionist approach still characterizes some sectors of the brain sciences, many neuroscientists routinely discredit it.[24] As elaborated by neuroscientist Susan Fitzpatrick, the current fascination with neuroimaging among nonspecialists "may arise from views about the capabilities of fMRI, or for that matter how the brain works, that may be more in line with portrayals for popular consumption rather than with the more limited uses dictated by the constraints of neuroscience, experimental cognitive psychology, physics, and imaging statistics."[25]

The remainder of this chapter will be devoted to Mori's targeted artistic engagement with neuroimaging and its cultural reception. Thus far, we have seen how the recent neuroscientific turn in the humanities has forged

a contested terrain that, while risking an essentializing treatment of both fields, also offers the possibility of complicating research methodologies and creating fresh interdisciplinary approaches to interpretation. While art historians have begun to explore the neuroscience of perception (i.e., analyses of the neuroaesthetic bases for the construction and appreciation of images), other important questions—such as evaluating how works of art may themselves complicate and augment brain-science research as well as its dissemination into other social and cultural arenas—remain underexplored. In the following section, we explore the ways in which Mori's *Wave UFO* addresses the field of neuroscience through explicit engagement with neuroimaging in both form and content. In so doing, Mori offers a practical and inventive critique of widespread misunderstandings associated with brain measuring and imaging as well as the related problems of neuroessentialism and scientific reductionism that continue to plague certain sectors of research in the humanities-based neurodisciplines.

Wave UFO and the Matter of Experience

Mori's multimedia environment and brainwave interface, *Wave UFO,* consists of a room-sized 493 cm × 1,134 cm × 528 cm (194 × 446.5 × 208 inches) structure housing a computer system, brainwave visualization apparatus, spherical Vision Dome screen, projector, and seating for three visitors/participants.[26] An additional computing station, tucked discretely behind the main structure, houses a technician responsible for overseeing the multifaceted computing operations. At first glance, Mori's gleaming engineering marvel appears to be armed with an impenetrable shell.[27] Upon closer inspection, however, the teardrop-shaped aluminum structure proves to be profoundly enveloping and receptive: for example, it admits and discharges a fluctuating stream of visitors; its holographic veneer changes constantly in response to nearby lighting; and the interior seating is composed of Technogel—a viscous, fleshy-feeling substance that cradles recumbent viewers in the capsule's center.

Three viewers at a time are invited to ascend eight steps to board the pod, whereupon attendants in white smocks settle them into a reclining position beneath the Vision Dome screen and outfit their foreheads with EEG electrodes. Once electronically enmeshed inside the Technogel womb, viewers experience a two-part series of moving images projected onto the hemispherical overhead screen. Part 1 consists of real-time imagery representing the three participants' brainwave activity. This is made possible by Mori's creative use of EEG technology. Electrode headsets record the electrical signals on each individual's scalp, which reflect the activity of

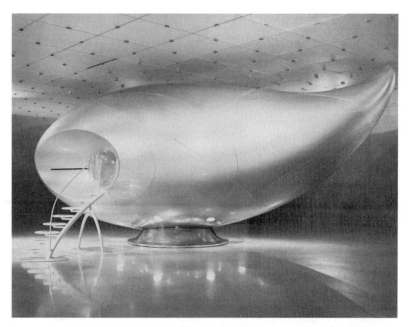

FIGURE 27. Mariko Mori, *Wave UFO*, 1999–2003. Brainwave interface, Vison Dome projector, computer system, fiberglass, Technogel, acrylic, carbon fiber, aluminum, magnesium. 493 cm × 1,134 cm × 528 cm (194 × 446.5 × 208 inches). The UFO-like structure houses a computer system, brainwave visualization apparatus, spherical Vision Dome screen, projector, and seating for three visitors/participants. Courtesy of Shiraishi Contemporary Art, Inc., Tokyo, Deitch Projects, New York. Artwork copyright Mariko Mori 2009 and photo copyright Richard Learoyd. All rights reserved. Photo courtesy of Mariko Mori / Art Resource, New York. Copyright 2016 Mariko Mori, Member Artists Rights Society (ARS), New York.

populations of neurons within the brain. The EEG data are delivered to visualization software designed by Mori's collaborator, engineer Masahiro Kahata. The purpose-made software instantaneously translates the otherwise relatively tedious EEG data into lyrical moving images intended to represent each participant's neural activity.

The visual data are organized into three interlocking rings. Quivering yellow lines on the outermost level denote eye and facial movements. Each of six pulsating egg-shaped objects in the second level symbolizes the left- or right-brain activity of each of the three viewers, as recorded by the electrodes. Each color signifies a distinct neural state. Blue Alpha waves indicate wakeful relaxation, pink Beta waves indicate alertness or agitation, and yellow Theta waves indicate a dreamlike state. These colorful moving

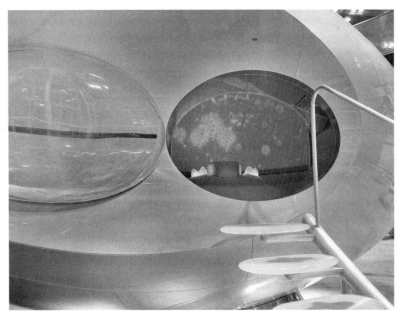

FIGURE 28. Mariko Mori, *Wave UFO*, 1999–2003, detail. Brainwave interface, Vison Dome projector, computer system, fiberglass, Technogel, acrylic, carbon fiber, aluminum, magnesium. 493 cm × 1,134 cm × 528 cm (194 × 446.5 × 208 inches). This view shows the steps leading up to the "UFO's" entrance and offers a glimpse of the interior projected images beyond the transparent, capsule-like door. Courtesy of Shiraishi Contemporary Art, Inc., Tokyo, Deitch Projects, New York. Artwork copyright Mariko Mori 2009. All rights reserved. Photo courtesy of Mariko Mori / Art Resource, New York. Copyright 2016 Mariko Mori, Member Artists Rights Society (ARS), New York.

images on the screen affect the ongoing brain activity of the participants in turn, creating a neurofeedback loop that allows them to see an evocative, and, crucially, highly mediated, translation of their brainwaves in action. Small twin silver balls at the innermost band reveal the degree to which each individual's left and right brain are in sync; if the left and right hemispheres synchronize, the balls form a single "coherence sphere." Under *ideal* conditions, however, the visualization software renders something even more remarkable: the three viewers' brainwaves begin to synchronize with each other so that the usually independent right and left sides of the brains start to function in unison in a shared Alpha (wakeful relaxation or daydream) state.[28] This moment of connectedness is symbolized by the six distinct silver elements merging to form a single ring.

FIGURE 29. Mariko Mori, *Wave UFO*, 1999–2003, detail. This still shows three interlocking rings of moving images inspired by real-time EEG data generated from the participants' brainwaves. Courtesy of Shiraishi Contemporary Art, Inc., Tokyo, Deitch Projects, New York. Copyright Mariko Mori 2009. All rights reserved. Photo courtesy of Mariko Mori / Art Resource, New York. Copyright 2016 Mariko Mori, Member Artists Rights Society (ARS), New York. See also figure 3.

The second part of the Vision Dome sequence features a scripted three-minute audiovisual piece coproduced by Mori and composer Ken Ikeda, titled *Connected World*. Recalling the color palette and fluctuating capsule forms employed in part 1, the pre-programmed segment in part 2 consists of bulbous pastel-colored forms morphing in meditative harmony set to otherworldly music. The video begins with very simple particles that expand, contract, and eventually warp and blossom into other worlds; showers of golden particles mutate into composite bubble images suggestive of celestial, floral, or aquatic scenes, each of which proves related to the other. For Mori, *Connected World*'s abstract audiovisual sequences of capsules in transition symbolize the empirically verifiable yet invisible connections among all forms of life and the broader material universe. It is helpful to recall the artist's statement at the chapter's outset: "I hoped that if someone entered *Wave UFO* expecting to see interwoven layers of

consciousness, they would be able to perceive them in this visual sequence. We [normally] may not be able to see them visually, but life is evidence of the multidimensional connection of all things."[29]

Mori's use of neuroimaging technology in *Wave UFO* is tactical. The artist investigates conventional scientific usages of brainwave visualization equipment by making a series of deliberately nonnormative choices of both *what* to depict and *how*. The work quotes conventional brain-imaging techniques just enough to reveal the extent to which audiences tend to fetishize the neuroimaging process and the allegedly unmediated and infallible results. Put simply, *Wave UFO* stages brain scanning as spectacle. The whole *Wave UFO* experience—from boarding to brain scans and back—lasts approximately seven minutes. Long lines of audience members stand patiently outside of the high-tech "UFO," awaiting white-coated assistants who will admit them in groups of three into the futuristic technoscientific machine. The selected participants are anointed with electrode headsets and strapped into the polished imaging apparatus where they eagerly anticipate viewing authentic neural "portraits" of themselves. Mori's exaggerated dramatization of brain imaging is strategic in that it encourages viewers to realize that there is nothing natural or inevitable about the ways in which brain imaging occurs. *Wave UFO*'s artistically rendered mutating pastel images of body–brain activity throw into relief the authoritative Technicolor brain images popularized in the mass media. The viewer's experience with *Wave UFO*—collective, multisensory, process-based—also stands in deliberate contrast to the way in which neuroimaging technologies are deployed in clinical or research settings. Generously cognizant of bodies as culturally and contextually inflected and dispersed, and ever mindful of the mediation inherent in images and imaging technologies, the work creatively repurposes brain imaging to engender a series of timely questions: What might be the critical advantages and liabilities of the increasing influence of the brain sciences in contemporary society? How might the emphasis on neural visual imaging technologies foreclose other ways of knowing the body or experience?

Mori uses brain-measuring technology in such a way as to demonstrate that embodied, environmentally and socially situated human subjects cannot in fact be reduced to their neural activity. *Wave UFO* validates instead the condition of embodied cognition—that is, the fundamental entanglement of body, brain, and environment central to the various feminist new materialisms examined throughout this book. The work's neurofeedback loop extends even beyond the body–brain activity of a single subject, however. Thanks to the ingenious combination of EEG data and custom visualization software, globular forms appear to pulse across the screen in

FIGURE 30. Mariko Mori, EEG headsets utilized in *Wave UFO,* 1999–2003.
Close-up view of the custom EEG (electroencephalogram) headsets used to track
participants' brainwaves in Mori's installation. Copyright Mariko Mori 2009.
All rights reserved. Photo courtesy of Mariko Mori / Art Resource, New York.
Copyright 2016 Mariko Mori, Member Artists Rights Society (ARS), New York.

direct response to the viewers' collective cerebral and corporeal activity.
By rendering the participants' embodied intersubjective experience as
real-time moving images, the work provocatively points to the invisible
yet operative connections among seemingly separate individuals; instead
of generating data pertinent to a single participant's neural activity, it
encompasses the moving, real-time traffic among all three viewers' bodies
and brains as they engage with the work's audiovisual and sculptural ma-
terials. Each process is understood to be distributed within another and is
visualized accordingly: the biomorphic sculpture's domed screen depicts
an ongoing series of bubbles and pods developing and intermingling inside
of yet another capsule. (The question arises—if Mori could pick any shape,
why does she consistently return to interpenetrating and nested spherical
forms? I will address the significance of what I call Mori's capsule aesthetic
in the book's conclusion.)

The arrangement of the participants' three reclining bodies in semi-
darkness stimulates the participants in a more subtle but equally affective

fashion—one that reminds how embodied experience is always networked and distributed, and thus irreducible to neural imaging premised on a modular, stand-alone brain. Like being on an airplane or subway, it is extremely difficult for *Wave UFO*'s participants to ignore the emotional or physical demeanor of the neighboring prone bodies. Cultural theorist Anna Gibbs describes something similar in her characterization of affective contagion: "Bodies can catch feelings as easily as catch fire: affect leaps from one body to another, evoking tenderness, inciting shame, igniting rage, exciting fear—in short, communicable affect can inflame nerves and muscles in a conflagration of every conceivable kind of passion."[30] The work's multiple sensory inputs, from Ikeda's spatialized electronic musical scores, to the flesh-like Technogel seating and adhesive electrode headsets, make plain the centrality of technology and located embodiment to any assessment of human experience.

Wave UFO's dynamic neurofeedback loop effectively puts affective contagion on display. The installation reveals the interimplication between the individual experience of watching the projections (your body/neural activity reacts in real time to what you see, feel, and hear) and the experiential interaction among all three viewers (your body/neural activity reacts to the physical and psychological activities of your coparticipants as well as the screen-based representations of said activities). In short, viewers can observe mediated representations of their bodies and brains reacting instinctively to what is going on around (across?) them, and can even try to influence it. In this sense, *Wave UFO* visualizes what scientifically minded philosophers like phenomenologist Diether Lohmar have already argued: "We are not confined to a single consciousness. The 'voices' of others, i.e. their sensations, feelings, and volition are somehow 'really there' and we co-experience them."[31] *Wave UFO*, however, goes a step further. The work's brainwave interface induces viewers to understand how, in their inescapable material embodiment, they are not entirely dissimilar from networked computers—while individual viewers can to some extent turn their own "frequencies" up and down, the human copassengers and technological inputs exert comparable influence. (We will explore the implications of this model of "encapsuled" posthuman subjectivity in the conclusion.)

The Wave of the Future

While the neuroskeptics are right to point out the shortcomings of certain scholarship at the intersection of the humanities and the brain sciences, the most successful instances of interdisciplinarity acknowledge ecological relations of interaction that do not reduce the brain to a closed,

self-sustaining system. The writings and research activities of the critical neuroscience group (a network of collaborators in Germany, Canada, the United States, the United Kingdom, Brazil, and Switzerland, led by Suparna Choudhury and Jan Slaby) are exemplary in this regard.[32] Choudhury and Slaby champion an enactive approach to understanding mental processes for those working at the intersection of neuroscience, the humanities, and various areas of social practice and policy. The scholars expressly theorize this project in terms of what John Protevi has called 4EA cognitivism: an understanding of the mind as *embodied, embedded, enacted, extended,* and *affective.* These scholars forge new research methods that accommodate and translate new information from the brain sciences, acknowledging the crucial role of biological and material actors. At the same time, however, they appreciate how human, technological, and natural actors *jointly* construct our world. As philosopher Mark Johnson and cognitive linguist George Lakoff have argued, any account of the embodied mind that is even remotely adequate to the complexity of human nature requires multiple, nonreductive levels of explanation.[33] For these critical thinkers, accordingly, questions regarding aesthetic experience, creativity, and human consciousness are best approached through the integrated processing regimes that weave together activity in brain, body, and world.

Choudhury and Slaby astutely observe that although the nature/culture dichotomy has often been criticized on *conceptual* grounds, few scholars have so far provided concrete suggestions as to how integrative experimental work might function in any *practical* sense. As we have seen, Mori's experiential new media installation *Wave UFO,* in its artistic, material engagement with neuroscience, suggests a prospective approach. *Wave UFO* both reflects and performs the best of the neuroscientific turn—specifically, the recognition of the potential relevance of empirical research about the natural world for advanced inquiry in all fields, including the arts and humanities, and the conception of human experience as materially embodied, networked, and ecological. At the same time, by encouraging its viewers to appreciate how neural functioning is on some level socially and culturally produced, and how neuroimaging is likewise thoroughly mediated by sociocultural factors, *Wave UFO* effectively serves as an applied refutation of scientific reductionism and neuroessentialism. Mori's prodigious achievement is to create an interactive art installation that allows her audience a way to directly experience and investigate this condition while also critically assessing mainstream perceptions surrounding the brain sciences and neuroimaging. The installation performs the fact that the brain is a necessary, but not necessarily *sufficient,* requirement for human consciousness. This is not to say that Mori discounts the proposition that humans are in some sense determinist physical systems, however.

Disabusing viewers of any lingering notion that they autonomously control their relationships to other subjects or objects/technologies, *Wave UFO* instead demonstrates their contingency and dynamic interpenetration. *Wave UFO* stages human experience as distributed not merely beyond our brains but beyond ourselves; we are profoundly connected to each other, to technology, and to the rest of the world. Works such as *Wave UFO*, by enacting and problematizing body–brain events in interactive artistic environments, productively test the limits of technoscientific discourse on the brain and human experience.

Although written in a different context, Alva Noë offers a fitting way to understand the fundamental significance of *Wave UFO* in light of the emerging neurodisciplines. The philosopher speculates that art may ultimately trump contemporary neuroscience in the quest to develop a biologically adequate account of human experience. "Far from its being the case that we can apply neuroscience as an intellectual ready-made to understand art, it may be that art, by disclosing the ways in which human experience in general is something we enact together, in exchange, may provide new resources for shaping a more plausible, more empirically rigorous, account of our human nature."[34] Noë's insightful formulation suggests that all works of art deploy implicit knowledge about how the brain functions, even without explicitly addressing the brain sciences themselves. This chapter has argued that artworks directly engaged with neuroscience are particularly revelatory, however, insofar as they serve as potential models for effective and nonhierarchical interdisciplinary interchanges. Careful attention to works like Mori's *Wave UFO* reveals that scholars interested in the nature of consciousness, perception, and visuality, especially as these topics intersect with both art history and neuroscience, would benefit from taking the visual arts as a starting point.

Lohmar memorably describes the functional challenges and potential rewards of what he calls true interdisciplinarity: "One could say that one discipline should serve as the 'truffle hound' for the other. A truffle-hound has an excellent nose and its only task is to lead the farmer to a place in the forest where truffles are likely to grow underground. The truffle-hound is not to excavate the truffles, however, since it would eat them immediately. One could rephrase this point by saying that the findings of one discipline must be evaluated with the means of the other in order to achieve fruitful co-operation."[35] Indeed, the most convincing future elaborations of the neuroscientific turn may well emerge from an equal partnership among art, art history, and the brain sciences.

This chapter has explored how *Wave UFO* conceives of human subjects as complex material systems relentlessly interpenetrating, and interpenetrated by, other systems. Mori's multimedia installation theorizes human

experience as a rich biocultural entanglement, intimately entwined with other bodies and with the rest of the material world. Taking *Wave UFO* as a jumping-off point, the book's conclusion will explore Mori's decades-long investigation of technoscience, subjectivity, and corporeality in her larger media art practice as it reveals what I call a "capsule aesthetic." For the postdualist capsule aesthetic, all matter, including living matter, is interrelated and separation is only an illusion. We are connected, "encapsuled," if you will, in ways that challenge our conceptions of moral and political agency and may even compel us to rethink our very definitions of human experience.

Conclusion
A Capsule Aesthetic

Through our advances, we participate in bringing forth the world
in its specificity, including ourselves. We have to meet the universe
halfway, to move toward what may come to be in ways that are
accountable for our part in the world's differential becoming. All
real living is meeting. And each meeting matters.

—KAREN BARAD, *MEETING THE UNIVERSE HALFWAY*

In chapter 5, I remarked upon Mariko Mori's distinctive use of capsules,
bubbles, and pods in her multimedia installation *Wave UFO* (1999–2003)
and suggested that it had a broader significance. In this, the book's final
chapter, we will explore how Mori's larger oeuvre even beyond *Wave UFO*
is unified by what I call a capsule aesthetic: an artistic engagement with
the notion of human experience as an ever-changing intermingling of the
human and nonhuman, the material and immaterial, the social and physi-
cal. Mori's artistic production offers the most apparent engagement with
capsules and encapsulation and thus serves as our central case study here.
Ultimately, however, we will see that the capsule aesthetic is not restricted
to Mori's body of work. I propose that a capsule aesthetic unites the artistic
instantiations of feminist materialisms examined throughout this book.
The experiential and material artistic practices of Rist, Piccinini, and Mori
all demonstrate a metaphorical capsule aesthetic in the distinctive ways
they elaborate upon the mutual entanglements between humans and non-
humans and the conditions of postanthropocentric posthumanism (Braidotti)
more broadly.

I begin by establishing a capsule aesthetic as it manifests in Mori's new
media art since approximately 1995. I conclude by articulating the artistic

and philosophical stakes associated with the postdualist capsule aesthetic as it intersects with the ethical-political aspirations of other feminist critiques of technoscience.

Mariko Mori and the Capsule Aesthetic

As we saw in chapter 5, Mori's multimedia installation and brainwave interface *Wave UFO* reveals capsule shapes at every turn—from the architectural casing and domed screen, to the dew-like moving images of "consciousness" projected inside. Now we will see how the past two decades mark the evolution of a metaphorical capsule aesthetic in Mori's artistic practice more generally. The artist's early production—large-scale glossy photographs of Mori's alluring body implanted in a series of futuristic landscapes—is well known. Her work underwent a transition around 1995, however. Since the mid-1990s Mori has continued to employ a range of artistic media, including her own body, but with particular emphasis on engaging philosophical and scientific theories of consciousness. This interest has been reinforced by selective experimentation with advanced technologies. Mori herself acknowledges the turn, characterizing it as a shift from interrogating first, "the contrast between reality and non-reality" (the deconstructive media critique that characterized her elaborately staged self-photographs), to later exploring the "hyperreal world within *non-reality*" (the exploration of material and spiritual realms that typifies her more recent production engaged with technoscience).[1]

The capsule aesthetic in Mori's works is both literal and figurative. I employ the capsule metaphor to evoke something that encases while remaining fundamentally mutable and in process—we might think of a soap bubble or a gelatin pill. Capsules are on some level materially differentiated from the rest of the world; like birds' eggs, they have outer shells that are tangible and seemingly solid, but, meaningfully, they nevertheless always retain the potential to be dissolved into something else. There is no hard-and-fast hierarchical privilege given to the inside versus the outside of a capsule; they are coextensive, contingent, and even meant for each other. In Mori's new media artworks, capsules partially *contain* even as they endlessly *connect*.

On the most basic level, Mori's oeuvre is overflowing with capsule motifs and even with capsule titles, as in the case of the translucent sculptures *Body Capsule* (1995–present) and *Enlightenment Capsule* (1998).[2] Prominent capsule/pod/bubble forms are clearly visible in the otherworldly landscapes of the artist's four-part photographic series *Esoteric Cosmos* (1996–98).[3] Each image in the mandala-inspired series finds its protagonists interwoven

with simulated landscapes composed of spaces inside other spaces: *Entropy of Love* depicts Mori and her sister nestled inside what she calls a "mother-womb" in front of the bulbous Arizona biosphere; *Burning Desire* finds Mori floating inside a luminous rainbow orb deep inside a crevice in the Chinese desert; *Mirror of Water* shows multiple Moris and a surreal "egg-shaped tea room" embedded in a cave in Southern France; and finally, *Pure Land* renders the artist as a heavenly being perched gracefully on a lotus flower suspended above the Dead Sea (the lowest place on Earth). As in *Esoteric Cosmos,* celestial and biomorphic orbs pervade the series of *Connected World* photopaintings (2002) and *White Hole* drawings (2009). Egg-shaped and lozenge forms also abound in Mori's early videos, such as *Miko no Inori* (1996) and *Nirvana* (1997), and in her later abstract sculptures, such as *Tom Na h-iu* (2005–6) and *Transcircle* (2004). Finally, the artist's most long-term project, the decade-long performance-based photographic series *Beginning of the End* (1995–2006), consists of installing *Body Capsule* in historically significant locations around the globe with Mori's own body enveloped, embryo-like, inside the transient capsule shell. (We will return to this important series in more detail shortly.)

In works like these, Mori suggestively challenges the traditional humanist notion of an emotionally or physically self-contained subject by creatively manifesting the contingent interpenetration of various forms of matter. Human and nonhuman objects unceasingly comingle and merge into other things. Consciousness itself is imagined as a postdualist "encapsulation." Indeed, Mori has written about her interest in Buddhist enlightenment and spiritual transmigration in analogous terms, noting that the "elements of time, space, and movement" implanted in her persistent imagery of "rain, bubbles, clouds, and floating cells" evolved in part from her experience studying meditation and the sutras.[4] (She is quick to distance her work from any single spiritual or cultural tradition, however.[5])

Most important for our purposes are Mori's artworks that advance an even more distinctive capsule aesthetic: these works "encapsule" or immerse their embodied viewers in what we might call a spectatorship of encapsulation. Beyond merely *representing* the notion of a capsule-like posthuman subjectivity, Mori's environmental installation artworks (like the other new media installations examined throughout this book) present encapsuled selfhood itself as an experiential site of critical contemplation. In works such as the multimedia environments *Wave UFO* and *Dream Temple* (1997–99) and the panorama-like installation of the *Esoteric Cosmos* and the *Beginning of the End* series of photographs, spectators experience themselves as coconstituted with other capsuled bodies and material forms

FIGURE 31. Mariko Mori, *Beginning of the End: Piccadilly Circus, London,* 1996. Cibachrome print. 100.0 cm × 500.0 cm × 7.5 cm (39.37 × 196.85 × 2.95 inches). This photograph is one of the "Present" sites associated with Mori's larger *Beginning of the End* series, in which the artist appears inside a transparent casing at the center of each image. Courtesy of Galerie Emmanuel Perrotin, Paris. Copyright Mariko Mori 2009. All rights reserved. Photo courtesy of Mariko Mori / Art Resource, New York. Copyright 2016 Mariko Mori, member Artists Rights Society (ARS), New York.

at various sites of interchange between technology and flesh. These remarkable works allow embodied spectators to perceive that what we often take to be singular, subjective experience is in fact deeply contingent upon, and constantly in process with, other material forces. In contrast to conventional humanist conceptions of subjectivity as enclosed and autonomous, Mori's posthumanist conception of encapsuled subjectivity recognizes the soft, porous contours of the capsule's skin.

Mori's suggestion of a located, embodied, and connectionist posthumanism is perhaps most apparent in her multipart work *Beginning of the End.* The series consists of thirteen performance-based photographs portraying sites associated with the birth of human civilization, present-day metropolises, and "future" cities.[6] Costumed in a hooded Lycra suit to complement the background colors of a given locale, the artist is depicted at the center of each image inside a transparent vessel *(Body Capsule).* Yet these are in no way self-portraits: rather, Mori's recumbent figure appears simply as an incidental foreground detail, seamlessly enmeshed with the wider environs. The work appears to invalidate the idea of a rational human subject separated from the external environment: both the images and the sculptural arrangement of forms suggest that all matter, including

living matter, is interrelated. Crucially, however, the capsule model acknowledges the subjective experience of containment and (highly permeable) boundaries, even as it gestures toward interconnection and absorption. When installed as a complete series, the photographs are arranged in a spherical and nonchronological format that encircles spectators at the center of the panorama—neatly recalling Mori's own embedded and encapsuled position. In short, the work instantiates an encapsulated posthuman selfhood: located and embodied viewers continuously interwoven and immersed amid other encapsulated bodies.

A Capsule Aesthetic at the Interface

This book has proposed that the new media installations of artists such as Pipilotti Rist, Patricia Piccinini, and Mariko Mori, similar to the new theoretical materialisms inaugurated by feminist scholars of technoscience, including Karen Barad, Donna Haraway, Rosi Braidotti, N. Katherine Hayles, Elizabeth Grosz, and others, offer timely critical perspectives about how our contemporary sciences and technologies create us even as we create them. We have seen that experiential, material art practices are exceptional among the feminist new materialisms in that they draw attention to our interactions with science and technology as lived experiences in real space. Rather than working primarily with words, artists like Rist, Piccinini, and Mori work *with* materials and *through* bodies; their installations allow us to experience and inhabit embodied technointerfaces firsthand. We have also seen how these post-1990 artists mine the inheritance of a range of feminist media art practices and critical spectatorship theories from the 1970s and 1980s to the present day. In projects informed by feminism's

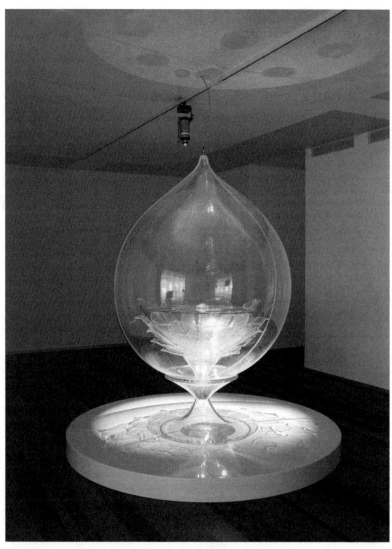

FIGURE 32. Mariko Mori, *Enlightenment Capsule*, 1998. Plastic, Himawari System (fiber optics, solar transmitter). 229 cm × 168 cm (90.16 × 66.14 inches). *Enlightenment Capsule* features the imaginative Himawari system invented by the artist's father; the fiber-optic system collects unfiltered sun rays, returning them to the gallery and its viewers in the mediated form of purified light displayed on the illuminated rainbow-colored acrylic lotus at the sculpture's core. Artwork copyright Mariko Mori 2009 and photograph copyright Richard Learoyd. All rights reserved. Photo courtesy of Mariko Mori / Art Resource, New York. Copyright 2016 Mariko Mori, member Artists Rights Society (ARS), New York.

FIGURE 33. Mariko Mori, *Dream Temple,* 1997–99. Metal, glass, plastic, fiber optics, fabric, Vision Dome (3D hemispherical display), audio. 500 cm × 1,000 cm (197 × 394 inches). Much like Mori's later *Wave UFO* (the works in fact share the same designer and Vision Dome technology), the video sequence in *Dream Temple* comprises biomorphic squiggles, bubbles, and capsule-like forms that Mori favors to evoke the process of going deep inside one's consciousness and experiencing that (in the artist's words) "there are no boundaries between you and others." Artwork copyright Mariko Mori 2009 and photograph copyright Richard Learoyd. All rights reserved. Photo courtesy of Mariko Mori / Art Resource, New York. Copyright 2016 Mariko Mori, member Artists Rights Society (ARS), New York.

long-standing epistemological concerns, Rist, Piccinini, and Mori use the art institution as a frame to set off and activate experience—in this case, the experience of embodied technointerfaces and encapsuled subjectivity— as a site of critical contemplation. As feminist materialisms in their own right, the artworks explored in this book serve as novel and previously un-recognized sites for theorizing subject–object relations befitting our twenty-first-century technoculture.

As stated above, the emblematic capsule aesthetic I have identified in Mori's practice—the framing of "capsuled" posthumanist subjectivity

FIGURE 34. Mariko Mori, *Beginning of the End: Giza, Egypt,* triptych, 2000.
Cibachrome print. 100.0 cm × 500.0 cm × 7.5 cm (39.5 × 197 × 3 inches). The
artist's unobtrusive, color-coded body rests in the translucent capsule in the center
of this photograph depicting one of the "Past" sites associated with the larger
Beginning of the End series. Copyright Artists Rights Society, New York.
Copyright Mariko Mori 2009. All rights reserved. Photo courtesy of Mariko
Mori / Art Resource, New York.

in experiential works of new media art—encompasses the critical project
associated with the feminist materialisms of Rist and Piccinini as well.
These artists, too, carefully explore the fluid and ongoing exchanges among
human subjects, technological objects, and other forms of matter. And
they do so through and with human experience. As with Mori, Rist's and
Piccinini's spectators are invited to experience themselves as capsule-like:
both completely connected *and* somehow contained. Consider, for example,
Rist's insistence on the reciprocal relation between "pouring one's body
out" and critical perception. In installations such as *Pour Your Body Out,*
the artist proposes a form of critical aesthetics that I have termed critical
proximity: a model premised not upon (Cartesian/dualist) critical distance,
but rather upon (postdualist) nearness and immersion. For Rist, facilitating
a critical spectatorship remains crucial. At the same time, however, her work
suggests that human experience is inexorably embedded, entangled, and

FIGURE 35. Mariko Mori, *Beginning of the End,* 1995–2006. Installation view of the *Beginning of the End* series of photographs installed in panorama-like circular bands that surround (or "encapsule") spectators. Copyright Mariko Mori 2009. Copyright Artists Rights Society, New York. All rights reserved. Photo courtesy of Mariko Mori / Art Resource, New York. Copyright 2016 Mariko Mori, member Artists Rights Society (ARS), New York.

enacted with the material world—a "distant" critical perspective therefore is untenable.

Piccinini's bioart practice similarly infers a capsule aesthetic. The artist's hyperrealistic sculptures of invented biotech creatures such as those in *We Are Family* underscore the affective and self-organizing properties of matter. These "cutely grotesque" creatures have an uncanny lifelike quality that effectively solicits viewers' empathy and care. With detailed analysis, we have seen that these works propose an ethic of care for nonhuman beings that ultimately exceeds familiar anthropomorphic frameworks. Piccinini's particular staging of capsuled subjectivity invites us to experience how a postanthropocentric posthumanism need not be *anti*human, even as it highlights the urgency of reconceptualizing subjective agency and ethical accountability.

The conception of posthuman subjectivity as capsule-like—distributed, but also discrete—helpfully recalls the distinctive contribution of the scholarly feminist new materialisms delineated in chapter 1. As we saw

there, key feminist materialist engagements with technoscience, Barad's explanation of intra-activity foremost among them, are remarkable in part because they account for the activity of matter while also forging an ethical politics for posthuman subjects.[7] This is in no way an attempt to revive humanism: it is a model of subjectivity that it is resolutely materialist and posthumanist, even as it maintains a nuanced appreciation of limits, agency, and responsibility. In ways deeply sympathetic to Barad's striking invitation excerpted in this chapter's epigraph, the works of art examined in this book invite their viewers to contemplate and, indeed, to *inhabit* this revised notion of subjective agency; these environmental works of art offer us opportunities to "move toward what may come to be in ways that are accountable for our part in the world's differential becoming."[8] Artistic feminist materialisms allow us to experience ourselves as enacted with the stuff of the world, yet, at the same time, to recognize that *we still are responsible on some level for these enactments.* The implications are profound. The embodied materialisms of Rist, Piccinini, and Mori allow viewers to inhabit not only the new possibilities but also, by implication, the enduring ethical and political *accountability* occasioned by the human–nonhuman interfaces that define our contemporary technoculture.

This book has been dedicated to thinking new media art through feminist materialisms, and feminist materialisms through new media art. Throughout, I have demonstrated how connecting these seemingly discrete projects yields discoveries that serve to enrich and enhance both fields. The capsule aesthetic and the notion of encapsuled subjectivity exemplify how art and theory may in fact collaborate in the interest of broader ethical-political projects. As feminist materialisms, the new media installations by Pipilotti Rist, Patricia Piccinini, and Mariko Mori examined in *A Capsule Aesthetic: Feminist Materialisms in New Media Art* consistently interrogate our ongoing interactive relations with new technologies and other forms of matter. At their best, however, these works of art invite us to experience not only our embodied absorption *within,* but also our ethical-political responsibility *toward,* the rest of the material world.

ACKNOWLEDGMENTS

This book is the product of many kindnesses. A long list of colleagues and friends generously served as interlocutors and supporters along the way. I am especially grateful to Yalchin Abdullaev, Michael Allen, Monica Baak, Francois Bovier, David Carrier, Alison Carruth, Liska Chan, Cynthia Colburn, Catherine Fowler, Gabrielle Gopinath, Kate Hayles, Gina Herrmann, Erkki Huhtamo, Amy Ione, Gabrielle Jennings, Amelia Jones, Colin Koopman, Miwon Kwon, Charles Lachman, Stephanie LeMenager, Jenny Lin, Saloni Mathur, Adeena Mey, Albert Narath, Chon Noriega, Tim Olmstead, Mathilde Roman, Daniel Rosenberg, Carol Stabile, Laura Vandenburgh, Anthony Vidler, Akiko Walley, Michele White, and Louise Whiteley. Jenn Marshall deserves special recognition: our scholarly collaboration and long-standing friendship continue to make all the difference.

As always, I am indebted to my colleagues at the University of Oregon for their collegiality and intellectual rigor, especially those in the School of Architecture and Allied Arts. Dean Christoph Lindner and interim dean Brook Muller have been stalwart supporters of my research, for which I am grateful. I am appreciative especially of my students in art history and in the New Media and Culture Certificate program for their curiosity and willingness to question the things we are convinced we already know. The journey has been more spirited—even feisty at times—because of their company. Thanks are also due to my wonderful graduate research assistants, Alison Parman, Kaitie Garvin, and Emily Shinn, and to the staff in the Digital Scholarship Center, especially Julia Simic, John Russell, Karen Estlund, and Sheila Rabun.

Preliminary versions of this research were published in *Feminist Media Studies, Art Journal, Leonardo,* and *Exhibiting the Moving Image.* I am grateful to those editors and reviewers for their incisive comments; the

book is stronger for all their input. Likewise, I am appreciative of the perceptive observations of the University of Minnesota Press editorial board, the book's anonymous peer reviewers, and the colleagues who shared constructive feedback on my work at talks and conferences throughout North America and Europe.

The Getty Foundation, Clark Art Institute, Terra Foundation for American Art, American Council of Learned Societies, Oregon Humanities Center, and the Center for the Study of Women in Society enabled me to conduct research, refine my writing, and cover image reproduction costs. I am humbled by this generosity, especially in challenging economic times.

Many thanks to humanities editor Danielle Kasprzak, editorial assistant Anne Carter, production editor John Donohue, indexer Doug Easton, and the entire team at the University of Minnesota Press for their gracious shepherding of this project from inkling to manuscript.

My most heartfelt thankfulness goes to the artists and scholars whose work inspired this book. It is a privilege to write alongside them in the interest of advancing lines of inquiry that exceed the mastery of any individual.

Finally, *grazie mille* to my family, most especially to Andrea and Oliver, for their patience, compassion, cheerleading, and good humor as this book came to fruition. They always know how to keep the sun shining, even in Oregon's rain.

NOTES

1. Inhabiting Matter

1. Definitions of media art and new media art are in flux within art historical discourse and the terms are sometimes used interchangeably. Throughout the book I use the term "new media art" to refer to contemporary artworks that incorporate and/or address new and emerging technologies, including digital art, bioart, virtual art, and multimedia installations. I use the term "media art" to indicate a broader category that encompasses contemporary art engaged with pre-digital forms of photography, film, and video technologies as well as new media formations.

2. The profoundly influential concept of the culture industry (which proposes that the increasing commodification of culture in modern capitalist society has transformed culture itself into a crucial medium of ideological domination) was first introduced by Max Horkheimer and Theodor Adorno in their 1944 essay "The Culture Industry: Enlightenment as Mass Deception," published in their *Dialectic of Enlightenment,* trans. John Cumming (New York: Continuum, 1995), 120–67. Guy Debord, *The Society of the Spectacle,* trans. Donald Nicholson-Smith (New York: Zone Books, 1995). Rosalind Krauss details the challenges associated with the experience-hungry contemporary art museum in "The Cultural Logic of the Late Capitalist Museum," *October* 54 (1990): 3–17.

3. The neglect and/or disdain of these practices among many (although by no means all) critics suggests not only an ill-disguised apprehension about feminized bodies, passivity, and sensuous collective viewing (especially as it intersects with mass culture) but also the perceived threat of feminist art itself. Griselda Pollock neatly surmises what is at stake with art and feminism: "Be it politics, theory or personal reference, [feminist art] is all perceived as threatening the same excess. Complaint against excess is not a critical position; it is a response to an experience of threat when the established frameworks for consumption of art and critical response are transgressed by that which those frameworks can no longer contain and

by that which threatens to expose those frameworks as precarious and contentious." Griselda Pollock, "What's the Difference? Feminism, Representation and Sexuality," *Aspects (UK)* 32 (Spring 1986): 10.

4. Giuliana Bruno's *Surface: Matters of Aesthetics, Materiality, and Media* (Chicago: University of Chicago Press, 2014) is a powerful counterexample here. In a project sympathetic to my own rethinking of art and media models of critique and complicity through new materialist theories, Bruno strategically employs the concept of immersion "to theorize a notion of absorption in artworks that actively involve a 'projection' into the work that materially creates a transformative becoming of the subject, in some cases leading to a relational empathy" (254n2).

5. For representative collections of the literature associated with the new materialisms as they intersect with feminism, see Stacy Alaimo and Susan Hekman, *Material Feminisms* (Bloomington: Indiana University Press, 2008); Susan Hekman, *The Material of Knowledge: Feminist Disclosures* (Bloomington: Indiana University Press, 2010); and Rick Dolphijn and Iris van der Tuin, *New Materialism: Interviews & Cartographies* (Ann Arbor, Mich.: Open Humanities Press, 2012). Although not explicitly grounded in feminist theory, Jane Bennett outlines how her construct of "vital materialism" is applicable to salient political and ethical concerns in the twenty-first century in Jane Bennett, *Vibrant Matter: A Political Ecology of Things* (Durham, N.C.: Duke University Press, 2010). See also Richard Grusin, ed., *Anthropocene Feminism* (Minneapolis: University of Minnesota Press, 2017).

6. On the problematic technological progressivism inherent in the term "*new* media," see Wendy Chun and Thomas Keenan, *New Media, Old Media: A History and Theory Reader* (New York: Routledge, 2006).

7. Rist (Swiss, b. 1962), Piccinini (Australian, b. 1965), and Mori (Japanese, b. 1967) all have extensive exhibition histories on an international scale, including, for example, career-defining exhibitions at the prestigious international Venice Biennale art exhibition (Rist in 1997, Piccinini in 2003, and Mori in 2005). (Rist was also the Swiss representative to the 2005 Biennale; her contribution was *Homo Sapiens Sapiens* in the Church of St. Stae.) The three artists have been discursively positioned in relationship to feminism to varying degrees. For instance, Rist and Piccinini were included in the Brooklyn Museum's landmark *Global Feminisms* exhibition in 2007, and Mori's practice is frequently cited as pertaining to cyberfeminism. The exemplary art practices explored throughout this book are not intended to represent an exhaustive study of all new media art practices that may intersect with feminism, however. My analysis of works by Rist, Piccicini, and Mori aspires to offer a critical framework for appreciating any number of artistic practices (in no way limited to female artists) as they engage provocatively with new sciences, technologies, and feminist materialist approaches.

8. Although there are no monographs to date on the topic of feminist new materialisms and new media art, Estelle Barrett and Barbara Bolt, and, more recently, Anna Hickey-Moody and Tara Page, have edited noteworthy anthologies dedicated

to the intersections between the creative arts and new materialism more generally. See Estelle Barrett and Barbara Bolt, eds., *Carnal Knowledge: Towards a "New Materialism" through the Arts* (London: I. B. Tauris, 2013) and *Material Inventions: Applying Creative Arts Research* (London: I. B. Tauris, 2014); and Anna Hickey-Moody and Tara Page, eds., *Arts, Pedagogy, and Cultural Resistance: New Materialisms* (Lanham, Md.: Rowman and Littlefield, 2015). In contrast to *A Capsule Aesthetic,* these collections, written from the perspective of art educators and practitioners, tend to focus especially on validating art as pedagogy and practice as research. While their critical investments differ, it is worth emphasizing that writers associated with new materialism have also been interested in art/artisanal practice or practice-based research. See, for example, Ian Bogost, *Alien Phenomenology, or, What It's Like to Be a Thing* (Minneapolis: University of Minnesota Press, 2012); N. Katherine Hayles, *How We Think: Digital Media and Contemporary Technogenesis* (Chicago: University of Chicago Press, 2012) and *Ways of Making and Knowing: The Material Culture of Empirical Knowledge,* ed. Pamela H. Smith, Amy R. W. Meyers, and Harold Cook (Ann Arbor: Bard Graduate Center and University of Michigan Press, 2014). Hayles established these connections as early as 2005. In N. Katherine Hayles, *My Mother Was a Computer: Digital Subjects and Literary Texts* (Chicago: University of Chicago Press, 2005), she cites approvingly Greg Egan's "subjective cosmology" trilogy, in which the author "envisions the human/computer connection not as a question of technology (shades of Heidegger) but as an ontological inquiry into the relation of humans to the universe" (218).

9. For a comprehensive summary of the main spectatorship theory debates, see Judith Mayne, *Cinema and Spectatorship* (New York: Routledge, 1993).

10. Note that I retain the seemingly dualistic terms "spectator" and "viewer" advisedly. I favor these terms in part because at present no descriptors are perfectly suited to emphasizing this fluidity and contingency (despite several contemporary efforts, as detailed in the body of the text). More important, I believe that visual studies' methodologies focusing on reception, spectatorship, and aesthetic figurations—methods that continue to use the terms "spectator" and "viewer," even if often in scare quotes—offer a heretofore undervalued means by which to theorize human/nonhuman encounters more generally.

11. I have developed this concept in detail elsewhere. See Kate Mondloch, *Screens: Viewing Media Installation Art* (Minneapolis: University of Minnesota Press, 2010), esp. chapter 1.

12. For historical and theoretical texts on the topic of installation art, see, for example, *Installation Art,* ed. Nicolas de Oliveira, Andrew Benjamin, Nicola Oxley, and Michael Petry (Washington, D.C.: Smithsonian Institution Press, 1994); Claire Bishop, *Installation Art: A Critical History* (New York: Routledge, 2005); Julie Reiss, *From Margin to Center: The Spaces of Installation Art* (Cambridge, Mass.: MIT Press, 2000); and Erika Suderburg, ed., *Space, Site, Intervention: Situating Installation Art* (Minneapolis: University of Minnesota Press, 2000).

13. Amelia Jones, *Self/Image: Technology, Representation, and the Contemporary Subject* (London: Routledge, 2006), 213. Similar to *A Capsule Aesthetic*, Jones's *Self/Image* makes compelling arguments about art, technology, and feminism. (See esp. chapter 6, "The Televisual Architecture of the Dream Body," on Pipilotti Rist, who we will return to in chapter 3.) However, while Jones's *Self/Image* offers a rich analysis of how subjectivity is always embodied and how the spectator is always implicated in viewing, my book, crucially, is concerned not only with the activity of the spectator but also with the activity of nonhuman forms and processes of matter, as well as the significance of the artistic enactment of these interpenetrating relations in terms of feminist theoretical materialisms (theoretical models that ultimately lead to the reconsideration of the priority of sexuality and the relevance of the sex/gender distinction central to Jones's theorization of "parafeminism").

14. In Sylvia Kolbowski, Mignon Nixon, Mary Kelly, Hal Foster, Liz Kotz, and Aiysha Abraham, "A Conversation on Recent Feminist Art Practices," *October* 71 (Winter 1995): 50.

15. Stacy Alaimo, "Thinking as the Stuff of the World," *O-Zone: A Journal of Object-Oriented Studies* 1 (2014): 16.

16. The so-called French Feminisms developed in the 1980s by Hélène Cixous, Julia Kristeva, Luce Irigaray, and others are especially notable in this regard. Rosi Braidotti, for her part, locates the beginning of this legacy as early as the pioneering work of Simone de Beauvoir in the mid-twentieth century: "Feminist philosophy builds on the embodied and embedded brand of materialism that was pioneered in the last century by Simone de Beauvoir. It combines, in a complex and groundbreaking manner, phenomenological theory of embodiment with Marxist—and later on poststructuralist—re-elaborations of the complex intersection between bodies and power." Interview with Rosi Braidotti in Dolphijn and van der Tuin, *New Materialism*, 21.

17. New definitions of matter stemming from quantum physics (in which matter/energy does not exist with any certainty in definite places, but rather shows "tendencies" to exist) and biogenetics (in which all forms of living matter are interchangeable through direct manipulation of an organism's genome) are primary among the sciences influencing the current scholarly emphasis on matter as unpredictable, productive, and exhibiting agency.

18. On the topic of new materialist thought (broadly conceived) as part of a long history of ongoing feminist work in multiple disciplines, see Sara Ahmed, "Open Forum, Imaginary Prohibitions: Some Preliminary Remarks on the Founding Gestures of the 'New Materialism,'" *European Journal of Women's Studies* 15 (2008): 23–39; Alaimo, "Thinking as the Stuff of the World"; Rebekah Sheldon, "Form/Matter/Chora: Object-Oriented Ontology and Feminist New Materialism," in *The Nonhuman Turn,* ed. Richard Grusin (Minneapolis: University of Minnesota Press, 2015), 193–222; Cecilia Åsberg, Kathrin Thiele, and Iris van der Tuin, "Speculative before the Turn: Reintroducing Feminist Materialist Performativity," *Cultural Studies*

Review 21, no. 2 (September 2015): 145–72; and Katherine Behar, ed., *Object-Oriented Feminism* (Minneapolis: University of Minnesota Press, 2016). Åsberg, Thiele, and van der Tuin precisely outline how the question of the speculative and the methodology of speculation associated with new materialism have long been at the very core of various feminisms; they cite Donna Haraway's *The Cyborg Manifesto* (1985), Judith Butler's *Gender Trouble* (1990) and *Bodies That Matter* (1993), Rosi Braidotti's *Nomadic Subjects* ([1994] 2011), Gayatri Spivak's *The Postcolonial Critic* (1990), Moira Gatens's *Imaginary Bodies* (1996), Elizabeth Grosz's *Volatile Bodies* (1994), and bell hooks's *Yearning: Race, Gender and Cultural Politics* (1990) among the "classic" texts demonstrating the specifically feminist—as well as anticolonial, antiracist, queer, and more-than-human—speculative concern with existing power relations and frames of thought.

19. Diana Coole and Samantha Frost, eds., *New Materialisms* (Durham, N.C.: Duke University Press, 2010), 10.

20. For an introduction to the central debates of the new materialisms in the humanities and social sciences, see Dolphijn and van der Tuin, *New Materialism,* and Coole and Frost, *New Materialisms.* New materialist philosophies differ most dramatically from their predecessors (both historical and "corporeal" materialisms) in their attention to the networked agency of human and nonhuman things. On historical materialism, see Leszek Kolakowski, *Main Currents of Marxism: The Founders—The Golden Age—The Breakdown,* trans. P. S. Falla (New York: Norton, 2008). On classical theories of corporeal materialism, see Michel Foucault, *History of Sexuality,* vol. 1 (New York: Vintage Books, 1980), and Judith Butler, *Bodies That Matter: On the Discursive Limits of Sex* (New York: Routledge, 2011).

21. Stacy Alaimo and Susan Hekman's *Material Feminisms* (Bloomington: Indiana University Press, 2008) offers a useful collection of representative writings from these key figures.

22. Bruno Latour, *Pandora's Hope: Essays on the Reality of Science Studies* (Cambridge, Mass.: Harvard University Press, 1999).

23. Bruno Latour, "Why Has Critique Run Out of Steam? From Matters of Fact to Matters of Concern," *Critical Inquiry* 30, no. 2 (2004): 225–48.

24. See Susan Hekman, "Constructing the Ballast," in Alaimo and Hekman, *Material Feminisms,* 85–119, and Hekman, *Material of Knowledge.* My account is indebted to Hekman's detailed and insightful analysis.

25. Alaimo and Hekman, *Material Feminisms,* 107.

26. N. Katherine Hayles's distinction between normative notions of the body versus embodiment is helpful here, in *How We Became Posthuman: Virtual Bodies in Cybernetics, Literature and Informatics* (Chicago: University of Chicago Press, 1999). Hayles writes that embodiment is "contextual, enmeshed within the specifics of place, time, physiology, and culture, which together compose enactment. Embodiment never coincides exactly with 'the body,' however that normalized concept is understood. Whereas the body is an idealized form that gestures toward a Platonic

reality, embodiment is the specific instantiation generated from the noise of difference. Relative to the body, embodiment is other and elsewhere, at once excessive and deficient in its infinite variations, particularities, and abnormalities" (196–97).

27. Elizabeth Grosz, *Volatile Bodies: Toward a Corporeal Feminism* (Baltimore: Johns Hopkins University Press, 1994), 210. Grosz has noted in several texts (see especially *Chaos, Territory, Art: Deleuze and the Framing of the Earth* [New York: Columbia University Press, 2008]) that Gilles Deleuze and Félix Guattari's writing on material vitalism offers an important precedent for conceptualizing social life as made up of "semiotic flows, material flows, and social flows simultaneously" (Gilles Deleuze and Félix Guattari, *A Thousand Plateaus: Capitalism and Schizophrenia* [Minneapolis: University of Minnesota Press, 1987], 22).

28. Dolphijn and van der Tuin, *New Materialism,* 34.

29. Braidotti, *The Posthuman* (Cambridge: Polity Press, 2013), 42.

30. Ibid., 43. Emphasis added.

31. I am thinking here specifically of the core texts associated with actor–network theory (ANT), speculative realism, and object-oriented philosophy, such as Bruno Latour, *Reassembling the Social: An Introduction to Actor-Network-Theory* (Oxford: Oxford University Press, 2005); Levi Bryant, Nick Srnicek, and Graham Harman, eds., *The Speculative Turn: Continental Materialism and Realism* (Melbourne: Re.Press, 2011); Graham Harman, *Guerrilla Metaphysics: Phenomenology and the Carpentry of Things* (Chicago: Open Court, 2005); and Quentin Meillassoux, *After Finitude: An Essay on the Necessity of Contingency*, trans. Ray Brassier (London: Continuum, 2008). For representative criticism of these models, see Andrew Cole, "The Call of Things: A Critique of Object-Oriented Ontologies," *Minnesota Review: A Journal of Committed Writing* 80 (2013): 106–18, and Alexander Galloway, "The Poverty of Philosophy: Realism and Post-Fordism," *Critical Inquiry* 39, no. 2 (2013): 347–66. On the possible dangers posed by new materialists to democratic politics, see Sharon Krause, "Bodies in Action: Corporeal Agency and Democratic Politics," *Political Theory* 39, no. 3 (2011): 299–324.

32. Åsberg, Thiele, and van der Tuin, "Speculative before the Turn," 148, 151.

33. Sheldon, "Form/Matter/Chora," 196. Dolphjin and van der Tuin expound upon this post-identitarian feminist perspective on the body in their *New Materialism,* where they write: "The body refers to the materialist but also vitalist groundings of human subjectivity and to the specifically human capacity to be both grounded and to flow and thus to transcend the very variables—class, race, sex, gender, age, disability—which structure us" (33).

34. Feminist criticism of technoscience is a hybrid field sometimes referred to by other names, such as feminist science studies or feminist studies of science and technology.

35. Hekman, *Material of Knowledge,* 68.

36. Introduction to inaugural issue of *Catalyst: Feminism, Theory, and Technoscience* 1 (2015): 2.

37. Following Barad, Suchman defines the interface this way: "'The interface' becomes the name for a category of contingently enacted cuts occurring always within social-material practices that effect 'person' and 'machines' as distinct entities, and that in turn enable particular forms of subject-object intra-actions. At the same time, the singularity of 'the interface' explodes into a multiplicity of more and less closely aligned, dynamically configured moments of encounter within social-material configurations objectified as persons or machines." Lucy Suchman, *Human–Machine Reconfigurations: Plans and Situated Actions* (Cambridge: Cambridge University Press, 2007), 267–68.

38. Karen Barad, "Posthumanist Performativity: Toward an Understanding of How Matter Comes to Matter," *Signs* 28, no. 3 (2003): 815. (Also reprinted in Alaimo and Hekman, *Material Feminisms*, 133.) See also Barad, *Meeting the Universe Halfway: Quantum Physics and the Entanglement of Matter and Meaning* (Durham, N.C.: Duke University Press, 2007).

39. Barad elaborates: "Discursive practices and material phenomena do not stand in a relationship of externality to one another; rather, the material and the discursive are mutually implicated in the dynamics of intra-activity" (Barad, "Posthumanist Performativity," 822).

40. Alaimo and Hekman, *Material Feminisms*, 5.

41. Stacy Alaimo, *Bodily Natures: Science, Environment and the Material Self* (Bloomington: Indiana University Press, 2010). See also *Exposed: Environmental Politics and Pleasures in Posthuman Times* (Minneapolis: University of Minnesota Press, 2016).

2. Thinking Through Feminism

1. Entire journal issues have been devoted to identifying the distaste for abstraction and theorizing of all kinds and to assessing the larger political and cultural consequences. In relationship to feminist theory, see, for example, Kathleen McHugh and Vivian Sobchack, "Beyond the Gaze: Recent Approaches to Film Feminisms," special issue, *Signs: Journal of Women in Culture and Society* 30, no. 1 (Autumn 2004); and Susan Gubar, "What Ails Feminist Criticism?," *Critical Inquiry* 24, no. 4 (Summer 1998): 878–902.

2. Sara Ahmed's "Open Forum, Imaginary Prohibitions: Some Preliminary Remarks on the Founding Gestures of the 'New Materialism'" is the foundational text for this critique (*European Journal of Women's Studies* 15 [2008]: 23–39). In a similar vein, Rebecca Coleman observes that key publications on the feminist new materialisms, such as Stacy Alaimo and Susan Hekman (2008) and Karen Barad (2007), unfairly take to task previous feminist theories of discourse and critiques of representation (or what Coleman calls "image studies") for allegedly insisting that only cultural forces have agency. Rebecca Coleman, "Inventive Feminist Theory: Representation, Materiality and Intensive Time," in "Feminist Matters: The Politics

of New Materialism," special issue, *Women: A Cultural Review* 25, no. 1 (2014): 27–45. See Stacy Alaimo and Susan Hekman, *Material Feminisms* (Bloomington: Indiana University Press, 2008); Karen Barad, *Meeting the Universe Halfway: Quantum Physics and the Entanglement of Matter and Meaning* (Durham, N.C.: Duke University Press, 2007).

3. Rebekah Sheldon, "Form/Matter/Chora: Object-Oriented Ontology and Feminist New Materialism," in *The Nonhuman Turn*, ed. Richard Grusin (Minneapolis: University of Minnesota Press, 2015), 203. See also Cecilia Åsberg, Kathrin Thiele, and Iris van der Tuin, "Speculative before the Turn: Reintroducing Feminist Materialist Performativity," *Cultural Studies Review* 21, no. 2 (September 2015): 145–72; and Stacy Alaimo, "Thinking as the Stuff of the World," *O-Zone: A Journal of Object-Oriented Studies* 1 (2014): 13–21.

4. Laura Mulvey, "Visual Pleasure and Narrative Cinema," *Screen* 16, no. 3 (Fall 1975): 6–18.

5. Contemporary Anglo-American feminism is typically periodized into three waves: a first wave initiated in the nineteenth century and associated with the women's suffrage movement, a second wave established in the 1960s and broadly focused on social conditions, and a third wave inaugurated in the early 1990s and focused on pluralism and the continued deconstruction of identity, including various "post"-feminisms. See, for example, Catherine Harnois, "Re-Presenting Feminisms: Past, Present, and Future," *NWSA Journal (Feminist Formations)* 20, no. 1 (Spring 2008): 120–45; and Misha Kavka, introduction to *Feminist Consequences: Theory for the New Century*, ed. Elisabeth Bronfen and Misha Kavka (New York: Columbia University Press, 2001), ix–xxvi. In art practice and criticism, the first self-identified feminist practices developed in the 1970s during feminism's second wave. (Note that the taxonomy for describing feminist art can be confusing insofar as art historians tend to identify two distinct "generations" of feminist art practice within feminism's second wave.)

6. See, for example, Mary Kelly, "Re-viewing Modernist Criticism," *Screen* 22, no. 3 (1981): 41–52, and "No Essential Femininity: A Conversation between Mary Kelly and Paul Smith," *Parachute* 26 (1982); Mira Schor, "Contemporary Feminism: Art Practice, Theory, and Activism—An Intergenerational Perspective," *Art Journal* 58, no. 4 (Winter 1999): 8–29; Thalia Gouma-Peterson and Patricia Mathews, "The Feminist Critique of Art History," *Art Bulletin* 69, no. 3 (1987): 326–57; Sylvia Kolbowski, Mignon Nixon, Mary Kelly, Hal Foster, Liz Kotz, and Aiysha Abraham, "A Conversation on Recent Feminist Art Practices," *October* 71 (Winter 1995); 49–69; Amelia Jones, *Sexual Politics: Judy Chicago's Dinner Party in Feminist Art History* (Berkeley: University of California Press, 1996); and Lucy Lippard, "Both Sides Now," in *The Pink Glass Swan: Selected Essays on Feminist Art* (New York: New Press, 1995).

7. The exhibition's critical project is frequently equated with Mulvey's arguments regarding the male gaze even though Mulvey was not an essayist for the catalog. However, Mulvey did participate in the New Museum's 1985 panel "Sexual

Identity: You Are Not Yourself: *Difference: On Representation and Sexuality*," moderated by Kate Linker, with Jane Weinstock, Victor Burgin, Craig Owens, Judith Barry, Mary Kelly, and Mulvey. Audio files are available at http://archive.newmuseum.org/index.php/Detail/Object/Show/object_id/7091 (as of October 23, 2015).

8. Curiously, given the priority assigned to cinema and to filmic discourses in Linker and Weinstock's curatorial project, only the video pieces traveled with the show (presumably for logistical reasons).

9. Marcia Tucker, preface to *Difference: On Representation and Sexuality* (New York: New Museum of Contemporary Art, 1984, exhibition catalog), n.p. Under Tucker's leadership, the New Museum mounted a series of exhibitions designed to examine important cultural issues through the lens of visual representation. For Tucker, the exhibition was composed of the still and moving-image artworks along with the catalog essays.

10. Mary Kelly in "Sexual Identity: You Are Not Yourself," New Museum panel discussion, 1985.

11. See Stephen Heath, *Questions of Cinema* (Bloomington: Indiana University Press, 1981).

12. Kate Linker, foreword and acknowledgments to *Difference*, n.p.

13. The two catalog essays in question are Peter Wollen's "Counter-Cinema and Sexual Difference" and Jane Weinstock's "Sexual Difference and the Moving Image," both in *Difference*, n.p.

14. See Gouma-Peterson and Mathews, "Feminist Critique of Art History." See also Hester Eisenstein and Alice Jardine, eds., *The Future of Difference* (Boston: G. K. Hall, 1980), which proposes a generational model for feminism that inspired Gouma-Peterson and Mathews's hypothesis of a generational model for feminist art.

15. On the problematic implications of the generational model for feminist art, see, for example, Schor, "Contemporary Feminism"; Lisa Tickner, "Mediating Generation: The Mother–Daughter Plot," *Art History* 25, no. 1 (February 2002): 23–46; Joanna Frueh, Cassandra L. Langer, and Arlene Raven, *New Feminist Criticism: Art, Identity, Action* (New York: Icon Editions. 1994); Amelia Jones, *Body Art / Performing the Subject* (Minneapolis: University of Minnesota Press, 1998); and Rosalind Deutsche, Aruna D'Souza, Miwon Kwon, Ulrike Muller, Mignon Nixon, and Senam Okudzeto, "Feminist Time: A Conversation," *Grey Room* 31 (2008): 32–67. Iris van der Tuin, for one, proposes a reconception of the feminist generation model as positive in *Generational Feminism: New Materialist Introduction to a Generative Approach* (Lanham, Md.: Lexington Books, 2015).

16. For representative examples of texts written by feminist writers of color attuned to differences beyond gender difference in the 1980s see, among others, bell hooks, *Ain't I a Woman: Black Women and Feminism* (Boston: South End Press, 1981); Gloria T. Hull, Patricia Bell-Scott, and Barbara Smith, *All the Women Are White, All the Blacks Are Men, but Some of Us Are Brave: Black Women's Studies* (Old Westbury, N.Y.: Feminist Press, 1982); Audre Lorde, *Sister Outsider: Essays*

and Speeches (Trumansburg, N.Y.: Crossing Press, 1984); Chandra Talpade Mohanty, "Under Western Eyes: Feminist Scholarship and Colonial Discourses," *Feminist Review* 30 (1988): 61–88; Cherríe Moraga and Gloria Anzaldúa, *This Bridge Called My Back: Writings by Radical Women of Color,* 2nd ed. (New York: Kitchen Table, Women of Color Press, 1983); and Gaytari Chakravorty Spivak, "Imperialism and Sexual Difference," *Oxford Literary Review* 8, no. 1–2 (1986): 225–40.

17. Art historians are not alone, and *Difference* is not exceptional in this regard. Misha Kavka, for example, offers an informative critique of the cultural theorist Michele Barrett's influential 1992 essay "Words and Things: Materialism and Method in Contemporary Feminist Analysis" for its affirmation of a radical split between the "materialist/social 'seventies' " and the "discursive 'eighties.' " See Kavka, introduction to *Feminist Consequences,* xiii. In the literary critic Harold Bloom's terms, the "anxiety of influence" between generations ensures a specifically patrilineal genealogy. Bloom, *The Anxiety of Influence: A Theory of Poetry* [1973] (New York: Oxford University Press, 1997).

18. Griselda Pollock, "The Politics of Theory: Generations and Geographies in Feminist Theory and the Histories of Art Histories," in *Generations and Geographies in the Visual Arts: Feminist Readings,* ed. Griselda Pollock (London: Routledge, 1996), 13.

19. Sylvia Kolbowski in Kolbowski et al., "A Conversation on Recent Feminist Art Practices," 50.

20. Lydia Yee, "Division of Labor: 'Women's Work' in Contemporary Art," in *Division of Labor: "Women's Work" in Contemporary Art,* ed. Lydia Yee and Arlene Raven (New York: Bronx Museum of Art, 1995, exhibition catalog), 9–45.

21. Ibid., 23–25.

22. Ibid., 24.

23. Yee's references to "sexuality as a cultural construction" in contradistinction to a "perspective based on natural or biological truth," tellingly, are borrowed not from the exhibition catalog but from Judith Barry and Sandy Flitterman-Lewis's uncompromising denunciation of "untheorized," "essentialist" feminist art practices in an influential 1980 article. See Judith Barry and Sandy Flitterman-Lewis, "Textual Strategies: The Politics of Art-Making," *Screen* 21, no. 2 (1980): 35–48. A revised version of the essay with the same title appeared in the 1981–82 issue of *LIP: Feminist Arts Journal.*

24. See Deutsche et al., "Feminist Time." The panelists make the point that suppressing "*Difference*-type" feminism in current historical accounts of art informed by feminism is, paradoxically, phallocentric.

25. The quotations are by Deutsche (ibid., 34) and Aruna D'Souza (ibid., 34), respectively.

26. Key publications include Juliet Mitchell and Jacqueline Rose, *Feminine Sexuality: Lacan and the Ecole Freudienne* (New York: Norton, 1982); Mary Kelly, *Post-Partum Document* (London: Routledge and Kegan Paul, 1983); Griselda Pollock, *Vision and Difference: Feminism, Femininity, and Histories of Art* (New

York; Routledge, 1988); Kaja Silverman, *The Subject of Semiotics* (New York: Oxford University Press, 1983); and Brian Wallis, ed., *Art after Modernism: Rethinking Representation* (New York: New Museum of Contemporary Art, 1984). The latter featured key essays by Mary Kelly ("Re-Viewing Modernist Criticism," 87–103), Kate Linker ("Representation and Sexuality," 391–415), and Laura Mulvey ("Visual Pleasure and Narrative Cinema," 361–74), which number among those most frequently cited in the *Difference* exhibition catalog.

27. See Juli Carson, "On Discourse as Monument: Institutional Spaces and Feminist Problematics," in *Alternative Art, New York, 1965–1985*, ed. Julie Ault (Minneapolis: University of Minnesota Press, 2002), 121–60. See also Carson's essay in *Museums after Modernism: Strategies of Engagement*, ed. Griselda Pollock and Joyce Zemans (Malden, Mass.: Blackwell, 2007), 190–224.

28. Carson cites the exhibitions *Events: En Foco, Heresies Collective* (1983, at the New Museum's original Fifth Avenue space) and *Difference* (the first show at the museum's new Broadway location) as examples of the New Museum's exhibitions in this vein.

29. Juliet Mitchell, *Psychoanalysis and Feminism* (New York: Pantheon, 1974); Julia Kristeva, "The System and the Speaking Subject," in *The Kristeva Reader*, ed. Toril Moi (Oxford: Basil Blackwell, 1986), 24–33; Simone de Beauvoir, *The Second Sex*, trans. H. M. Parshley (New York: Vintage Books, 1989); Kate Millet, *Sexual Politics* (Garden City, N.Y.: Doubleday, 1970); and Shulamith Firestone, *The Dialectic of Sex: The Case for Feminist Revolution* (New York: Morrow, 1970).

30. Rose, "Sexuality in the Field of Vision," in *Difference*, 32.

31. As mentioned above, Pollock, Mitchell, and especially Rose were equally influential for bringing psychoanalytic models to bear on the politics of visual practice; Mitchell and Rose's coedited anthology, *Feminine Sexuality*, introduced Lacan's later writings to English-speaking audiences. Mary Kelly's *Post-Partum Document* and Kaja Silverman's *The Subject of Semiotics* also predated *Difference*.

32. In the vast number of scholarly references to Mulvey's 1975 article, it is frequently overlooked that the author did not aspire to the tone or style of a scholarly essay in this article; instead, Mulvey composed the piece from the position of an active filmmaker and intentionally wrote in a manifesto style. See Mandy Merck, "Mulvey's Manifesto," *Camera Obscura* 22, no. 3 (2007): 1–23, for an intellectual history of this essay. For a useful anthology of interdisciplinary texts engaged with "gaze theory" from the 1970s through the 1990s, see Amelia Jones's *The Feminism and Visual Culture Reader* (London: Routledge, 2003). For this chapter's purposes, it is important to note that revisionist approaches include those by Mulvey herself as early as 1981. See Laura Mulvey, "On *Duel in the Sun*: Afterthoughts on 'Visual Pleasure and Narrative Cinema,'" *Framework* 6 (1981): 12–15.

33. Aimee Rankin, "*Difference* and Deference," *Screen* 28, no. 1 (1987): 99.

34. The panelists in Deutsche's "Feminist Time" roundtable, for example, cite Levine, Kolbowski, Kruger, Kelly, Jenny Holzer, Cindy Sherman, and Louise Lawler—all of whom are best known for still-photo-based works—as exemplars

of 1980s feminist art. That said, given the fact that exhibition catalogs typically represent moving-image works with still images (if they represent them at all), it is perhaps no wonder that the moving-image works are either eclipsed or misremembered as static images. On the importance of catalogs for the critical legacy of the works featured in a given exhibition, see Kelly, "Re-viewing Modernist Criticism."

35. See, for example, Jacques Lacan, *The Four Fundamental Concepts of Psychoanalysis,* trans. Alan Sheridan (New York: Norton, 1978).

36. Deutsche et al., "Feminist Time," 61.

37. Richard Rushton, "Deleuzian Spectatorship," in "Screen Theorizing Today: A Celebration of *Screen*'s Fiftieth Anniversary," special issue, *Screen* 5, no. 1 (Spring 2009): 45–53. Widely recognized shortcomings of the psychoanalytically informed art and theory celebrated in *Difference* include an overemphasis on active versus passive viewership, the naturalization of the concept of heterosexual difference, and the alleged inattention to issues of race and class. While these concerns are valid in many ways, the essays in the *Difference* catalog themselves identify certain shortcomings of psychoanalytic models and of the artistic practices they inspire. Weinstock, for example, wonders if perhaps a "strategic essentialism" might help counter the implied centrality of the male subject in psychoanalytic theory; Rose critiques feminist practices that would aspire to claim a wholly other psychic and representational domain outside dominant structures; and Wollen underlines the difficulty of developing a cinema that would destabilize the patriarchical symbolic order without eliminating the possibility of cinema altogether.

38. Iris van der Tuin, "Deflationary Logic: Response to Sara Ahmed's 'Imaginary Prohibitions: Some Preliminary Remarks on the Founding Gestures of the New Materialism,'" *European Journal of Women's Studies* 15, no. 4 (2008): 415. As detailed in chapter 1, feminist writers associated with new materialisms offer instructive models for a project of this nature. Influential examples include: Anu Koivunen, "An Affective Turn? Reimagining the Subject of Feminist Theory," in *Working with Affect in Feminist Readings: Disturbing Differences,* ed. Marianne Liljeström and Susanna Paasonen (New York: Routledge, 2010): 8–27; Susan J. Hekman, "Constructing the Ballast," in Alaimo and Hekman, *Material Feminisms,* 85–119; Myra Hird, "Feminist Engagements with Matter," *Feminist Studies* 35, no. 2 (Summer 2009): 329–46; and Ahmed, "Open Forum, Imaginary Prohibitions."

3. Critical Proximity

A portion of this chapter appeared as "The Medium Is the Eyeball Massage," in *Exhibiting the Moving Image,* ed. Francois Bovier and Adeena Mey (Zurich: JRP/Ringier, 2015), pp. 78–93.

1. Laura Mulvey, "Visual Pleasure and Narrative Cinema," *Screen* 16, no. 3 (Fall 1975): 6–18.

2. Prominent examples include Amelia Jones, *Self/Image: Technology, Representation, and the Contemporary Subject* (London: Routledge, 2006); Peggy Phelan,

"Opening Up Spaces within Spaces: The Expansive Art of Pipilotti Rist," in *Pipilotti Rist*, ed. Peggy Phelan (London: Phaidon, 2001), 32–77; Christine Ross, "Fantasy and Distraction: An Interview with Pipilotti Rist," *Afterimage* 28, no. 3 (2000): 7–9; and Christine Ross, "Pipilotti Rist: Images and Quasi-Objects," *n. paradoxa* 7 (2001): 18–25. Their specific critiques will be examined in the body of the text.

3. On the debates surrounding the concept of suture in film studies, see Kaja Silverman, *The Subject of Semiotics* (New York: Oxford University Press, 1983).

4. Jones, *Self/Image*, 210.

5. Phelan, "Opening Up Spaces within Spaces," 43.

6. Ross, "Fantasy and Distraction," 7–9.

7. Ross, "Pipilotti Rist," 19.

8. Ibid., 20.

9. Elisabeth Bronfen, "Pipilotti's Body Camera," in *Pipilotti Rist: Eyeball Massage*, ed. Stephanie Rosenthal and Konrad Bitterli (London: Hayward, 2012), 123.

10. A potential reason for this oversight is that, in specifically objecting to the cinemacentric theories of visuality proposed by Mulvey and others, these critics risk unintentionally directing themselves too exclusively to cinematic models of production and reception (as opposed to the specific conditions distinctive to the institutional context of the visual arts). On this topic, it is worth emphasizing that the overemphasis on representational strategies in much film theory has contributed to an overly textual-centric consideration of the cinema/ideology relation. Judith Mayne identifies the problem this way: "It is one thing to focus on particular aspects of the cinematic institution and another thing altogether to isolate and ultimately to fetishize certain of those aspects as more symptomatic, more significant than others." Judith Mayne, *Cinema and Spectatorship* (New York: Routledge, 1993), 29.

11. Rist's frequent self-appropriation can make it difficult to definitively state where any given work begins or ends. For one account, see Phelan, "Opening Up Spaces within Spaces," 72.

12. *Color of Your Socks: A Year with Pipilotti Rist*, 2009, directed by Michael Hegglin. The title refers to Rist's advice to the museum guards about how to disarm belligerent visitors who refuse to remove their shoes in the carpeted seating area. Rist urges them to defuse the situation with humor: "Oh, come on—I want to see the color of your socks!"

13. For an interesting analysis of Rist's practice as related to the Deleuzian color theory, see Carolyn Kane, "The Synthetic Color Sense of Pipilotti Rist, or, Deleuzian Color Theory for Electronic Media Art," *Visual Communication* 10, no. 4 (2011): 475–97.

14. Director's notes, *Pepperminta* Pressbook, n.p., http://www.the-match-factory.com/films/items/pepperminta.html.

15. For a historical overview of installation art, see, among others, Claire Bishop, *Installation Art: A Critical History* (New York: Routledge, 2005) and Julie

Reiss, *From Margin to Center: The Spaces of Installation Art* (Cambridge, Mass.: MIT Press, 2000). For a critical history specific to installation art practices engaged with media technologies, see Kate Mondloch, *Screens: Viewing Media Installation Art* (Minneapolis: University of Minnesota Press, 2010).

16. Ross, "Fantasy and Distraction," 7–9.

17. Brian O'Doherty, *Inside the White Cube: Ideology of the Gallery Space,* rev. and exp. ed. (Berkeley: University of California Press, 1986).

18. Claire Bishop, "Interview with Pipilotti Rist," *Make: The Magazine of Women's Art,* no. 91 (2001): 13–16.

19. Patricia Bickers, "Caressing SPACE (interview with Pipilotti Rist)," *Art Monthly* 350 (October 2011): 1–4.

20. Although this seems to put *Pepperminta* at a comparative disadvantage to other artists' films of the period (e.g., Steve McQueen, Shirin Neshat, Sam Taylor-Wood, etc.), it is worth noting that sculptural forms of film and video have consistently enjoyed greater institutional and popular support within the institutional confines of the art museum than noninstallation variants of media art (i.e., single-channel videotapes and films) *ever since their inception in the 1960s–1970s*—a fact frequently overlooked by contemporary writers who tend to equate the commercialization and institutionalization of moving-image installations with the popularity of projected-image works in the 1990s.

21. Cameron Shaw, "Pipilotti Rist at MOMA," *Artforum.com* 1 (2009): n.p.

22. Biesenbach cited in Carol Vogel, "Pigs, Worms and Pink in the Atrium at MoMA," Inside Art, *New York Times,* October 30, 2008, C24.

23. Catrien Schreuder, ed., *Elixir: The Video Organism of Pipilotti Rist* (Rotterdam: Museum Boijmans Van Beuningen, 2009), 162.

24. For an efficient overview of the dominant scholarly critical discourse surrounding the projected image in contemporary art, see George Baker, Matthew Buckingham, Hal Foster, Chrissie Iles, Anthony McCall, and Malcom Turvey, "Roundtable: The Projected Image," *October* 104 (2003): 71–96. Note also that the terms of these critiques were prefigured in many ways by writings in the 1970s by Annette Michelson, Peter Wollen, and others.

25. Tanya B. Leighton, ed., *Art and the Moving Image: A Critical Reader* (London: Tate Museum, 2008), 14.

26. Ibid., 33. On the immersive effects of the virtual image, Leighton is referencing specifically Hal Foster (in Hal Foster, Rosalind Krauss, Yve-Alain Bois, and Benjamin Buchloh, eds., *Art Since 1990* [New York: Thames and Hudson, 2005]) and Walter Benjamin ("The Work of Art in the Age of Mechanical Reproduction," in *Illuminations,* trans. Harry Zohn [New York: Schocken, 1968], 217–51).

27. On the expanded field of media art production in the 1960s and 1970s, see, for example, Leighton, *Art and the Moving Image,* and Tamara Trodd, ed., *Screen/Space: The Projected Image in Contemporary Art* (Manchester: University of Manchester Press, 2010). Several exhibition catalogs from the 1990s to the present

have focused specifically on gallery-based media installations and their particular genealogies. Among the most prominent are Sabine Breitwieser, *White Cube / Black Box: Skulpturensammlung: Video Installation Film* (Vienna: Generali Foundation, 1996); Chrissie Iles, ed., *Into the Light: The Projected Image in American Art, 1964–1977* (New York: Whitney Museum, 2001); Jeffrey Shaw and Peter Weibel, eds., *Future Cinema: The Cinematic Imaginary after Film* (Karlsruhe: ZKM I Center for Art and Media Karlsruhe, 2002); and Matthias Michalka, ed., *X-Screen: Film Installation and Actions in the 1960s and 1970s* (Cologne: Verlag der Buchhandlung Walther König, 2003).

28. Representative works include, for example: Valie Export, *Ping Pong* (1968); Peter Campus, *Interface* (1972); Dan Graham, *Present Continuous Past(s)* (1974); Michael Snow, *Two Sides to Every Story* (1974); and Bruce Nauman's video corridor series (1969–72). For detailed analysis of these works, see Mondloch, *Screens.*

29. Note that while cinema was never the exclusive concern of the various media art practices initiated in the 1960s–1970s, discussions of cinema and "the cinematic" continue to frame the critical discourse around these works as well as contemporary media art production such as Rist's. While many writers have attempted to address this slippery intermedia terrain, it is interesting to note that the terminology most often used to describe such practices—projected images, exhibited cinema, paracinema, artists' films, gallery films, the "other" cinema, and so on—retains an evident and arguably outdated emphasis on cinematic concerns. For an account of this phenomenon as it pertains to expanded cinema, see Eric de Bruyn, "The Expanded Field of Cinema, or Exercise on the Perimeter of a Square," in Michalka, *X-Screen,* 152–76. That said, it is of course important not to ignore medium and material specific concerns in practices that *do* explicitly engage film and cinema, as has sometimes occurred in histories of new media art too narrowly focused on digital convergence. On the importance of medium-specificity for film-based works, see Jonathan Walley, "Identity Crisis: Experimental Film and Artistic Expansion," *October* 137 (2011): 23–50.

30. On the relationship between installation variants of film and video art and the contemporary art museum see, among others, Erika Balsom, *Exhibiting Cinema in Contemporary Art* (Amsterdam: Amsterdam University Press, 2013); Giuliana Bruno, *Surface: Matters of Aesthetics, Materiality, and Media* (Chicago: University of Chicago Press, 2014); Maeve Connolly, *The Place of Artists' Cinema: Space, Site, and Screen* (Chicago: Intellect, 2009); Catherine Elwes, *Installation and the Moving Image* (New York: Columbia University Press, 2015); Catherine Fowler, "Room for Experiment: Gallery Films and Vertical Time from Maya Deren to Eija Liisa Ahtila," *Screen* 45, no. 4 (2004): 324–43; Mondloch, *Screens;* and Andrew Uroskie, *Between the Black Box and the White Cube: Expanded Cinema and Postwar Art* (Chicago: University of Chicago Press, 2014). For a discussion of the interactions among the viewer, the image, and the "space-in-between" as related specifically to video installation art, see Margaret Morse, *Virtualities:*

Television, Media Art, and Cyberculture (Bloomington: Indiana University Press, 1998).

31. For an early discussion of the experience economy, see B. Joseph Pine and James Gilmore, *The Experience Economy: Work as Theater and Every Business a Stage* (Boston: Harvard Business School Press, 1999). On the valorization of the creativity, mobility, flexibility, and connectivity of the art world as bound up with the reorganization of capitalism since 1968, see Luc Boltanski and Eve Chiapello, *The New Spirit of Capitalism* (London: Verso, 2007). As this book goes to press, Caroline Jones has offered a compelling reconsideration of these debates in her *The Global Work of Art: World's Fairs, Biennials, and the Aesthetics of Experience* (Chicago: University of Chicago Press, 2016). I regret that I was not able to engage her argument in the body of this text.

32. Dorothy Spears, "Pipilotti Rist: MoMA," *Art in America* 97, no. 1 (January 2009): 105.

33. Exemplary titles in this vein include Connolly, *The Place of Artists' Cinema;* Balsom, *Exhibiting Cinema in Contemporary Art;* and Erika Balsom, "Original Copies: How Film and Video Became Art Objects," *Cinema Journal* 53, no. 1 (2013): 97–118.

34. Balsom, *Exhibiting Cinema in Contemporary Art, 55.*

35. Ibid., 60.

36. For representative firsthand accounts focused on the installation's critique of MoMA itself, see Jerry Saltz, "MoMA's Sex Change: The Museum's Pipilotti Rist Show Cheekily Feminizes a Bastion of Masculinity," *New York Magazine,* no. 28 (January 2009): 69–70, or Karen Rosenberg, "Tiptoe by the Tulips (or Stretch by the Apples)," *New York Times,* November 21, 2008. For an informative account of the museum's traditional stodginess and sexism, see Carol Duncan and Alan Wallach, "The Universal Survey Museum," *Art History* 3, no. 4 (1980): 448–69. Although *Pour Your Body Out* effectively probes the alleged neutrality of certain of MoMA's institutional practices, it is undeniable that the multimedia work's immense popularity benefited the institution at the same time. I address this seeming inconsistency in the body of this text.

37. For an early account of the gendered production/consumption paradigm as pertains to the mass culture debate, see, for example, Tania Modleski, "Feminity as Mas(s)querade: A Feminist Approach to Mass Culture," in *High Theory / Low Culture,* ed. Colin MacCabe (New York: St. Martin's Press, 1986), 37–52.

38. As we saw in chapter 2, many scholars have addressed the by-now apparent flaws of this polarizing and dualistic conception of feminism. For a retrospective overview of the problems these binaries present for art history and criticism, see Helena Reckitt and Peggy Phelan, *Art and Feminism* (London: Phaidon Press, 2001).

39. Trodd, *Screen/Space,* 13.

40. Davide Panagia, *The Political Life of Sensation* (Durham, N.C.: Duke University Press, 2009), 3.

41. Mieke Bal, *Thinking in Film: The Politics of Video Art Installation According to Eija-Liisa Ahtila* (London: Bloomsbury Academic, 2013), 7. Bal notes that her account is indebted to political philosopher Wendy Brown's "Postmodern Exposures, Feminist Hesitations," in *States of Injury: Power and Freedom in Late Modernity* (Princeton, N.J.: Princeton University Press, 1995), 30–51.

42. Juliane Rebentisch, "Forms of Participation in Art," *Qui Parle* 23, no. 2 (2015): 37. Rebentisch argues that the aesthetic experience of installation art in particular is structured by a dialectic of attention and absorption in Juliane Rebentisch, *Aesthetics of Installation Art* (Berlin: Sternberg Press, 2012/13).

43. Rebentisch, "Forms of Participation in Art," 46. Emphasis added.

44. Donna Haraway, "Situated Knowledges: the Science Question in Feminism and the Privilege of Partial Perspective," *Feminist Studies* 14, no. 3 (1988): 575–99.

45. Jerry Saltz, "Completing Pipilotti Rist's MoMA Installation," *New York Magazine*, February 2, 2009, http://www.vulture.com/2009/02/saltz_completing _pipilotti_ris.html.

4. Unbecoming Human

1. Donna Haraway interprets Piccinini's oeuvre, following anthropologist Deborah Bird, in relationship to indigenous Australian models of care for Australia's land and peoples in her "Speculative Fabulations for Technoculture's Generations," in *(Tender) Creatures* (Vitoria-Gasteiz, Spain: Atrium Gallery, 2007, exhibition catalog). See also Deborah Bird Rose, *Reports from a Wild Country: Ethics for Decolonisation* (Sydney: University of New South Wales Press, 2004). While Haraway's essay is predominantly interested in the locational, Australian context of Piccinini's practice, I will return to her sympathetic reading of Piccinini's work in the context of a queer ethic of care in the body of the text.

2. Christoph Cox, "Of Humans, Animals, and Monsters," in *Becoming Animal: Contemporary Art in the Animal Kingdom*, curated by Nato Thompson, Massachusetts Museum of Contemporary Art (Cambridge, Mass.: MIT Press, 2005), 23. *Becoming Animal* featured Piccinini's sculpture *The Young Family* (2002–3), which first debuted in the *We Are Family* exhibition at the Venice Biennale in 2003.

3. Eugene Thacker, *Global Genome: Biotechnology, Politics, and Culture* (Cambridge, Mass.: MIT Press, 2005), 307.

4. Claire Pentecost, "Outfitting the Laboratory of the Symbolic: Toward a Critical Inventory of Bioart," in *Tactical Biopolitics: Art, Activism and Technoscience,* ed. Beatrice da Costa and Philip Kavita (Cambridge, Mass.: MIT Press, 2008), 110. Emphasis added.

5. Rosi Braidotti coins the term "postanthropocentric posthumanism" in *The Posthuman* (Cambridge: Polity Press, 2013). I address her analysis in detail in the later part of the chapter.

6. Indicative of the exhibition's widespread popularity, *We Are Family* was restaged in its entirety at the Hara Museum of Contemporary Art in Tokyo in December 2003, immediately following the Venice Biennale showing. Despite the fact that Piccinini is consistently written about, excerpted, and illustrated in relationship to critical debates on biotech, the artist herself does not claim any expertise or critical position on science. She describes herself as an "interested amateur" whose primary contact with advanced technologies is through a subscription to the generalist magazine *New Scientist*.

7. Linda Michael, *Patricia Piccinini: We Are Family* (Strawberry Hills, N.S.W.: Australia Council, 2003, exhibition catalog for the Australia Pavilion at Venice Biennale), 10.

8. While the polished crash helmets in *Team WAF (Precautions)* initially might seem like outliers to this family dynamic, the fiberglass helmets form part of Piccinini's larger automotive-inspired production in which biomorphic automotive parts appear to consciously engage in intimate encounters. (For example, the Madonna and child Vespas in *Nest* [2006], and the infantile *Truck Babies* [1999], who gaze adoringly at their equally cute preteen guardians in a multimedia installation titled *Big Sisters* [1999].)

9. The "skin" color of the biotech creatures in *We Are Family* unmistakably depicts Caucasian flesh tones. The artist's broader oeuvre demonstrates more diversity.

10. In addition to the many exhibition catalogs cited throughout this chapter, the artist's website provides a useful illustrated overview of Piccinini's production: http://www.patriciapiccinini.net.

11. Piccinini works extensively with expert craftspeople to produce her sculptures, including hyperrealist sculptor Ron Mueck and his studio. For an account of the specific work processes of the two artists, particularly as they relate to contemporary discourses on appropriation and the managerial ethos of contemporary art, see Linda Williams, "Spectacle or Critique? Reconsidering the Meaning of Reproduction in the Work of Patricia Piccinini," *Southern Review: Communication, Politics, Culture* 37, no. 1 (2004): 76–94.

12. Michael, *Patricia Piccinini: We Are Family*, 6.

13. Bioartists Oron Catts and Ionat Zurr of the Tissue Culture and Art Project (TC&A) refer to a class of object/being they call the "Semi-Living," although, in contrast to Piccinini, their practice involves the literal use of tissue technologies as an art medium. Marcos Cruz considers the relationship between Piccinini's depictions of inanimate, yet pulsing life forms and the strange-looking lumps of autonomous flesh that prove to be somehow alive in David Cronenberg's "body horror" film *eXistenZ* (1999) in "Synthetic Neoplasms," *Architectural Design* 78, no. 6 (2008): 36–43.

14. Patricia Piccinini, public presentation at the Tokyo National University of Fine Arts and Music, Faculty of Fine Arts, Tokyo, Japan, December 8, 2003.

15. Patricia Piccinini in "Patricia Piccinini in Conversation with Alasdair Foster," *Photofile* 68 (2003): 22.

16. Artist's statement on *SO2*, http://www.patriciapiccinini.net.

17. She has designed and reproduced *SO2* in a number of contexts. The strange beast has appeared in photographs as the passenger in the front seat of a Holden car in *Waiting for Jennifer* (2000), as the playmate of young boys in *Social Studies* (2001), as a laboratory animal in the *Science Story* series (2002), and in three-dimensional form installed in the wombat enclosure of the Melbourne Zoo (2001).

18. Piccinini, public presentation at the Tokyo National University of Fine Arts and Music, December 8, 2003.

19. Artist's statement on *SO2*.

20. Juliana Engberg, "Atmosphere," in Juliana Engberg, Edward Colless, and Hiroo Yamagatam, *Patricia Piccinini: Atmosphere, Autosphere, Biosphere* (Collingwood, Australia: Drome Pty Limited, 2000), n.p.

21. Helen McDonald, *Patricia Piccinini: Nearly Beloved* (Dawes Point, N.S.W.: Piper Press, 2012), 123.

22. Media press release for *Patricia Piccinini: Relativity* (Perth: Art Gallery of Western Australia, 2010), http://www.artgallery.wa.gov.au/about_us/documents/Patricia-Piccinini-media-release-2010.pdf.

23. Başak Doğa Temür, "Just Because Something Is Bad, Doesn't Mean It Isn't Good," *Hold Me Close to Your Heart* (exhibition catalog) (Istanbul: ARTER, 2011), n.p., http://www.patriciapiccinini.net/printessay.php?id=37.

24. Michael, *Patricia Piccinini: We Are Family,* 18.

25. While most reviewers do not explore the possibility, *Plasmid Region* could also be understood in relationship to the grotesque as it has played out in contemporary art in discourses on abjection and the *informe*. See, for example, Yve-Alain Bois and Rosalind E. Krauss, *Formless: A User's Guide* (New York: Zone Books, 1997).

26. Piccinini, public presentation at the Tokyo National University of Fine Arts and Music, December 8, 2003.

27. Stella Brennan, "Border Patrol," in *Another Life* (Wellington, N.Z.: Wellington City Gallery, 2006, exhibition catalog), 6.

28. Donna Haraway, "Situated Knowledges: The Science Question in Feminism and the Privilege of Partial Perspective," *Feminist Studies* 14, no. 3 (Fall 1988): 595.

29. See, among others, Hito Steyerl, "In Defense of the Poor Image," *e-flux* 10 (November 2009), n.p., http://www.e-flux.com/journal/10/61362/in-defense-of-the-poor-image/, and Orit Gat, "Global Audiences, Zero Visitors: How to Measure the Success of Museums' Online Publishing," *Rhizome* (March 2015), n.p., http://rhizome.org/editorial/2015/mar/12/global-audiences-zero-visitors/, for accounts of this and related trends in contemporary exhibition and publicity related to contemporary art.

30. Haraway, "Speculative Fabulations," 3. See also Haraway's discussion of Piccinini in *When Species Meet* (Minneapolis: University of Minnesota Press, 2008), 288–91.

31. Daniel Harris, *Cute, Quaint, Hungry, and Romantic: The Aesthetics of Consumerism* (New York: Basic Books, 2000) (quoted in Michael, *Patricia Piccinini:*

We Are Family, 21). I am indebted here to Michael's catalog essay in which the author proficiently details the ways in which Piccinini's oeuvre draws us "perilously close to [Harris's] mode of engagement," yet ultimately circumvents this critique, in part by asserting the "redemptive power of social values and relationships" (Michael, *Patricia Piccinini: We Are Family,* 21).

32. It is worth emphasizing that the problem is not merely with biotech, but science in the service of neoliberalism more broadly, in which twenty-first-century scientific and technological production benefits from traditional claims to truth and service to the public even while increasingly tied to narrow commercial agendas. For an introduction to these debates, see, for example, Melinda Cooper, *Life as Surplus: Biotechnology and Capitalism in the Neoliberal Era* (Seattle: University of Washington Press, 2008). On the topic of bioethics as pertinent to cultural and artistic concerns, see Joanna Zylinska, *Bioethics in the Age of New Media* (Cambridge, Mass.: MIT Press, 2009), especially chapter 5, "Green Bunnies and Speaking Ears: The Ethics of Bioart."

33. McDonald, *Patricia Piccinini: Nearly Beloved,* 35.

34. The culturally specific impulse to interpret Piccinini's works as tender creatures requiring our parental affection came into sharp relief in April 2006 when an image of one of the animal figures in Piccinini's sculpture *Leather Landscape* was repurposed on a Sudanese Arabic-language website. As reported by Brennan, the image was circulated in the Muslim world through newspapers, schools and mosques, and on Islamic message boards to illustrate a cautionary tale about a girl who was transformed into an inhuman beast for abusing the Koran. Brennan, "Border Patrol," 7.

35. Haraway, *When Species Meet,* 18. Haraway's classic cyborg manifesto—which playfully celebrates the cyborg figure for its ability to transgress boundaries of gender, race, and difference and to disrupt ontological categories—is the foundational text in this regard. Donna Haraway, "A Manifesto for Cyborgs: Science, Technology, and Socialist Feminism in the 1980s," in *Simians, Cyborgs and Women* (New York: Routledge, 1991), 149–81.

36. Michael, *Patricia Piccinini: We Are Family,* 18.

37. Rosi Braidotti stresses the need to conceptualize human/animal as constitutive of the identity of each, as opposed to anthropomorphizing animals as emblems of the universal ethical value of empathy, in *The Posthuman,* 79.

38. Haraway, "Speculative Fabulations," 14.

39. Braidotti, *The Posthuman,* 190.

40. Nicole Seymour, *Strange Natures: Futurity, Empathy, and the Queer Ecological Imagination* (Urbana: University of Illinois Press, 2013), 184. Seymour's embrace of compassion, optimism, and future generations is especially noteworthy in relationship to Lee Edelman's extended critique of reproductive futurism and environmental agendas grounded in heterosexist, proreproductive rhetoric. Lee Edelman, *No Future: Queer Theory and the Death Drive* (Durham, N.C.: Duke University Press, 2004). On the general interest in fluidity and indeterminacy

among queer theorists as a way to demonstrate the unstable distinction between the human and nonhuman, see, for example, Noreen Giffney and Myra Hird, eds., *Queering the Non/Human* (Farnham, U.K.: Ashgate, 2008).

41. Petra Lange-Berndt, *Materiality (Documents of Contemporary Art)* (Cambridge, Mass.: MIT Press, 2015), 17. For an interesting account of how artists have engaged with nonanthropocentrism, see Katherine Behar and Emmy Mikelson, eds., *And Another Thing: Nonanthropocentrism and Art* (Brooklyn, N.Y.: Punctum Books, 2016).

42. The "ear" on the original Vacanti mouse was actually an ear-shaped cartilage structure grown by seeding cow cartilage cells into a biodegradable ear-shaped mold and then implanted under the skin of the mouse. Note that Piccinini's rendition is not a mouse but a rat.

43. When *Protein Lattice* is installed as part of a complete photographic series, a row of video monitors plays a looped narrative beneath the nine photographs. McDonald explains that the video footage emulates the experience of playing a video game and features digitally constructed vignettes from the points of view of the mouse and the spectator, eventually collapsing the two perspectives. McDonald identifies this as a progressive empathetic exchange: "We will never know what it is to be the other, but there may be benefits in trying to imagine ourselves in the other's place" (McDonald, *Patricia Piccinini: Nearly Beloved,* 45).

44. Braidotti, *The Posthuman,* 190.

45. Karen Barad, in "Interview with Karen Barad," in Rick Dolphijn and Iris van der Tuin, *New Materialism: Interviews & Cartographies* (Ann Arbor, Mich.: Open Humanities Press, 2012), 69.

5. Mind over Matter

1. To cite just one example in each category: *Nirvana,* 1997 (3D video installation [projector, DVD, 3D glasses]); *Enlightenment Capsule,* 1998 (glass, plastic, Himawari system [fiber optics, solar transmitter]); *Tom Na H-iu,* 2005–6 (glass, steel, LED control system [creatively visualizes real-time neutrino activity data from Super Kamiokande in Japan]); *Wave UFO,* 1999–2003 (Vision Dome projector, computer system, fiberglass, Technogel, acrylic, carbon fiber, aluminum, magnesium).

2. For the purposes of this study, I am interested in self-identified instances of the neuroscientific turn since around 1990 (coincident with U.S. president George H. W. Bush's self-professed "Decade of the Brain" initiative). For a useful account of how these hybrid disciplinary initiatives were largely prefigured by developments in the nineteenth century, see Melissa Littlefield and Jenell Johnson, *The Neuroscientific Turn: Transdisciplinarity in the Age of the Brain* (Ann Arbor: University of Michigan Press, 2012), 1–28.

3. Mori, in Mariko Mori and Vicky Hayward, *Mariko Mori / Oneness* (Berlin: Hatje Cantz / Groninger Museum, 2007, exhibition catalog), n.p.

4. A wealth of recent conferences and blogs have been devoted to the critique of neuroscience and its alleged "colonization" of other research fields, particularly as it intersects with the traditionally humanist topics of emotion, art, aesthetics, and the like. Representative conferences and workshops include "Neurosociety . . . What Is It with the Brain These Days?" (Institute for Science, Innovation and Society [InSIS] and the European Neuroscience and Society Network [ENSN], Saïd Business School, University of Oxford, December 7–8, 2010); "Neuro-Reality Check: Scrutinizing the 'Neuro-turn' in the Humanities and Natural Sciences" (Max-Planck-Institute for the History of Science, Berlin, December 1–3, 2011); and the "Neuro-Humanities Entanglement Conference and Neuro Salon" (Georgia Tech School of Architecture, April 12–13, 2012). For a critical survey of the extremely active neuroskeptic blogosphere, see Alissa Quart, "Neuroscience under Attack," *New York Times,* November 23, 2012, http://www.nytimes.com/2012/11/25/opinion/sunday/neuroscience-under-attack.htm.

5. Alan Richardson and Francis Steen, "Literature and the Cognitive Revolution," *Poetics Today* 23, no. 1 (2002): 3.

6. Edward Slingerland, "Who's Afraid of Reductionism? The Study of Religion in the Age of Cognitive Science," *Journal of the American Academy of Religion* (2008): 375–411.

7. Ibid., 375.

8. See, for example, Gordon H. Orians and Judith Heerwagen, "Evolved Responses to Landscapes," in *The Adapted Mind,* ed. Jerome Barkow, Leda Cosmides, and John Tooby (New York: Oxford University Press, 1992), 555–79; David Freedberg and Vittorio Gallese, "Motion, Emotion and Empathy in Esthetic Experience," *Trends in Cognitive Science* 11, no. 5 (2007): 197–203; Denis Dutton, *The Art Instinct: Beauty, Pleasure and Human Evolution* (New York: Bloomsbury, 2009); and Vilayanur Ramachandran, *The Emerging Mind: The BBC Reith Lectures 2003* (London: Profile, 2003).

9. Barbara Maria Stafford, *Echo Objects: The Cognitive Work of Images* (Chicago: University of Chicago Press, 2007).

10. See, for example, Freedberg and Gallese, "Motion, Emotion and Empathy in Esthetic Experience"; and David Freedberg, "Memory in Art," in *The Memory Process: Neuroscientific and Humanistic Perspectives,* ed. Suzanne Nalbantian, Paul Matthews, and James McClelland (Cambridge, Mass.: MIT Press, 2011), 337–58. Note that despite the widespread excitement about the discovery of mirror neurons, especially among writers in the humanistic neurodisciplines (Vittorio Gallese's "The Shared Manifold Hypothesis: From Mirror Neurons to Empathy," *Journal of Consciousness Studies* 8 [2001]: 33–50 was pioneering in this regard), it is important to emphasize that the explanatory use of mirror neurons for understanding the intentions of others has been widely criticized from both scientific and philosophical points of view.

11. John Onians, "Neuroarchaeology and the Origins of Representation in the Grotte De Chauvet, a Neural Approach to Archaeology," in *Image and Imagination:*

A Global Prehistory of Figurative Representation, ed. Colin Renfrew and Iain Morley (Cambridge: McDonald Institute for Archeological Research, 2007), 307–20; Onians, *Neuroarthistory: From Aristotle and Pliny to Baxandall and Zeki* (New Haven, Conn.: Yale University Press, 2008).

12. Julian Bell, "Look Me in the Eye," *London Review of Books* 31, no. 19 (October 2009): 25.

13. Alva Noë, "Art and the Limits of Neuroscience," *New York Times,* December 4, 2011, http://opinionator.blogs.nytimes.com/2011/12/04/art-and-the-limits-of-neuroscience/.

14. Jenell Johnson and Melissa Littlefield, "Lost and Found in Translation: Popular Neuroscience in the Emerging Neurodisciplines," in *Sociological Reflections on the Neurosciences,* vol. 13, *Advances in Medical Sociology,* ed. Martyn Pickersgill and Ira van Keulen (Bingley, U.K.: Emerald Group, 2011), 279–98. See also Littlefield and Johnson, *The Neuroscientific Turn.*

15. Joshua Greene underlines how the history of eugenics offers the most familiar example of how uncomplicated biologism or Darwinism can lead to disastrous results. Joshua Greene, "From Neural 'Is' to Moral 'Ought': What Are the Moral Implications of Neuroscientific Moral Psychology?," *Nature Reviews Neuroscience* 4, no. 10 (2003): 847. Arne Rasmusson explores the sociopolitical implications of the "naturalistic fallacy" in his "Neuroethics as a Brain-Based Philosophy of Life: The Case of Michael S. Gazzaniga," *Neuroethics* 2, no. 1 (2009): 3–11.

16. Diana Coole and Samantha Frost, eds., *New Materialisms* (Durham, N.C.: Duke University Press 2010), 2.

17. Andy Clark, "Out of Our Brains," *New York Times,* December 12, 2010, http://opinionator.blogs.nytimes.com/2010/12/12/out-of-our-brains/.

18. Jorge Moll, Roland Zahn, Ricardo de Oliveira-Souza, Frank Krueger, and Jordan Grafman, "The Neural Basis of Human Moral Cognition," *Nature Reviews Neuroscience* 6 (2005): 799–809. The writers note: "As a general rule, moral emotions result from interactions among values, norms and contextual elements of social situations, and are elicited in response to violations or enforcement of social preferences and expectations. Although the contextual cues that link moral emotions to social norms are variable and shaped by culture, these emotions evolved from prototypes found in other primates and can be characterized across cultures" (806).

19. For a cogent analysis of these issues, see Suparna Choudhury and Jan Slaby, eds., *Critical Neuroscience: A Handbook of the Social and Cultural Contexts of Neuroscience* (Chichester, U.K.: Wiley-Blackwell, 2011); Andy Clark, *Supersizing the Mind: Embodiment, Action, and Cognitive Extension* (Oxford: Oxford University Press, 2008); Alva Noë, *Out of Our Heads: Why You Are Not Your Brain, and Other Lessons from the Biology of Consciousness* (New York: Hill and Wang, 2009); Noë, *Varieties of Presence* (Cambridge, Mass.: Harvard University Press, 2012); Barbara Maria Stafford, ed., *A Field Guide to a New Meta-Field: Bridging*

the Humanities–Neurosciences Divide (Chicago: University of Chicago Press, 2011); and Francisco Ortega and Fernando Vidal, *Neurocultures: Glimpses into an Expanding Universe* (Frankfurt am Main: Peter Lang, 2011).

20. Louise Whiteley, "Resisting the Revelatory Scanner? Critical Engagements with fMRI in Popular Media," *Biosocieties* 7 (2012): 261.

21. For the purposes of the present argument, it is important to note that both technologies share the same serious methodological limitations and fall short of affording real answers about neural network activity due to the circuitry and non-modular functional organization of the brain. On the disproportionately strong persuasive impact of neuroimaging and the well-documented tendency to accord "truth" value to these images, see Timothy Caulfield, Christen Rachul, Amy Zarzaczny, and Henrik Walter, "Mapping the Coverage of Neuroimaging Research," *SCRIPTed* 7, no. 3 (2010): 421–28; Cliodhna O'Connor, Geraint Rees, and Helene Joffe, "Neuroscience in the Public Sphere," *Neuron* 74, no. 2 (2012): 220–26; Kelly Joyce, *Magnetic Appeal: MRI and the Myth of Transparency* (Ithaca, N.Y.: Cornell University Press, 2008); and Whiteley, "Resisting the Revelatory Scanner?"

22. Tallis, "Neurotrash," *Humanist* 124, no. 6 (November/December 2009), http://newhumanist.org.uk/2172.

23. Eric Racine, Ofek Bar-Ilan, and Judy Illes, "fMRI in the Public Eye," *Nature Reviews Neuroscience* 6, no. 2 (2005): 160. See also Joyce, *Magnetic Appeal*. For an interesting account of the historical development of identifying the "brain as self" as ideologically embedded in modernity, see Francesco Vidal, "Brainhood, Anthropological Figure of Modernity," *History of the Human Sciences* 22, no. 1 (2009): 5–36.

24. For the growing literature on this topic, see, for example, Caulfield et al., "Mapping the Coverage of Neuroimaging Research," 421–28; O'Connor, Rees, and Joffe, "Neuroscience in the Public Sphere," 220–26. On the methodological shortcomings of fMRI from a research perspective, see Russell Poldrack, "The Role of fMRI in Cognitive Neuroscience: Where Do We Stand?," *Current Opinion in Neurobiology* 18, no. 2 (2008): 223–27; "The Future of fMRI in Cognitive Neuroscience," *NeuroImage* 62, no. 2 (2012): 1216–20; and Nikos Logothesis, "What We Can Do and What We Cannot Do with fMRI," *Nature* 453 (2008): 869–78.

25. Susan Fitzpatrick, "Functional Brain Imaging: Neuro-Turn or Wrong Turn," in Littlefield and Johnson, *The Neuroscientific Turn,* 192. Fitzpatrick emphasizes that the difficulties associated with constructing explanations that cross levels of analysis from brain function to cognitive functions to behavior are rarely acknowledged but are central to the difficulties of designing and interpreting brain-imaging studies addressing questions of interest to the humanities and social sciences.

26. *Wave UFO* has no permanent institutional home. It has been exhibited several times—first in Austria at the Kunsthaus Bregenz (Peter Zumthor, 2003),

then in New York in the courtyard of the IBM Building (through Public Art Fund sponsorship, 2003), and then at the 2005 Venice Biennale. *Wave UFO* has been exhibited after 2005, but only in conjunction with the large traveling exhibition *Mariko Mori / Oneness* (Vicky Hayward, Groningen Museum, 2007).

27. It took more than two years to find the appropriate collaborators and technologies to implement the artist's vision for *Wave UFO*. To cite just one example of its sophisticated engineering, the exterior (constructed by an Italian design company that develops racing-car prototypes) consists of approximately forty ingeniously matched fiberglass pieces that can then be realigned with only one millimeter of space between them in order to facilitate shipping and reassembly.

28. Alpha activity can be observed in about 75 percent of awake, relaxed individuals and is replaced by low-amplitude desynchronized beta activity during movement, complex problem solving, and visual focusing. This phenomenon is called "alpha blocking."

29. Mori, in Mori and Hayward, *Mariko Mori / Oneness*, n.p.

30. Anna Gibbs, "Contagious Feelings: Pauline Hanson and the Epidemiology of Affect," *Australian Humanities Review* (2001), cited in Kristyn Gorton, "Theorizing Emotion and Affect: Feminist Engagements," *Feminist Theory* 8, no. 3 (2007): 337.

31. Diether Lohmar, "Mirror Neurons and the Phenomenology of Intersubjectivity," *Phenomenology and the Cognitive Sciences* 5, no. 1 (2006): 15. As noted above, there is significant dissent regarding the transdisciplinary application of research on mirror neurons. For a neurophilosophical critique, see Patricia Churchland, *Braintrust: What Neuroscience Tells Us about Morality* (Princeton, N.J.: Princeton University Press, 2011).

32. See Choudhury and Slaby, *Critical Neuroscience*. The European Neuroscience and Society Network Neuroschools is one of the first programs devoted to bringing together early career social scientists and neuroscientists: http://www.kcl.ac.uk/sspp/departments/sshm/research/ensn/neuroschools/Neuroschools.aspx.

33. For an examination of how human meaning, imagination, and reason emerge from structures of bodily perception and movement, see Mark Johnson, *The Body in the Mind: The Bodily Basis of Meaning, Imagination, and Reason* (Chicago: University of Chicago Press, 1987); Johnson, *The Meaning of the Body: Aesthetics of Human Understanding* (Chicago: University of Chicago Press, 2007); George Lakoff and Mark Johnson, *Philosophy in the Flesh: The Embodied Mind and Its Challenge to Western Thought* (New York: Basic Books, 1999). In *Philosophy in the Flesh*, Lakoff and Johnson compellingly suggest that there are at least five interwoven dimensions of human embodiment: (1) The Body as Biological Organism, (2) The Ecological Body (the body is not separate from its environment and any boundaries we choose to mark between them are merely artifacts of our interests and forms of inquiry), (3) The Phenomenological Body (our body as we live and experience it), (4) The Social Body (intersubjective relationships), and (5) The

Cultural Body (gender, race, class, socioeconomic status, aesthetic values, and various modes of bodily posture).

34. Noë, "Art and the Limits of Neuroscience." See also Noë, *Out of Our Heads* and *Varieties of Presence*.

35. Lohmar, "Mirror Neurons and the Phenomenology of Intersubjectivity," 10.

Conclusion

1. Mariko Mori, in Mori and Vicky Hayward, *Mariko Mori / Oneness* (Berlin: Hatje Cantz / Groninger Museum, 2007, exhibition catalog), n.p. The artist also refers to this as a transition from "earthly to heavenly themes" (Mori, *Mariko Mori / Oneness*, n.p).

2. According to Ingrid Sischy's article on Mori published in the *New York Times,* Mori's gallerist Jeffrey Deitch ascribes the artist's persistent interest in bubbles, capsules, and pods to the fact that Mori's mother's doctorate was on the iconography of the soap bubble in Northern Renaissance artwork. Sischy remarks that it was "Deitch who told me that Mori's mother's doctorate was on the iconography of the soap bubble in Northern Renaissance artwork, providing the genetic link to all the bubbles and pods that show up in Mori's work" (273). Ingrid Sischy, "The Space Cadet," *New York Times,* August 27, 2006, 270–73.

3. Mori's description of *Esoteric Cosmos* is illuminating: "This work represents the mandala, a pictorial structure depicting the continuous circulation of life. Wind is generated from emptiness, wind causes fire, fire causes water, water causes earth, and earth decays to emptiness. This circulation also represents the Buddhist path of conception, practice, enlightenment, and Nirvana. (emptiness → wind → fire → water → earth → emptiness)" (Mori and Hayward, *Mariko Mori / Oneness,* n.p.). Significantly, as will be explained in the body of this text, Mori's installation of these large-scale works (each approx. 3.05 m × 6.1 m [10 × 20 ft.]) on all four walls of a room invites an immersive (encapsulating) spectatorial experience as well.

4. On the topic of popular contemporary applications of Buddhism, R. John Williams offers an interesting account of what he identifies as a "techne-zen" aesthetic developed from the 1960s counterculture to the present, which, according to Williams, risks habituating subjects to the technocentrism of cybernetics ("Techne-Zen and the Spiritual Quality of Global Capitalism," *Critical Inquiry* 38, no. 1 [2011]: 17–70). For Williams, an effective response to the late capitalist culture of techne-zen must involve a commitment not only to aesthetics and political egalitarianism but also to historiography; *A Capsule Aesthetic*'s historiographical account of embodied technointerfaces in feminist media art and theory in Chapter 2 supports this approach. Philosophically speaking, the notion of distributed or ecological subjectivity has roots deeper than the new materialisms of the past thirty years; while Mori explicitly references variations in Buddhist and premodern

formations, other examples are found in the work of William James, Martin Heidegger, Gregory Bateson, Maurice Merleau-Ponty, Daniel Dennett, and others. Similar views are expressed in many indigenous philosophies of materiality. For a detailed investigation of the "microspace" of the self or individual through investigations of spatial structures that allow couplings (e.g., bubbles, spheres, envelopes), see Peter Sloterdijk, *Bubbles: Spheres*, vol. 1, *Microspherology* (Cambridge, Mass.: Semiotext(e), 2011).

5. While Buddhism is an important reference point for Mori's artistic production—for example, the apparent visual and conceptual similarities between the Buddhist temple at Hōryū-ji and Mori's *Dream Temple*, or the depictions of Amida's Pure Land and Mori's photograph of the same name—the artist has consistently maintained that she is not committed to its orthodox interpretation or application. Mori has written extensively about her interest in a range of other cultures and (pre)historic objects such as the Standing Stones of Stenness (3000 BC), Standing Stones of Callanish (2000 BC) (Scotland), clay masks and dogu clay figurines from Final Jomon period (ca. 1000–400 BC), Mirrors of Western Han period (China, 206 BC–AD 8), Indian mudras, and Tibetan sand mandalas. See, for example, Mori in Mori and Hayward, *Mariko Mori / Oneness*, n.p.

6. The roster of sites includes "past" sites: Giza (Egypt), Teotihuacan (Mexico), Angkor Wat (Cambodia), Tiahuanacu (Bolivia); "present" sites: Tsim Sha Tsui (Hong Kong), Piccadilly Circus (London), Times Square (New York), Shibuya (Tokyo); and "future" sites: La Defense (Paris), Congresso Nacional (Brasilia), Docklands (London), Wai Tan (Shanghai), Jumeriah (Dubai). When exhibited as a complete series, the panoramic images are arranged into groups (Past, Present, and Future) and displayed in a circular formation inside of three rings suspended from the ceiling in the center of the exhibition space. The circle diameters measure 6.5 meters (approx. 21.3 ft.) each.

7. Although outside of the context of the visual arts, feminist critics of science have articulated concepts suggestively similar to what I am calling a capsule aesthetic; see, for example, Karen Barad on "intra-action" ("Posthumanist Performativity: Toward an Understanding of How Matter Comes to Matter," *Signs* 28, no. 3 [2003]: 801–31); Nancy Tuana on "viscous porosity" ("Viscous Porosity: Witnessing Katrina," in *Material Feminisms,* ed. Susan Hekman and Stacy Alaimo [Durham, N.C.: Duke University Press, 2007], 188–213); and Stacy Alaimo on "trans-corporeality" (*Bodily Natures: Science, Environment, and the Material Self* [Bloomington: Indiana University Press, 2010]). Alaimo outlines the conceptual parallels among the latter three models in "Thinking as the Stuff of the World," *O-Zone: A Journal of Object-Oriented Studies* 1 (2014): 13–21.

8. Karen Barad, *Meeting the Universe Halfway: Quantum Physics and the Entanglement of Matter and Meaning* (Durham, N.C.: Duke University Press, 2007), 353.

INDEX

Page numbers in *italics* refer to figures.

KATE MONDLOCH is professor of contemporary art and head of the Department of the History of Art and Architecture at the University of Oregon. She is author of *Screens: Viewing Media Installation Art* (Minnesota, 2010).